Beginning Sculpture

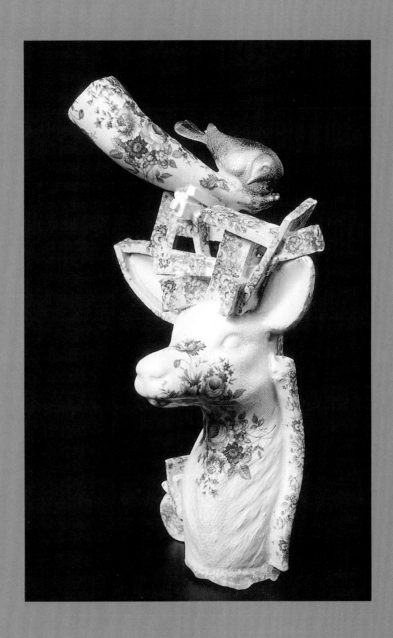

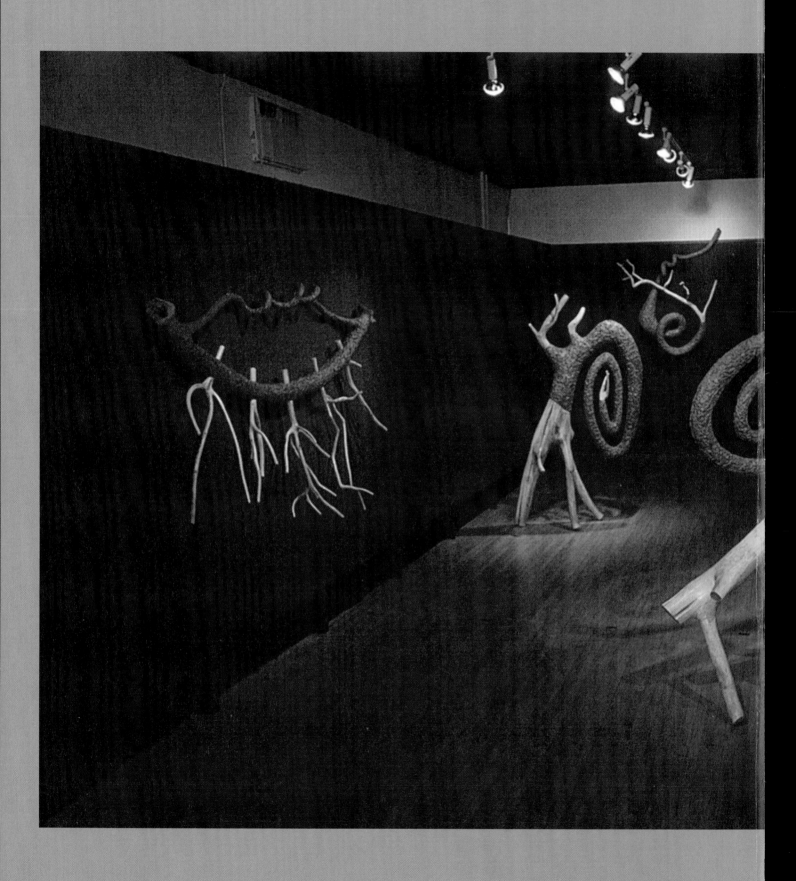

Beginning
SCULPTURE

Arthur Williams

Davis Publications, Inc.
Worcester, Massachusetts

Front Cover: Don Smith, *Forms*. Wood, bronze, limestone, 17" (43cm).
Instructor: Arthur Williams.
Half-title page: Jeff Schmuki, *Trophy*, 2002. Porcelain-slip casting,
17" x 8" x 7" (43 x 20.3 x 17.7 cm).
Frontispiece: Duane Paxson, *Spiral Dancers Installation*, 2000.
Wood, resin, fiberglass, acrylic, 144" x 360" x 216".

Publisher: Wyatt Wade
Editorial Consultant: Claire Golding, Helen Ronan
Managing Editor: David Coen
Senior Editor: Carol Traynor
Editorial Assistance: Jillian Johnstone
Copyediting: Melissa Clemence and Marilyn Rash,
 Books By Design, Inc.
Manufacturing: Georgiana Rock
Design: Douglass Scott, Cara Joslin, WGBH Design
Layout/Production: Janis Owens and Nancy Benjamin,
 Books By Design, Inc.

Contributing Authors:
Jennifer L. Childress, Albany, NY
Judy Drake, Murray Hill, NJ
Jan Wilson, Hamilton, NJ
Diana Woodruff, Northborough, MA
Art Sherwyn, Los Angeles, CA
Cindy McGuire, Los Angeles, CA

Acknowledgments
This book owes a great debt of thanks to the efforts of students,
teachers, and artists who submitted photographic images to the
author. Davis Publications has done an excellent job of organizing
and arranging this text, and it is appreciated. Senior Editor, Carol
Traynor, is to be commended for completing the task that had
involved so many along the way. No author is self-sufficient; obvious
witnesses to this are all of the consultants involved in **Beginning
Sculpture**. However, my best friend, who happens to be my wife,
Jacqueline LaJune Williams, is quietly responsible for translating my
handwriting into useful typed script. Without her help and under-
standing, this book would not have come into existence.

About the Author
Arthur Williams received his Doctor of Arts from Carnegie-Mellon
University and has been a teacher for over twenty-four years. He has
been selected for *Who's Who Among America's Teachers* in 1996, 1998,
and 2004. He has more than 300 sculptures in collections in twenty-
five states, D.C., Canada, and Mexico. His studio is located in Gulf-
port, Mississippi.

Educational Consultants:
Gretchen Behre, Varina High School, Richmond, Virginia; Mary
Elaine Cash Bernard, Mandeville High School, Mandeville,
Louisiana; Kevin Cole, North Springs High School, Atlanta, Georgia;
Jennifer Costa, Illinois Central College, Peoria, Illinois; Bob Duca,
Washington Township High School, Sewell, New Jersey; Bill Eleazer,
North Carolina Center for the Advancement of Teaching, Cullowhee,
North Carolina; Chris Ellison, White Hall High School, White Hall,
Arkansas; Ellen Estes, South Mecklenburg High School, Charlotte,
North Carolina; John B. Gilliam, South Carolina School for the Arts,
Greenville, South Carolina; Kim Gratton, Sequoyah High School,
Canton, Georgia; Brenda Hardin, Al Brown High School, Kannapous,
North Carolina; Andres Hill, Ocean Springs High School, Ocean
Springs, Mississippi; Carmella Jarvi, Northwest Cabarrus High
School, Concord, North Carolina; Jann Jeffrey, Corrigan Camden
High School, Corrigan, Texas; Ron Koehler, Delta State University,
Cleveland, Mississippi; Terry Lenihan, Los Angeles, CA; Kelly Lillib-
ridge, Palm Desert High School, Palm Desert, California; Cindy
Maguire, North Hollywood High School, Los Angeles, California;
Cindy Maguire, Wilson High School, East Los Angeles, California;
Kreg R. Owens, St. Stephen's and St. Agnes' School, Alexandria, Vir-
ginia; Marion Packard, Northeast High School, Oakland Park,
Florida; Jessica Perry, Mendham High School, Mendham, New Jer-
sey; Dorothy Plummer, East Illinois Central College, East Peoria, Illi-
nois; Susanne Rees, Tri-City Prep High School, Prescott, Arizona;
George Reiley, South Mountain High School, Phoenix, Arizona;
Joanne remppel, Bradwell Institute High School, Hinesville, Georgia;
Jodie Schoonover, Oshkosh North High School, Oshkosh, Wisconsin;
Debra Schuh, Manchester High School, Manchester, Indiana; Wendy
Singer, Wakefield High School, Arlington, Virginia; Don Smith, Van
Cleave High School, Van Cleave, Mississippi; Ron Venable, Eisen-
hower High School, Houston, Texas; Jared Ward, Canyon View High
School, Cedar City, Utah; Kathleen Willingham, Liberty High School,
Bealeton, Virginia; Jan Wilson, Hamilton, NJ.

Printed in the United States of America
ISBN 10: 0-87192-629-6
ISBN 13: 978-0-87192-629-6
07 08 09 QW 10 9 8 7 6

Contents

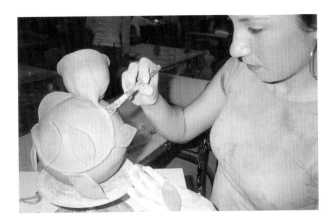

(p. v bottom) Ken Little, *Burn*. Mixed media, 72" x 30" x 48".

(p. v top)Sianneth Sanchez applies clay slip to one of her sculptures. South Mecklenburg High School, Charlotte, North Carolina. Instructor: Ellen Estes.

(p. vi middle) Juan Vera, *My Other Self*, 1999. Plaster, 18" x 18" x 18" (45.7 x 45.7 x 45.7 cm). Corrigan Camden High School, Corrigan, Texas. Instructor: Jann Jeffrey.

(p. vi bottom) Patricia Renick, *Stegowagenvolkssaurus*, 1974. Fiberglass and re-furbished Volkswagen, 12' x 7' x 20'. Photograph: Laura H. Chapman.

(p. vii top) Melvin Edwards, *Gate of Ogun*, 1983. Stainless steel, 96" x 144" x 48" (243.8 x 365.7 x 121.9 cm). Collection, Neuberger Museum of Art, Purchase College, State University of New York, Museum Purchase with Funds from Vera List and the Roy R. and Marie S. Neuberger Foundation. Photograph: Jim Frank.

(p. vii bottom)Suzanne Cagle, *Untitled*, 2002. Bedpost assemblage, 4' x 6' (1.2 x 1.8 m). Sequoyah High School, Canton, Georgia. Instructor: Kim Gratton.

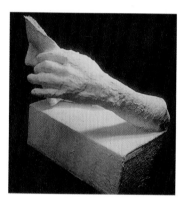

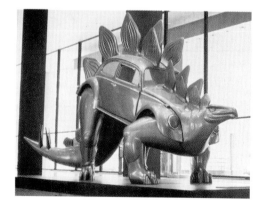

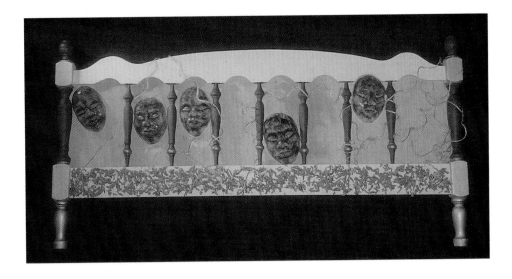

Owner's Manual for *Beginning Sculpture*

To get the most out of any tool it is valuable to understand its key features and intended uses. In detailing the unique design and features in this textbook, the following will help make *Beginning Sculpture* the most valuable tool in your sculpture studio.

These opening pages **introduce a topic with a visual and verbal overview** of the concepts and ideas in the chapter.

Build your sculpture vocabulary.
Key terms are highlighted and defined the first time they appear. These and other terms are also defined in the Glossary.

These headings, which divide large ideas into **manageable, easy-to-follow concepts,** are ideal for quick reference and review.

Develop visual literacy!
These captions and questions help you to look deeper at the artwork.

Key Terms
steatite
sandpaper
vermiculite
laminating

5 Carving

Of all the methods used to create sculpture, *carving* has endured with the lowest changes. Sculptors today carve in much the same way as those working thousands of years ago. Some tools have been improved, new tools and materials have been developed, yet the process remains essentially the same—cutting away material to reveal the desired image. This subtractive process requires much foresight and planning because once material has been removed it is impossible to restore.

Carved works in stone, bone, and shell survive from prehistoric cultures. People worldwide have carved common materials they came across every day, transforming these substances into personal sculptures with complex meanings often known only to them. The surfaces of many 3,000-year-old Egyptian carvings in granite and other stone are nearly unchanged since the day they were created. The colossal carved stone heads of Easter Island in Polynesia, large-scale stone figures of pre-Hispanic Central and South America, and monumental wooden totems of native North American peoples are testaments to the sculptural traditions of sometimes lost cultures. The explosive power of carving is also exemplified in the work of Renaissance artist Michelangelo Buonarroti, whose remarkable marble carvings, both finished and unfinished, are an expression of the philosophies and ideas of his time.

In this chapter, you will learn about and experiment with a variety of materials, from wood to marble and other types of stone. Each material is unique and requires a different approach. Through a careful study of carving tools and techniques, you will learn the characteristics of each material and the best method to use to attain success as a carver.

plaster

stone

wood

Fig. 5–1. A combination ... natural colors in this life-size sculpture.
Philip John Evett, Maize ...
Maple and andicap on, No ...

102 Chapter 5

Carving 103

Fig. 3–29. There are many ways of using plaster casts of human forms. This student used the plaster cast of his face and hands as his final piece. Other artists prefer to use casts as an accent or starting point.
Juan Vera, My Other Self, 1999.
Plaster photo: Moonly: Corrigan Camden High School, Corrigan, Texas. Instructor: Tonn Jeffries.

Life Molding

Creating a mold from a live model is often a possibility. However, extreme care must be taken to protect the model. The work should be supervised by mold makers experienced in the type of material being used.

Safety Note Never attempt to do molds of the human form without at least two workers and a teacher present. Since the model is in a temporarily helpless state, he or she should never be left alone in darkness. You should communicate with the model often. With two workers, one can always be present to reassure the model or to secure special needs, if necessary.

There are three main materials for molding directly from the human form. These are plaster-impregnated surgical gauze, alginate, and liquid plaster.

Plaster gauze is one of the easiest methods of molding, especially from human body parts. The major thing to remember is to apply a heavy release agent (petroleum jelly) and provide an escape route for the model. The bandages harden quickly, usually within 10–15 minutes, and can be removed as they are still hardening.

Alginate is an expensive material used in small quantities by dentists for tooth impressions. In sculpture it is used when

Fig. 3–30. Quita Reagle and Goddess Freeman apply plaster gauze to Anisha McCord's head.
Corrigan Camden High School, Corrigan, Texas. Instructor: Tonn Jeffries.

Fig. 3–31. Anisha and Quita apply plaster gauze to their own feet.
Corrigan Camden High School, Corrigan, Texas. Instructor: Tonn Jeffries.

Fig. 3–32. Student Chauntee Aitken makes a plaster-gauze mask.
Wakefield High School, Arlington, Virginia. Instructor: Dendy Shepp.

the finest detail is needed. Usually, this is a face or head, hands or feet. Alginate is not toxic and is safe and quick to use. Although it is reasonably easy to apply, it must be done quickly. The resulting mold must be used within a few hours, or the alginate will lose its flexible quality and resistance to sticking.

Liquid plaster is the most available material but requires more preparation in order to avoid "entrapping" or burning the model. It is the least expensive method of body molding, although it requires the longest setting time and requires more cleanup. The major benefit

is that it produces a rigid, reusable mold of high accuracy and detail.

Plaster gauze can be found in medical supply houses, at hobby stores, or at professional mold supplies. The widths vary, but 4-inch-wide rolls are common. A small amount of salt added to the warm water can shorten the curing time. The gauze should be cut in measured strips and placed in pairs so that two strips can be dampened at the same time.

The gauze is held by each end and quickly pulled through the water. The strips can be blotted between paper towels immediately for an even quicker hardening time. They are applied directly onto the release-agent-coated skin or object. The artist can press the shape and smooth the surface to conform to the model. Removal is quick and painless. Afterward, the mold should be allowed to continue to harden.

One way to body-mold without a living model is to use a mannequin. The process is the same, and the model stays still!

Fig. 3–33. Student Lyndsay Duncan applies plaster gauze over the head of a mannequin.
White Hall High School, White Hall, Arkansas. Instructor: Clara Ellison.

Fig. 3–34. Lyndsay removes a "body cast" from the mannequin torso.

Fig. 3–35. Student Torre Finley applies plaster gauze over a mannequin's leg. Notice the parting line made by the bandage.

Fig. 3–36. He removes the plaster gauze from the leg. Notice where the mold separates on the parting line.
White Hall High School, White Hall, Arkansas. Instructor: Clara Ellison.

68 Chapter 3

Molding 69

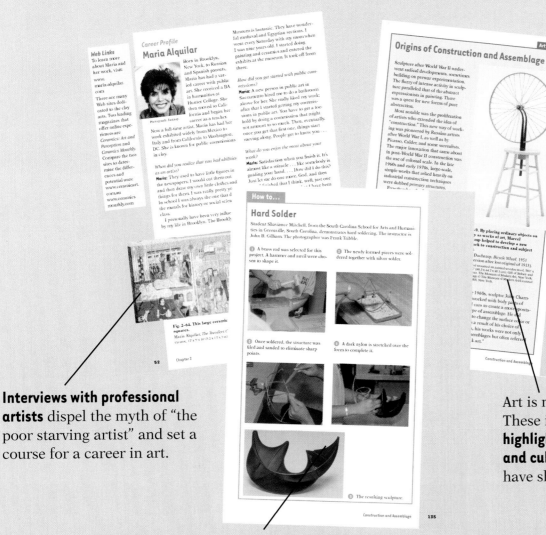

Interviews with professional artists dispel the myth of "the poor starving artist" and set a course for a career in art.

Art is not made in a vacuum. These in-depth profiles **highlight the historical and cultural influences** that have shaped a work of art.

These illustrated, step-by-step studio guides will help you **master fundamental techniques and skills.**

Samples of student art in each studio-rich chapter encourage peer sharing and critique.

Don't miss the **sculpture timeline, glossary,** and the **technical support** in the appendix.

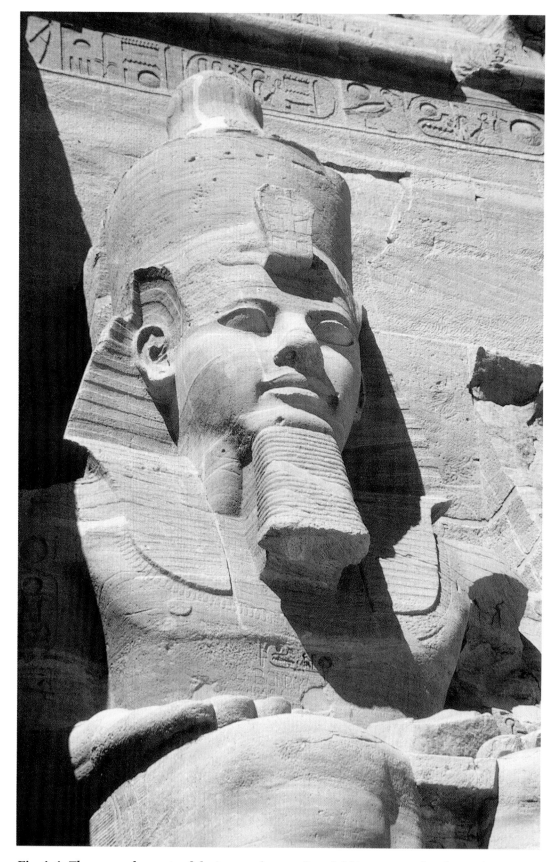

Fig. 1–1. The same elements of design used more than 3,000 years ago by the sculptor of this masterpiece are still used to create art today. How did the artist achieve a sense of power and stability in this figure?

Egypt, *Colossal Figure of Rameses II*, from the Temple of Rameses II at Abu Simbel, c. 1257 BC.

Sculptured from rock, overall height 69' (18 m). Courtesy Davis Art Images.

1 Introduction to Sculpture

Sculpture is the art of using materials to transform an idea into a real object. In the context of this book, the term *sculpture* is used to designate a three-dimensional form that is mostly nonutilitarian.

Whether functional or decorative, all sculpture is a record of human existence. Throughout history, people have experimented with material, form, and process in their search for meaningful sculpture that enhances their lives.

People—both past and present—create sculptures for many reasons: to send a message, beautify their surroundings, express religious beliefs, or for the sheer joy of using their hands to touch and shape material. From the hand-size carvings of prehistory to the monumental statues of ancient America, and from the majestic marble figures of the Renaissance to the intricate mixed-media constructions of today, sculpture is a reflection of the society in which it is produced.

Do you, too, feel this desire to transform materials into sculptures that express your ideas? With the help of this text, you will create works using traditional materials and processes, such as wax modeling, plaster mold making, clay casting, and stone carving. And, even more important, you will learn to find inspiration in new materials, explore new methods, and invent new sculptural forms.

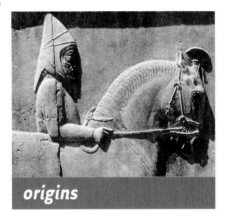

origins

concepts

fundamentals

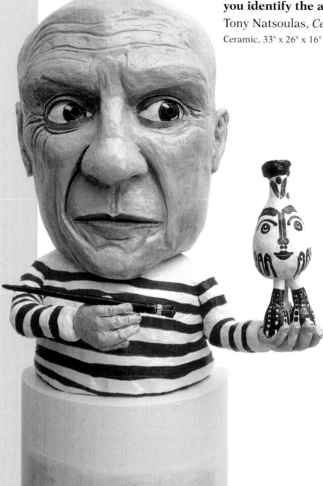

Becoming a Sculptor

Everyone has made a sculpture, although you may not have used that term to describe what you created. Sculpting is as easy as picking up a material—perhaps mud, paper, dough, or clay—and molding it with your hands into a new form. Indeed, to do so seems to be human nature—people love to touch things.

We all possess the sense of touch. It is through touch that we differentiate between smooth and rough, soft and hard, whatever the texture of the surface. If allowed to experiment, we learn to develop better control of our tactile abilities. With materials in our hands and the knowledge of how to work with them, we begin to create sculptures.

At first, it may be a pleasant surprise to learn how easily many objects are made. Yet it takes much more to create a sculpture that has value as an artwork. With practice and study, your works will take on additional merit and refinement so that others will also enjoy and appreciate them. As you continue to experiment with materials, master processes, and perfect your technique, you will become a true sculptor.

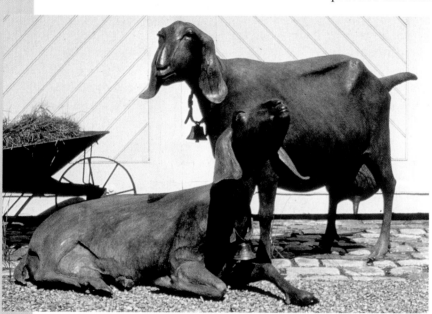

Fig. 1–3. These life-size Nubian goats and normal, everyday animals have become the trademark of subject matter for André Harvey. What subject matter appeals to you?
André Harvey, *Chloe and Lucinda*.
Cast bronze, life-size.

Origins of Sculpture

The history of sculpture dates to prehistoric times according to archaeological evidence of small carvings that may be as much as 30,000 years old. Prehistoric people of the Paleolithic and later Neolithic eras used the materials at hand—stone, shell, bone—to carve small animals and figures that are extraordinary in their naturalistic detail. Although the exact meaning of these early sculptures is unknown, it is likely that such objects held special symbolic and religious meanings. Early people also produced practical items, such as knives, axes, and storage vessels. These objects are so well designed that today they, too, are considered forms of sculpture.

From these earliest beginnings, sculpture has become a vital part of the artistic production of civilizations worldwide. In the ancient world, lasting traditions of carving, casting, and modeling emerged. In ancient Mesopotamia, such cultures as the Sumerians, Babylonians, Assyrians, and Persians created both small-scale and monumental sculptures of marble, stone, and precious metals. Many of the works show portraits of rulers and images of court life, indicating the importance of government. Meanwhile, in ancient Egypt, sculpture was closely related to religious life. The amazing variety, including colossal stone statues and reliefs of rulers, life-size gold coffins, and intimate carved scarabs, communicates the central role of religion in Egyptian daily life. Sculptors followed specific rules for creating sculpture—from gestures and poses to proportions and colors—working in a style that would continue nearly

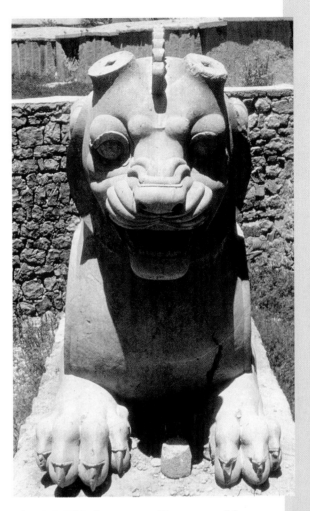

Fig. 1–5. This huge stone lioness would have sat on top of a tall column in the palace at Persepolis. Notice the facial features and stance of the lioness. What kind of message was this meant to convey to visitors?

Iran, Persepolis, *Double-Headed Lioness Capital*, from the Palace of Darius I and Xerxes I, c. 521–465 BC.

Courtesy Davis Art Images.

Fig. 1–4. The great Persian palace at Persepolis was carved with reliefs of tribute bearers and other courtiers who served the king. What different kinds of tribute, or gifts, to the king can you see?

Iran, Persepolis, *Tribute Bearers with Horse*, detail of east wall relief of the Royal Audience Hall, Palace of Darius I and Xerxes I, c. 521–465 BC.

Courtesy Davis Art Images.

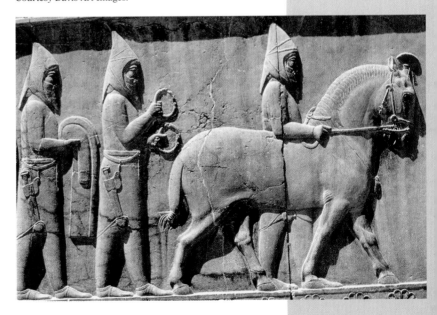

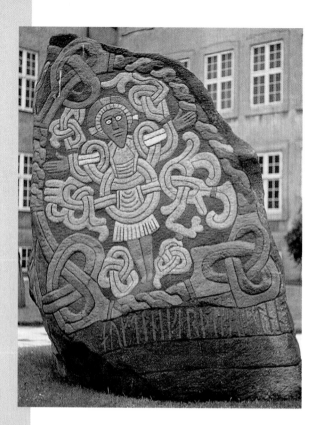

unchanged for more than 2,000 years. In ancient Asia, Chinese sculptors were masters of casting bronze, creating intricate ritual vessels and containers covered with designs of animal and human forms, while carvers in India produced figurative works of beautiful naturalism.

The sculpture of ancient Greece and Rome is often considered one of the great achievements in Western art. Although much Greek sculpture is known only through Roman copies, they show the preoccupation with achieving perfection of the human form. Sculptors focused on

Fig. 1–6. Erected at the church in Jelling, Denmark, this stone honored the ancestors of a Danish king. The curving, intersecting lines are associated with Celtic art.
Denmark, *Jelling Stone: Crucifixion*, c. 980 AD.
Statens Museum for Kunst, Copenhagen, Denmark.

The Olmec: Ancient Sculptors of Mesoamerica

The first evidence of Olmec culture, the earliest known Mesoamerican civilization, was discovered in 1862 when workers digging in a field uncovered a colossal carved-stone head with striking, unique features. Although details about the Olmec remain unknown, archaeological evidence suggests that they flourished along the southern Gulf Coast of Mexico from about 1200 to 600 BC. Living in a highly developed agricultural society with complex urban centers, the Olmec built their cities around a central raised mound, later replaced by pyramidal structures, that was used for religious ceremonies. Olmec political systems, city planning, art, and religious beliefs were continued and elaborated on by later cultures of pre-Hispanic Mexico, including the Zapotec and Maya.

During nearly 700 years, the Olmec created monumental sculpture, including life-size statues of their rulers, huge carved portrait heads, and altars. Much of this monumental art was found damaged—parts had been broken off and heads removed from statues. Because this practice continued throughout the existence of the culture, scholars now believe that it was the Olmec who destroyed their own sculptures, perhaps for religious or ritual purposes.

Six colossal heads like this one have been found at the urban center of San Lorenzo; all had been mutilated and buried around 900 BC, the time of the city's decline. San Lorenzo was laid out on a central axis surrounding a ceremonial pyramid built of pounded earth; the colossal heads were likely placed on the four sides of the platform at the base of the pyramid. Because of the individualized features of each sculpture, scholars believe that

the individual, and their works became increasingly naturalistic, yet highly idealized. Following the decline of the Roman Empire during the third and fourth century AD, the Byzantine empire flourished in Constantinople, and present-day Europe saw the migration of nomadic tribes across the continent. Much of the art of these migratory peoples is small, portable metal sculptures, often with animal themes, that were used for personal adornment or as weapons. Later, during the period known as Romanesque, sculpture once again became closely tied to religion, and sculptors created expressive stone reliefs and large-scale figures for the interiors and exteriors of churches.

At the same time in the Americas, native cultures were thriving. Distinct sculptural traditions developed throughout both continents; most artists chose

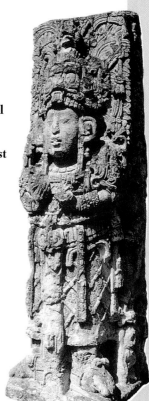

Fig. 1–8. The Maya erected huge stelae, elaborately carved stone images of their rulers. They were carved with stone tools because metal was not used at this time in Mexico. Notice the amount of detail the artist was able to achieve.

Honduras, Copan, Stele H, *The Ruler Eighteen Rabbit*, c. 782 AD.

Stone with traces of pigment. Courtesy Davis Art Images.

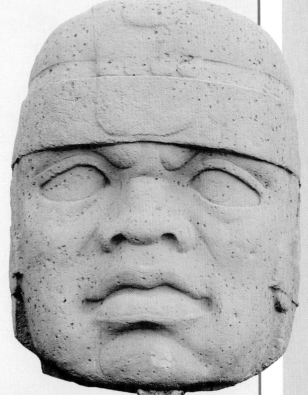

they represent portraits of Olmec rulers. Not only are these sculptures heavy and huge—weighing more than ten tons and nearly ten feet tall—they are also made of basalt, one of the hardest stones. The Olmec transported the boulders almost sixty miles, probably on rafts navigated downstream. Basalt is very difficult to carve, yet the Olmec were able to create sophisticated sculptures using only stone and jade tools.

Olmec sculpture, both utilitarian and ceremonial, features animal as well as human themes. Carved jade figurines have been found in burial sites. Monkeys, serpents, and jaguars are also popular subjects and likely had important symbolic and religious meanings. But perhaps most important, Olmec sculptors decorated their objects with signs that were found to be a form of writing. The decipherment of these inscriptions has provided valuable insight into this fascinating culture.

Fig. 1–7. The Olmec carved huge basalt sculptures of the faces of their gods and rulers. This carving tradition greatly influenced the Maya, who also decorated their cities with stone portraits of rulers and gods.

Mexico, Olmec, *Colossal Head*, c. 200 AD.

Basalt, 305 cm high. Courtesy Davis Art Images.

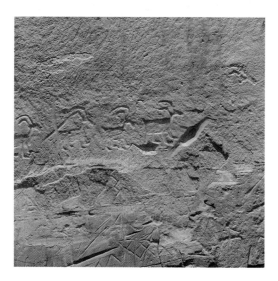

Fig. 1–9. A petroglyph is a carving or inscription on a rock. Petroglyphs are found throughout the American Southwest. Some are more than 5,000 years old.
New Mexico, El Morro, Pueblo ruins, Petroglyphs symbolizing goats and other animals, from the Anasazi culture, 13–14th century AD. Courtesy Davis Art Images.

natural, readily available materials, such as stone, clay, and feathers. The Maya, of present-day Mexico, produced lively clay figures, and the Inca of South America created extraordinary works in metal. Although many such traditions have since died out in Central and South America, those of North American peoples continue to the present day. Pueblo Indians, for example, continue to make small spirit figures known as kachinas. Northwest Coast tribes also continue the mask- and totem-making traditions of their ancestors.

Peoples in Oceania—a collective term that comprises the islands of Melanesia, Micronesia, and Polynesia—also have a long tradition of both utilitarian and ritual sculpture. As in the Americas, Oceanic artists used and continue to rely on natural materials to create wooden masks and prow figures for canoes as well as bone utensils and featherworks.

Although early traditional art in Africa has not survived, sculptures in less perishable materials, such as bronze and ivory, remain to attest to the great skill and craftsmanship of African sculptors.

Among the outstanding works are the carved wooden masks and headdresses as well as the sophisticated portrait heads in bronze created by the Ife of Nigeria and the kingdom of Benin.

The Renaissance in Europe, which began in the early fifteenth century AD, was characterized by a growing interest in the human form. Sculptors looked back to the works of ancient Greece and Rome, and marble sculpture was once again the perfect vehicle for depicting the human form. Michelangelo Buonarroti, born in Italy in 1475, excelled at creating powerful, realistic sculptures of technical excellence. He considered his sculpture a reflection of beauty in the world and sought to release the image that was "locked" in the stone. Michelangelo broke with the tradition of the artists of his day; he did not use the accepted mathematical formulas for human proportions. As a result, each of his works contains a

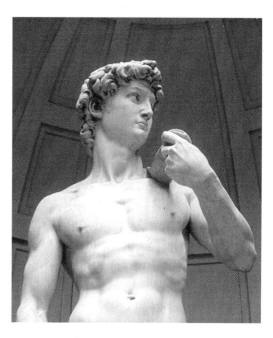

Fig. 1–10 (detail). Michelangelo is best known for the monumental forms of his sculpture. Here the boy David is huge in size and envisioned just before he would kill Goliath. What do you think might be one reason Michelangelo made the statue of the boy David so large—almost 18 feet tall?
Michelangelo Buonarroti, *David* (detail), 1501–1504.

Marble, 171⅛" h (435 cm). Galleria dell'Accademia, Florence, Italy. Courtesy Davis Art Images.

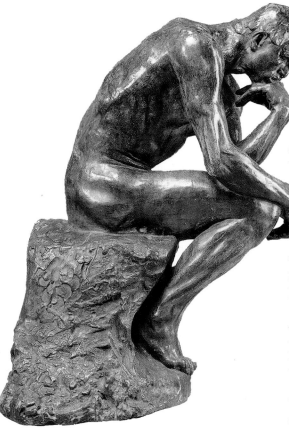

Rodin loved modeling. He manipulated moist clay with his fingers, creating works that were often cast into bronze.

In the early twentieth century, sculpture as an art form underwent dramatic changes. Artists working in traditional materials and processes (carving wood or stone; casting metal; modeling clay) began to explore **abstraction,** a simplification and elimination of details.

Romanian sculptor Constantin Brancusi (1876–1957) reduced objects to simple forms that captured the essence of a subject but still remained recognizable. His *Bird in Space* (**Fig. 1–12**) embodies the very notion of flight. British sculptor Henry Moore (1898–1986) transformed the human figure into simplified forms and played with solids and voids to create dynamic sculptures that interact with the space around them.

Fig. 1–11. Rodin was one of a group of artists who rejected classical traditions in art to explore texture, expression, and realism. What elements does Rodin use to express the mood of *The Thinker*?

Auguste Rodin, *The Thinker (Le Penseur)*, model 1880, cast 1901.

Bronze, 28⅛" x 14⅞" x 23⅞" (71.5 x 36.4 x 59.5 cm). National Gallery of Art, Washington; gift of Mrs. John W. Simpson. Image © 2003 Board of Trustees, National Gallery of Art, Washington, DC.

unique personality and energy. Note, for example, how he furrowed the brow of David (**Fig. 1–10**). Later sculptors of the Baroque and Neoclassical periods continued to focus on the human figure, as seen in the dramatic religious sculptures of Gianlorenzo Bernini (1598–1680) and the calm, classically inspired works of Antonio Canova (1757–1822).

Among the great sculptors of the nineteenth century was French artist Auguste Rodin (1840–1917). Like Michelangelo, Rodin focused on the human figure. He, too, shunned the accepted style of his day, choosing instead to distort the figure to demonstrate the physical and emotional responses of his subject. But unlike Michelangelo, who was an expert carver,

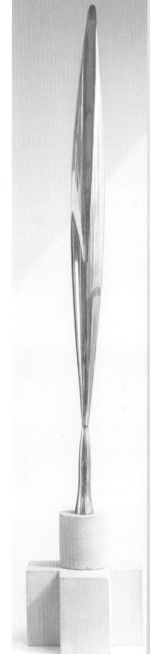

Fig. 1–12. In his sculpture, Brancusi wanted to express the essence of flight by reducing all detail. How was Brancusi able to accomplish this? How successful do you think he was?

Constantin Brancusi, *Bird in Space*, 1928.

Bronze (unique cast), 54" x 8½" x 6½" (137 x 21.6 x 16.5 cm). The Museum of Modern Art, New York; given anonymously. Digital Image © The Museum of Modern Art/Licensed by Scala. © ARS, New York.

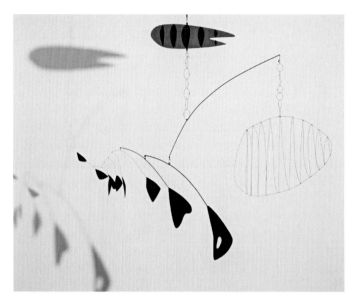

Other artists have sought new ways to use traditional materials. American sculptor Alexander Calder (1898–1976) created an entirely new kind of sculpture called a **mobile.** He used metal shapes and wires to create balanced forms that move with air currents. This **kinetic,** or moving, sculpture is itself recognized as an art form.

Still other sculptors abandoned traditional materials and methods. These artists began assembling discarded, often functional, objects to create new sculptural forms. Around midcentury, bicycle parts were especially popular, appearing in Pablo Picasso's *Bull's Head* from 1943

and *Bicycle Wheel* (**Fig. 6–9,** p. 125) by Marcel Duchamp. American artist Louise Nevelson (1900–1988) assembled fragments of furniture and architectural elements into large upright constructions. Later, twentieth-century artists Betye Saar (b. 1926) and Red Grooms (b. 1937) began creating provocative, highly personal constructions with multilayered personal meanings.

Contemporary artists continue to push the boundaries of sculpture, redefining it as an art form. As new materials become available, they explore ways to transform them into unique artworks. At the same time, artists challenge traditional ideas

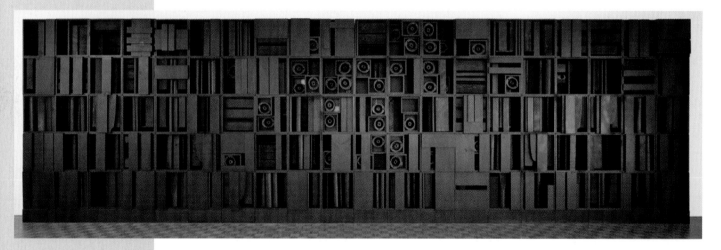

Fig. 1–14. Sculptor Louise Nevelson enjoyed working with wood for what she called its quality of "livingness." Why do you think Nevelson often painted her sculptures completely black or white?

Louise Nevelson, *Homage to the World*, 1966.

Painted wood, 8' 6" x 28' 8" (2.6 x 8.7 m). The Detroit Institute of the Arts; Founders Society Purchase, Friends of Modern Art Fund and other Founders Society Funds. Photograph © 1980 The Detroit Institute of the Arts.

about the role of sculpture in our lives. Soon you, too, will take part in this exciting movement as you create your own work as a sculptor.

Sculpture Fundamentals

Anyone can make a three-dimensional form, whether packing a snowball or carving a sand castle. However, not everyone can create a successful sculpture. To do so, all three of the fundamentals of sculpture—form, content, and technique—must be present. These three concepts are interdependent; if any one is missing, the final work will likely not be as successful.

Form is the total mass or configuration that the subject or idea takes. It is the final physical structure of the sculpture. Although this structure need not be recognizable or naturalistic, it must show skillful use of the design elements and principles to be successful.

Content is the emotion, passion, or message that the sculptor intends to convey through the sculpture. It is also the viewer's reaction to the work, and how the sculpture interacts with the viewer in an aesthetic sense. Without content, the design elements and principles mean little.

Technique is the marriage of materials and tools with the ability of the sculptor. It is the result of the sculptor's knowledge, preparation, and practice. Through technique, the sculptor is also able to show his or her understanding of the elements and principles of design. Without technique, ideas remain just that; they are not developed into a concrete sculptural object.

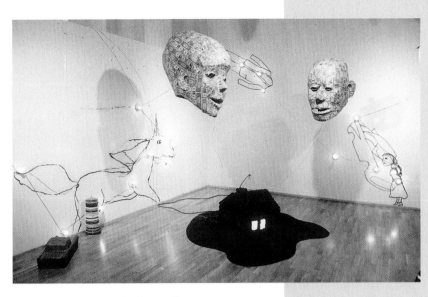

Fig. 1–15. This kind of installation demands that a viewer be involved with it, and react to it. What is your reaction to this work?
Ken Little, *The Elements of Progress: Dreams Escape*, 1990.
Installation: Washington Project for the Arts, Washington, DC.

Fig. 1–16. A good understanding of the techniques involved in wood carving and inlay was required to produce this piece. How has the artist used pattern to create visual interest?
Michael Ferris Jr., *Bud*, 2001.
Wood/inlaid wood, 22" x 24" x 12" (55.8 x 61 x 30.5 cm).

Elements of Design: The Meaningful Use of Space

All artists communicate visually in their work. How? First, they must learn the elements of design. These elements are the visual "tools" that artists use to create an artwork. They allow artists to work with materials in a successful way. It is important to learn the terms for these elements; they will provide the building blocks of the structure you are trying to create.

Form is a three-dimensional mass; it is an object that has height, width, and depth. Forms can be either geometric (regular) or organic (irregular). Three-dimensional art, such as sculpture, is composed of forms. Therefore, form can indicate both the individual parts and the entire structure of a sculpture.

Shape is a two-dimensional, or flat, element. Like forms, shapes can be geometric or organic. Because it is a two-dimensional term, *shape* is best used to describe the silhouette, or outline, of a sculpture.

Texture in sculpture is real; it can be touched and felt. This tactile quality clearly separates sculpture from two-dimensional art forms, such as painting

Fig. 1–17. This ceramic sculpture includes several visual textures. How would you describe its texture?
Elise Megremis, *Kissing Cousins*, 2000.
Ceramic, 9" x 7" x 3" (22.8 x 17.7 x 7.6 cm).

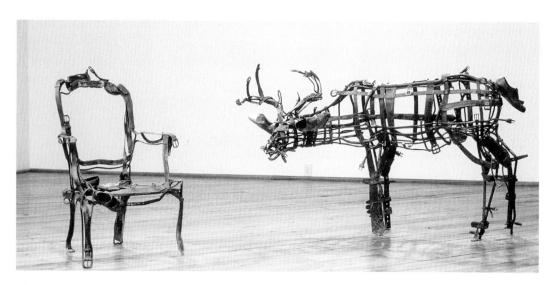

Fig. 1–18. Multipiece sculpture always relies on space to create a reaction between the two or more forms. Would either of these parts succeed without the space between them?
Ken Little, *Dawn*, 1999.
Bronze, 39" x 103" x 83" (99 x 261.6 x 211 cm).

or drawing. Sculpture offers natural tactile texture, such as the grain of stone and wood or the smoothness of glass. However, the sculptor can also control tactile sensations by smoothing the surface, leaving tool marks, or placing materials next to others to create contrasting touch sensations.

Space is the area around and within the sculpture as well as the area that the sculpture occupies. Sculpture cannot exist without depth; it must occupy space. The sculpture itself is called "positive" space, whereas the area around and within it is called "negative" space. As a sculptor, it is important to consider both the sculpture itself and the surrounding space, which becomes an integral part of the final work.

Line is a mark made by a moving point. It directs a visual path from one point to another. In sculpture, line can define the

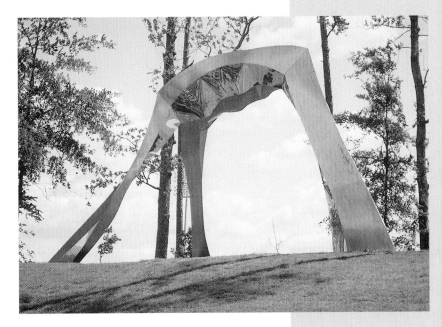

Fig. 1–19. Notice the beautiful planes of this large outdoor sculpture. Why do you think the artist chose the title he did for this piece?
Ali Baudoin, *Rainbow Walker*.
Stainless steel, 38' x 19½' x 17' (11.5 x 6 x 5.2 m). Huntsville, Texas.

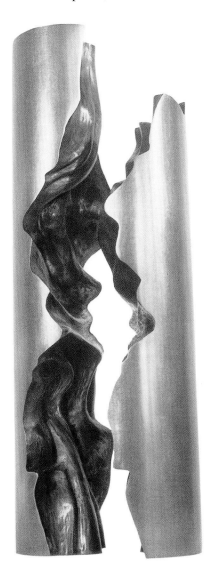

solid mass—it serves as the outline. We perceive the "edges" of the surface, the masses and shadows created by sudden changes in path or alignment, as lines. In fact, these edges are planes, and this term should be used to refer to sculptural forms. Line, used as a three-dimensional term, usually indicates a surface decoration on the form.

Color is a quality of light; the color spectrum is created when white light passes through a prism and is split into bands. Each object has its own unique color, and many sculptors prefer to keep the natural colors of such materials as wood or stone rather than painting or otherwise modifying them. However, sculptors will sometimes choose to change the natural color of a material, as when surface treatments (patinas, for example) are applied to enhance the work.

Fig. 1–20. Artists use chemicals and a technique known as patina to enhance the natural color and shape of bronze sculptures.
Roler Shipley, *Pictorial Participation #64*, 1981.
Cast bronze, 26" x 8" x 6" (66 x 20.3 x 15 cm).

For Your Sketchbook
Research the sculpture of an ancient civilization. Choose several sculptures from this civilization and record the titles, dates they were created, and the materials used. Note the purpose for which these sculptures were created. Also note whether the style of sculpture from this civilization was generally naturalistic or abstract.

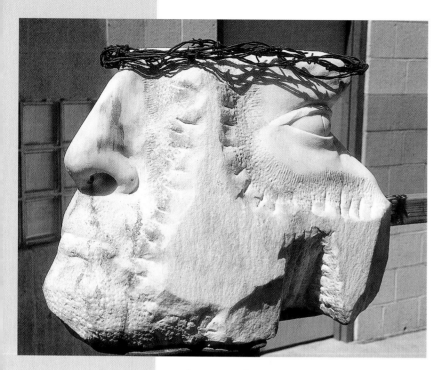

Value is the lightness or darkness of a surface. In sculpture, values define a work by creating a pattern of light and dark that shows its three-dimensional form. A white sculpture will have more values than a black one because a greater range of shadows, or values, can be seen. Textures and planes also become more visible as the value changes.

Discuss It How can color change a form? Notice how color misused and misplaced on a three-dimensional form can easily destroy the form.

Fig. 1–21. The way we see value depends on the amount of light absorbed or reflected by an object's surface. We can distinguish the features in this piece by the shadows or values it projects.
Gilbert Perez, *Column to Salvation*, 1992.
Soapstone, 21" x 15" x 14" (53.3 x 38 x 35.5 cm). Instructor: George Reiley.

Fig. 1–22. This work possesses a dynamic formal, or symmetrical, balance.
Chyrl L. Savoy, *Cuerpo y Alma*, 1992.
Polystyrene and paper, suspended, 72" x 96" x 12" (183 x 244 x 30.5 cm).

Principles of Design

Now that you know the terms for the elements of design, what do you do with them? The principles of design will provide you with the guidelines you need to arrange and build with the elements. The purpose of these principles is to allow you to develop the elements into an aesthetic form. Working with these principles in mind will help you produce effective sculptures that are understandable to the viewer.

Fig. 1–23. The asymmetrical balance of this wood sculpture creates a sense of tension. What other elements in this piece contribute to this sense of tension?
Duane Paxson, *Fallen Angel*, 2000.
Wood, fiberglass, acrylic, 43" x 43" x 29" (107 x 107 x 74 cm).

Balance refers to how well the elements of design are placed together; in other words, whether all parts of the work have equal "visual weight" and create a feeling of equilibrium. In three-dimensional work such as sculpture, balance becomes a structural issue; if the work can stand without falling over, it is stable and has balance. There are three types of balance discussed in sculpture: radial, symmetrical, and asymmetrical. *Radial balance* is created when all sides radiate from or rotate around a central point. In three-dimensional form, the most obvious form of radial balance is a ball. Sculptures that have radial balance are also often symmetrical. *Symmetrical balance* is achieved when both sides of a design are exactly, or very nearly, the same. Spheres and cubes are examples of forms with symmetrical balance. When a form is symmetrically balanced, it is said to have formal balance. *Asymmetrical balance*, sometimes called informal balance, is achieved when different, opposing parts of a design are balanced like a seesaw to achieve a feeling of equilibrium. For example, a grouping of smaller parts may be offset by a single, larger part. Asymmetrical balance creates a sense of tension and opposing forces,

whereas symmetrical balance is more calm and restful.

Proportion is the size relationship of one part to another part or to the whole. People, regardless of their size, share common proportions. When looking at portrait sculpture, note whether the artist used naturalistic proportions or whether they are exaggerated in some way. Sculptors often use exaggerated proportions to convey symbolic meaning. In addition, proportion can lend a sense of balance to a sculpture. If the base is too small in proportion to the rest of the work, the sculpture will have a feeling of instability or disproportion.

Scale also refers to a size relationship; it is the size of one object compared to other objects or its surroundings. When speaking of a sculpture, scale refers to the work's total size or how it relates to its setting or environment.

Contrast is a great difference between two things. In both two- and three-dimensional artworks, contrast may be

Fig. 1–24. The human face is perhaps the best way to demonstrate proportion. Can you imagine what this work would look like if the placement of the facial features was different?
Carole A. Feuerman, *Mask*, 1997.
Bronze, 8" x 6" x 2" (20.3 x 15 x 5 cm). Photograph: David Finn.

Fig. 1–25. This sculpture has a scale, or size, that fits the surroundings.
Arthur Silverman, *MLK Jr. Memorial*, 1995–97.
Painted aluminum, 21' x 7' x 3½' (6.4 x 2 x 1 m).

often manipulate materials or the design elements to create a focal point in their artwork. Such a focus is called the *emphasis*, and it should be carefully planned because the viewer's eye will be drawn naturally to that area. It is important for the sculptor to consider how to use emphasis to help communicate the message.

Unity is the appearance that all of the components of an artwork are working in harmony. A feeling of unity can be created by a theme or idea or through the use of a dominant design element. Ultimately, the viewer must sense that all of the parts belong and work together in one form. Within a unified artwork, however, diversity is also necessary.

Variety adds visual interest to a work and keeps the viewer curious or involved.

Fig. 1–26. What overall theme has the sculptor used to unify this piece?
J. Jaia Chen, *Neon Dress*, 1998.
Neon tubes and string, 61" x 16" x 12" (155 x 40.6 x 30.5 cm).

created through the use of strong highlights and shadows, clashing colors, or differing shapes or patterns. In addition, a sculptor can create contrast by using a material or texture that is different from and stands out against others, or by introducing a new, divergent three-dimensional form. Such contrasting elements may also produce a distinct center of interest in an artwork. Artists

and provide a variation on a theme that is unexpected and exciting.

Movement is the sense of motion created by angles or planes to further the sculptural idea. It may be the indicated or implied movement of a leg in a representational sculpture, or it may be a jagged crack in an abstract sculpture. A strong sense of movement can be created in a sculpture through the use of diagonal edges and planes. Opposing, asymmetri-

Fig. 1–27. Because of its versatility, ceramic sculpture can uniquely fuse several colorful items together to create variety within unity.

Michael Hough, *Thumb Puzzle*, 1998.

Hand-built ceramics, 76" (193 cm). Photograph: Ellen Martin.

A unified artwork that lacks variety will seem visually boring, yet one that has only variety will appear chaotic and confused. The sculptor must balance these two design principles to achieve success.

Pattern is the repetition of texture, forms, colors, or other design elements. Such recurrence of visual elements helps to unify the artwork and creates a sense of structure. Pattern, if used in a regular and planned way, may also emphasize the main idea. If used in an unplanned or random way, it can add a sense of energy

Fig. 1–28. How has the artist used the qualities of unity, rhythm, and balance in this clay sculpture?

Mark D. Chatterley, *Journey*.

High-fired clay, 7½' x 4' (2.3 x 1.2 m)

Fig. 1–29. Notice this work's sense of movement, tension, and isolation.

Harry Geffert, *Wind*, 2001.

Cast bronze, 64" x 62" x 24" (162.5 x 157.5 x 61 cm). Photograph: David Wharton. Private collection: Cathy Abbott.

cal paths of movement will challenge the viewer's sense of balance and can be used to dramatic effect in sculpture.

Rhythm is related to both pattern and movement. Use of pattern, or repeated elements or recurring paths of movement, will create a feeling of rhythm in a sculpture. Visual rhythm is like the beat in music—it may be simple and predictable, or complex and unexpected.

Sculpture Concepts

Our world is full of three-dimensional sculpture that is easily described in a few three-dimensional terms: freestanding, relief, and kinetic.

Freestanding sculpture, or sculpture "in the round," is a work that has been developed for viewing on all sides. It stands by itself, regardless of the material or subject matter. Freestanding sculpture may be visualized as a human figure being dis-

played as a form independent of its surroundings.

Relief sculpture juts out from a surface or wall and has at least one side that is not developed. Usually, relief sculptures are shallow but have the illusion of greater depth. The illusion is created through the use of light, which produces highlights and shadows that simulate a deep space. There are two types of relief sculpture. A sculpture that projects only slightly from the background is known as *low relief*, or *bas-relief*. This type is most common on coins and medals. In *high-relief* sculpture, about one-half of a figure's normal thickness projects from the background.

Kinetic sculpture moves or possesses moving parts. The energy that produces the movement is from nature, people, or motorized machines. A wind-driven mobile and a water-driven paddle sculpture are examples of kinetic sculptures that move with the help of natural energy. If a sculpture has a hand-cranked moving part, it is driven by the force of a person. Motorized kinetic sculpture is any sculpture whose movement is powered by machinery.

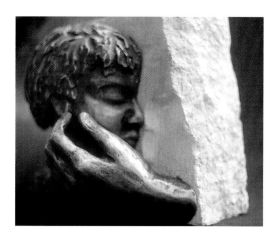

Fig. 1–30. Notice how the artist has used high relief so that not only is the head half exposed, the hand reaches out even further to encircle the child. This technique enabled the artist to create a moving and expressive piece with strong emotional content.

Sheila Robnett, *A Mother's Touch*, 1997.

Bronze and stone, 12" x 12" x 7" (30.5 x 30.5 x 17.8 cm). Instructor: Arthur Williams.

Fig. 1–31. This example of low-relief plaster demonstrates the value of modeling to create shadows from the shapes.
Sheryl McRoberts, *Self-Portrait with Frog/Two Bats*.
Ceramic clay.

Discuss It From what you have now read in this chapter, what do you think is the most significant difference between sculpture (three-dimensional) and painting (two-dimensional)? Can a relief exist without light? When viewing a freestanding sculpture, do you think it should have a front and back or are all sides of equal importance?

Getting Started

Perhaps the most difficult question to answer before beginning a sculpture is "What will I do?" Art is about expressing

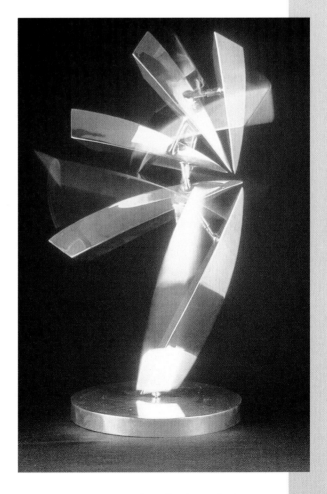

Fig. 1–32. Time-lapse photography was used in order to show the movement of this piece.
Lin Emery, *Palmetto (in motion)*, 2001.
Metal, 5' x 3' (1.5 x 1 m) orbit.

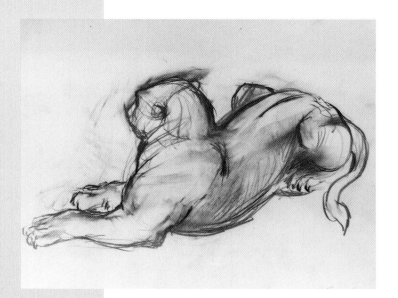

yourself and your ideas, and to do so may require some inventive ways of thinking about and seeing the world. First, it helps to become truly aware of your surroundings—the forms, colors, textures, and patterns of three-dimensional objects. Take the time to study your world and the objects in it so that you can then translate what you have observed into a sculpture. By learning to see with heightened awareness, you will very likely discover inspiration in familiar and unexpected places.

Fig. 1–33. This drawing demonstrates movement and gesture of form. Compare it to the final work in Fig. 1–34.

Carter Jones, *Late Afternoon on the Savannah* (drawing), 1999.

Paper and pencil, 12" x 18" (30.5 x 46 cm).

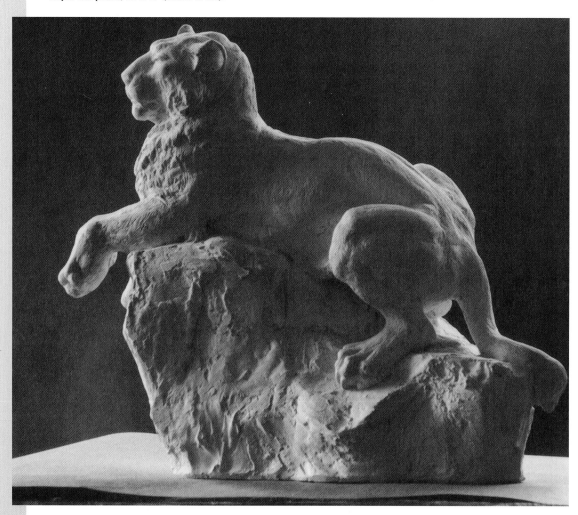

Fig. 1–34. Notice how much the work has evolved from the original idea.

Carter Jones, *Late Afternoon on the Savannah*, 1999.

Cast stone, 23" x 18" x 10" (58.5 x 45.7 x 25.5 cm).

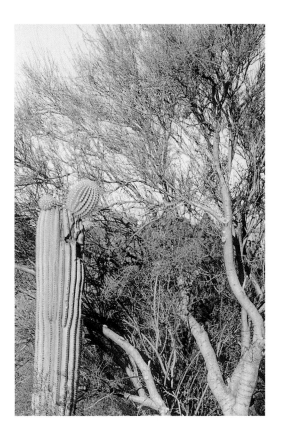

Fig. 1–35. Artists often find inspiration in nature. Sculptor Remo Williams spotted a saguaro cactus in the desert and was inspired by its shape and form to create the image of a mother and child.

Fig. 1–36. Remo goes back to his studio and makes a clay model of his idea in preparation for molding.

You may also wonder if it is better to create realistic or abstract sculpture. The answer is *both*. Keep in mind that good realistic work is more than a copy, and an abstract work that demonstrates a careful economy of detail and a focus on form will express much.

The next decision you will need to make is what material to work with, followed by what techniques to use. Techniques and materials are part of the creative process. Choice of material depends on not only what is available but also your skills. Remember that technique is the method of approach—it is the combination of your knowledge of materials and tools and how to use them. The more you work with materials and tools, the better your technique will become. Then you will be able to spend more time on your ideas and their execution without interference or technical constraints.

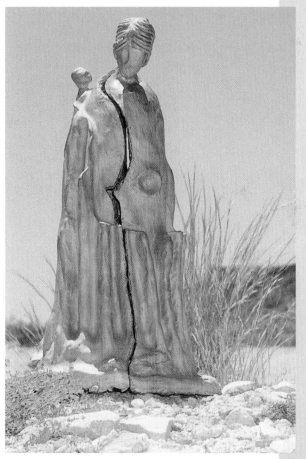

Fig. 1–37. Remo's final design in bronze demonstrates how an idea can be transformed into a permanent medium. What elements from the original saguaro cactus can you still see in the finished piece?
Remo Williams, *Saguaro Papoose*, 2001.
Bronze, 28' x 8".

Studio Experience
Abstract Natural Objects

Forms found in nature serve as an excellent starting point for abstraction. This studio experience will help you to become more perceptive. You will use a natural object as inspiration to create a completely new form—a bold sculpture abstraction. Modeling clay is best for this exercise because it can be instantly manipulated without tools.

Before You Begin

• Choose a subject as your source for inspiration. Avoid simplistic objects such as rocks or potatoes, and complex subjects such as a bouquet of flowers.
• Study your object. Look at its overall form, investigate its tiniest details, touch it and note its texture. Can you see any elements of design? Can you recognize some principles of design?

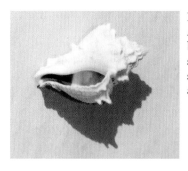

Fig. 1–38. A shell can be a good subject to start an abstraction.

You will need:
• oil-based modeling clay (alternative: polymer or ceramic clay)
• dry towels
• table knives or other simple modeling tools (optional)

Create It

1 Manipulate a small handful of clay; begin modeling. The clay will soften as you work it. Make several smaller forms—about the size of a golf ball—rather than concentrating on one large copy of the object. Avoid detail; just play with the overall form. This is an opportunity to actually "feel" the third dimension as you modify the form. As you change one side, you can quickly see the effect on the other side, top, and bottom.

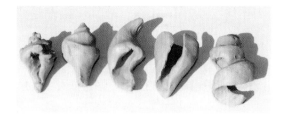

Fig. 1–39. Several small models are created from the shell. Notice the progression of form.

2 If you find it difficult to steer away from an exact likeness, then create a likeness but be prepared to make adjustments. Cut it up into smaller forms. Exaggerate its characteristics; bend it; stretch it.
3 Select a model that you like, set it aside, and create variations of that model.
4 From the variations, select one, set it aside, and make a larger model that will be your final sculpture. Be aware that although the basic form of your model is to be retained, the sculpture can, and often does, change for the better as you spend time working. Always seek to improve. If things appear worse, then go back to the original model.
5 Finish your abstract sculpture in any way you choose. Photograph it for your portfolio.

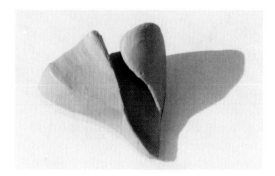

Fig. 1–40. In the final seashell abstraction, which element of the shell has been emphasized—shape, color, and/or line?

Check It Revisit the original object. Have you created an abstract sculpture based on this object?

Sketchbook Connection

Your abstraction of a natural object may lead to ideas for future sculptures. You do not need to try out all of your ideas right now—you can save some ideas in a sketchbook. Include ideas in three-dimensional terms by sketching multiple views. For example, show the top of a form as well as its side. Accompany your sketches with notes about possible materials, tools, and dimensions.

Fig. 1–41. Enrico Pinardi's drawing demonstrates several ideas and views for potential sculpture. This is a good illustration of drawing three dimensionally.
Enrico Pinardi, *Sculpture Drawings*, 2002. 26" x 36" (66 x 91.5 cm).

Rubric: Studio Assessment

4	3	2	1
Evolving Abstraction • Nonrepresentational • Investigates design aspect of natural form • Takes risks			
Sculpture completely abstract; lively bold quality; features natural object-inspired elements/principles; lots of growth and experimentation evident.	Sculpture abstract; elements/principles from natural object used in a pleasing, interesting way; experimentation evident in most stages of process.	Sculpture somewhat abstract *or* very abstract but minimally related to elements/principles found in natural object; some experimentation evident.	Sculpture resembles original object too closely *or* no longer related to elements/principles found in natural object; little experimentation evident.
Fully realized, original, experimental	Satisfying, competent, experimental	Moderate risk or arguable connection	Task misunderstood
3-D Composition • In the round • Movement • Interaction with space • Use of value • Balance			
Sculpture interesting from all views; movement in form leads the eye around whole sculpture; totally involves surrounding space; shadow/value add interest and drama; visually balanced.	Sculpture interesting from most views; movement in form leads the eye around sculpture; interacts with surrounding space; some use of shadow/value; visually balanced.	Sculpture resolved from some views; interaction with surrounding space, movement, value, or balance may need more development to create a finished feeling.	Sculpture resolved from only 1 or 2 views; interaction with surrounding space, movement, value, and/or balance need much more exploration and development.
Unified, strongly 3-D, effective	Unified, effective	Needs refinement, more time on-task	Unresolved, disjointed
Media Use • Physical balance • Craftsmanship • Texture			
Sculpture physically balanced—stands on its own—well constructed; surface texture handled well, thoroughly integrated into sculptural idea.	Sculpture physically balanced but may need a little help to stand on its own; well constructed; surface texture helps express sculptural idea.	Sculpture unable to stand on its own or has other construction problems *or* surface texture may need more refinement—detracts somewhat from idea.	Sculpture very unbalanced or poorly constructed; surface texture needs much more refinement; detracts from sculptural idea.
Skillful, controlled, appropriate	Competent, appropriate	More practice or thought indicated	Rudimentary difficulties
Work Process • Observation/Exploration • Sketches • Iteration of idea • Refinement of idea • Reflection			
All products and time on-task; exhibits strong personal interest and independent drive.	Most products and time on-task meet assignment expectations; some independence exhibited.	Uneven effort in products and/or time on-task—lacks some steps of the process.	Products and/or time on-task minimal; lacks many steps of the process.
Exceeds expectations, independent	Meets expectations, satisfactory	Needs prompting, hit and miss	Disengaged, inattentive

Career Profile

Sheryl McRoberts

Sheryl received her master's degree from St. Cloud State University in sculpture and went on to Indiana University to earn her MFA in sculpture. She teaches at Normandale Community College in Bloomington, Minnesota. She has received numerous commissions and grants, including a Fulbright research grant.

What do you like most about teaching?
Sheryl: I always find wonderful, wonderful students. I think that the world is so visual right now that people who have a good background in the arts can do lots of things.

How did you become interested in sculpture?
Sheryl: I always drew, but I was very involved in music, and always thought that I was going to be a music major. It was not until my junior year of college that I decided to take one of those tests that told of your interest. I was feeling that music was not right. Art received, by far, the highest rating…though I had never taken an art class. I decided, "Let me try it," so I started. I took a sculpture class the year I was in Germany. It was very much classical modeling. I didn't get that from my classes in the United States, because it was all conceptual. I loved working with clay.

How do you choose your media and subject matter?
Sheryl: I gradually just started working in the relief format. I feel like I am painting with clay. Basically, I am studying seventeenth- through twentieth-century still-life painting. I am trying to re-create the painting three dimensionally, and interpret the way the artist created color on the painting—blurring the boundaries between painting and sculpture.

What kind of preparation do you advise for a career in art?
Sheryl: I tell students to live more in the present. If you are really true to yourself, follow your dreams. You don't have to worry about the competition because you will be the best at whatever you choose to do. Get a really good foundation and then interests will be revealed to you eventually.

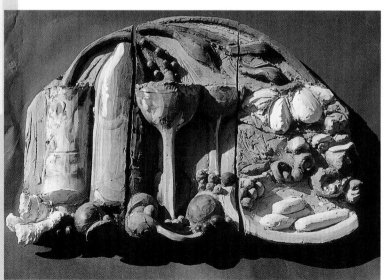

Fig. 1–42. Sheryl creates a high relief with modeling. In the final process she also adds color. How does this technique blur the boundaries between painting and sculpture?
Sheryl McRoberts, *Still Life*, 1998.
Clay, oil paint, 36" x 24" x 6" (91.5 x 60.1 x 15 cm).

Chapter Review

Recall Name the three types of balance in sculpture.

Understand Explain why a white sculpture will have more values than a black one.

Apply If you have modeling clay or ceramic clay, compare them by the "feel" or touch. Does one feel better than another? Which one do you think will allow more detail? Why?

Analyze The three sculpture fundamentals are technique, form, and content. Why is each one an important component of any sculpture?

Synthesize Compare the Egyptian sculpture of Rameses in **Fig. 1–1** with the Olmec head in **Fig. 1–7**. How are they similar in terms of style, content, technique, and decoration? How are they different?

Evaluate The principles of design are balance, proportion, contrast, unity, pattern, movement, and rhythm. Select an example of an artwork from the chapter that you feel best exemplifies two of these principles. Discuss why you feel your selection is an effective example of that design principle.

Fig. 1–43. The goal is to be able to combine design elements with technical ability. This student work demonstrates that knowledge.

Abby Corbett, *Repetition's Rampage*, 2000.

Nu-Gold, Plexiglas, 12" (30.5 cm) tall. Oshkosh North High School, Oshkosh, Wisconsin. Instructor: Jodie Schoonover.

Writing about Art
This chapter includes works by several well-known sculptors. Maybe you know of a sculptor that you think should have been included. Explore your library for additional sculptors to consider. Select a sculptor not mentioned in this chapter whose work you especially enjoy, and write a paragraph explaining why the artist's work should be in a book like this one.

For Your Portfolio

A portfolio provides a place to keep a record of your progress and accomplishments in sculpture. It should contain slides or photographs of your completed pieces. Carefully select artworks for your portfolio. You may want to include work that shows how you have grown as an artist. You may also want to choose works that show your use of different media and techniques. With each portfolio artwork, include your name, the completion date, the purpose of the assignment, what you learned, and why you selected the work.

Key Terms

modeling
models
maquettes
plasticity
slip
portrait bust
armature
proportional
 calipers

Fig. 2–1. Do you get the sense that this artist thinks art should be fun? Notice the title of this piece. In what way does Patz Fowle use humor to express a message?

Patz Fowle, *Gone Fishing . . . in His Head*, 1989.

Porcelain and stoneware, 11" x 8" x 5" (28 x 20.3 x 12.7 cm). Photograph: Joseph D. Sullivan.

2 Modeling

Now that you have reviewed the origins of sculpture as an art form, you are probably eager to begin creating sculptures of your own. You may be wondering: How do people shape materials into sculptures? What are some of the materials they use? What techniques do they rely on to transform these substances into works of art?

A logical place to begin exploring sculptural processes is with the technique of modeling. **Modeling** is the process of manipulating a flexible material into a sculptural form. In essence, it is the building of a three-dimensional image from a somewhat formless material. When material is built up to create the form, modeling is an *additive* process. The artist takes a substance—clay or wax, for instance—and squeezes, pinches, or otherwise shapes it into a work of art.

Modeling dates to prehistoric times, when early cultures shaped clay into human and animal figures with symbolic meanings. Because clay is a modeling material that hardens when fired, many ceramic objects have survived. Ancient cultures, such as the Minoans, modeled *terracotta* into elegant female forms, and the Chinese created extraordinary ceramic sculptures for their tombs. Today, artists may choose clay, wax, or newly developed materials to model sculptures.

In this chapter, you will learn about modeling clays as well as the tools and techniques to work with them. You will explore a variety of modeling methods to form clay sculpture, and the opportunity to create a self-portrait bust will allow you to demonstrate your newly found skill and technique.

creating a model

working with clay

sculpting figures

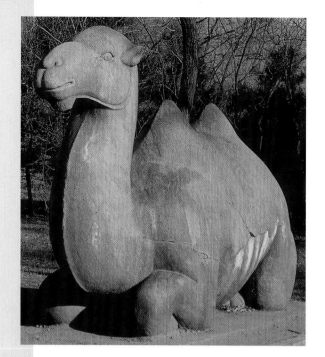

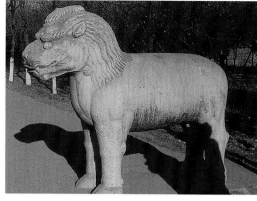

Fig. 2–2 and Fig. 2–3. These elaborate marble animals were created to symbolically guard The Sacred Way, an avenue leading to the tombs of thirteen emperors of the Ming dynasty of China (1368–1644 AD).

China, *Kneeling Camel* and *Standing Lion*, from The Sacred Way, Valley of the Thirteen Tombs.

Marble, life-size.

Models and Modeling

As you have just read, modeling is the act of manipulating a material to reshape it into a sculptural object; in other words, to model, or shape, a form. Within this definition is also the process of creating a model or facsimile. Sculptors often create **models,** also called **maquettes,** to give form to their ideas and to try out different options. Models are not necessarily finalized artworks. Rather, they are like studies, used to indicate the physical form that demonstrates all sides, every view of the projected sculpture.

Artists will often make several models based on the same idea or theme to arrive at a better, more complete concept. They then choose one model for the final work, which is often created on a much larger scale. This fashioning process is usually necessary to design a prototype that serves to demonstrate the general appearance for a larger work. The advantage of a model is that its small size makes it easier to work with—it can be corrected, rearranged, or changed as necessary until the artist is comfortable with a final version. Then it can be used to identify the scale and proportion of a larger work or model.

Note It Whenever possible, try to create a model for your sculpture ideas. This process will help you identify design issues. Models help to inform your final work of art.

Fig. 2–4. Modeling clay was used to carve the details in this work in preparation for a bronze casting.

Greg Polutanovich, *The Final Arrow*, 2002.

Modeling clay, 20" x 18" x 8" (50 x 45.7 x 20.3 cm).

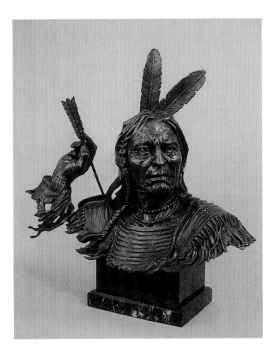

Fig. 2–5. This bronze was cast from the modeling clay image pictured in Fig. 2–4. How would you describe the feelings this work inspires?
Greg Polutanovich, *The Final Arrow*, 2002.
Bronze, 22" x 21" x 8" (55.8 x 53.3 x 20.3 cm).

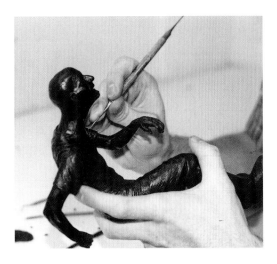

Fig. 2–6. Student Ron Ott is working on a wax mold. Notice the small dental tool that can be used with wax to achieve detail.

Fig. 2–7. Student Chase Mitchell preheated wax in a bucket of hot water and then modeled this piece by hand. How did he play with shapes and forms to make a unified and playful artwork?
Chase Mitchell, *Hand to Foot*, 2002.
Brown wax, 11" x 4" x 8" (28 x 10 x 20.3 cm).

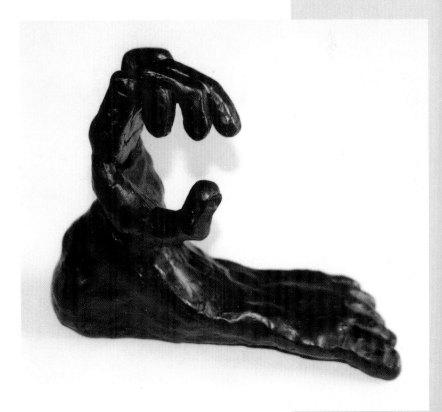

Creating a Model

You can make models, or maquettes, for sculpture using almost any material. One choice is oil-based modeling clay. Oil-based clay allows constant reuse, is easy to manipulate, and permits fine details. As it is worked, it temporarily softens, becoming easier to form. The quality of bending and stretching without breakage is known as **plasticity.**

Models are sometimes made of wax or other materials such as construction board. Wax is fairly easy to use but must be warmed either by soaking it in hot water or allowing it to sit in a warm area. Artists sometimes prefer to model large works in wax because when cold, wax holds great detail. Also, wax is used as a final model material in the process of *lost-wax metal casting*. Construction materials such as cardboard or foam core can be used for creating geometric-shaped models, especially for larger forms.

Terracotta and other ceramic clays are also used for modeling media and for finished work. These clays serve well as

Fig. 2–8. A work being modeled in ceramic clay in preparation for firing. The water spray bottle at the side is used occasionally to keep the clay from drying out as it is worked.

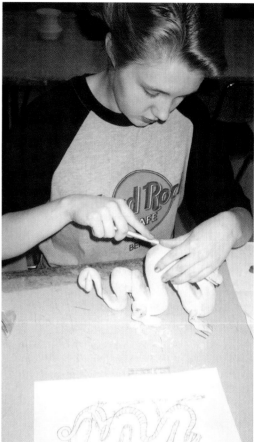

Fig. 2–9. Student Katherine Bolt uses a drawing as a basis for her sculpture. Notice how she has incorporated curves into her design. What effect does this create?

Katherine Bolt, *Oaxacan Dragon*.

South Mecklenburg High School, Charlotte, North Carolina. Instructor: Ellen Estes.

models for larger ceramic works, because they give the artist a sense of feel for the same type of clay. However, once a ceramic clay form is dry it can no longer be modeled.

Drawings are frequently used as a method of recording and preparing model ideas. The best drawings generally show several views of the proposed work and some close-up detail of specific areas.

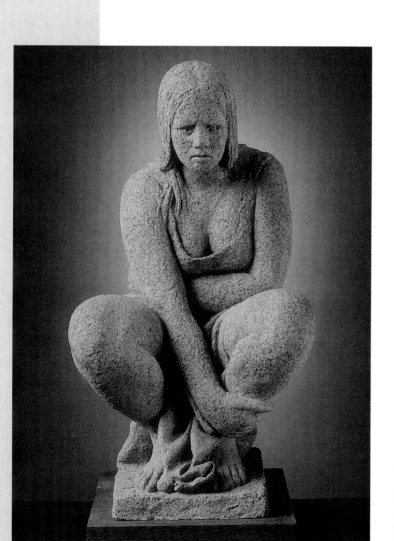

Fig. 2–10. Terracotta is a good medium for displaying unglazed sculpture in its natural color. How has the artist made his work realistic and expressive?

Norman Holen, *Adolescent I*.

Terracotta, 10⅜" x 11½" x 19¾" (26.3 x 29 x 50 cm). Photograph: Peter Lee.

Henry Moore

Henry Moore (1898–1986) was eleven years old when his Sunday school teacher told him about the sculptor Michelangelo. As a result, he said that when he grew up, he, too, would be a "great sculptor." Living in a coal-mining town in Yorkshire, England, he had little help to prepare for a sculpture career. But he did find three-dimensional materials. He enjoyed playing in clay pits owned by a pottery company. He and his friends would sculpt the clay; he loved the medium's *malleability*—its ease of manipulation. He often carved with his only tool, a penknife. Then, when he was sixteen, his art teacher provided him with a set of carving tools and taught him how to use them. As his interest in art grew, his father convinced him to earn a living by other means, and encouraged him to pursue teaching. Young Henry began student teaching at the age of seventeen and was soon taking art lessons at England's Leeds School of Art in the evenings. It was obvious that he had three-dimensional skills. Leeds did not offer sculpture classes when Henry started but the school began a special sculpture program just for him. Shortly thereafter, he won a scholarship to the Royal College of Art to continue his study of sculpture. Wanting to be more creative, he broke from the tradition of using mechanical "pointing machines" that created exact copies of works. He began the process of direct carving, a path he would explore for the rest of his life.

By the time of his death in 1986, Henry Moore had won international art awards in many different countries. In addition to sculpting, he produced well-known drawings and was an accomplished printmaker. He was awarded honorary doctorates from prestigious universities. His work is some of the most recognizable sculpture in the world because of the way he changed the human figure, simplifying and stylizing its forms.

How did Henry Moore approach sculpture? By drawing and by making dozens of models, one after the other. His studio was filled with ideas in the form of models and drawings. He would work with modeling clay until he captured the form he visualized. Then he would enlarge it into another clay model or use plaster. Eventually he would carve it into stone or cast it into bronze. He knew the importance of beginning with a well-designed form.

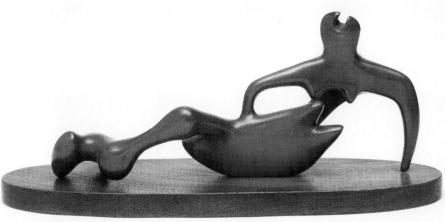

Fig. 2–11. Moore stripped his figures down to the minimum—basic organic shapes of ovals and curved lines. What feeling do you get when viewing this sculpture?

Henry Moore, *Reclining Figure*, 1938.

Cast lead, 5¾" x 13" (14.6 x 33 cm). The Museum of Modern Art, New York; purchase. Digital Image © The Museum of Modern Art/Licensed by Scala. © Henry Moore Foundation.

Oil-Based Clays

Oil-based modeling clays, better known simply as modeling clays, are commonly used for sculpting. They are manufactured by heating and blending a mixture of fine earth clay, wax, grease, and oil. They do not dry out like water-based (ceramic) clays and are completely reusable, in a "like new" state for years. An oil-based clay is one of the most plastic, easily manipulated materials available to a sculptor. Oil-based clays come in various categories from firm to soft.

Working with modeling clay is simple. Begin with small, thin strips of clay that are easily cut with a potter's wire. Although you can use knives to cut small pieces, do not use them to cut large chunks of cold clay. As you fold and bend the clay, it will loosen and become more plastic. You will discover that it can be cut, torn, shredded, kneaded, and pounded, yet always reattached without effort into a larger mass.

Modeling clay does not need to be hollowed (as does ceramic clay), and it can be placed on other items to build up bulk. The warmer the clay, the easier it is to work. Thus, colder clays will take more time to work, while the warmer, softer ones could actually slump, even melt, if left inside a car on a hot day.

As an oil-based material, modeling clay does not permanently stick to other objects. However, it will temporarily adhere to surfaces, fill small crevices, and leave an oily residue on tabletops.

Modeling tools can be almost anything from knives to spoons to professionally designed tools. As with ceramic clays, modeling clays allow the sculptor's fingers to do most of the work. However, since finer details can be achieved with modeling clay, you will find that smaller and sharper tools are useful.

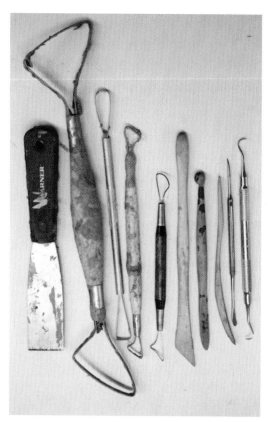

Fig. 2–13. Tools of many shapes and sizes can be used to model clay.

Note It While you can add modeling clay to almost any surface for design or mass, not all surfaces are appropriate. If you use Styrofoam, make sure that it is smooth (not a broken end) or it will become mixed into the clay, resulting in limited reuse of the clay. Avoid plaster or ceramic clay. Test the object before adding clay; make sure the surface is free of dirt or dust and can withstand the weight of the applied clay.

Fig. 2–12. Student BaBa Scaturo is using a wire-loop tool to complete her work in modeling clay. This work will later be cast into bronze.

Fig. 2–14. Notice the detail possible with modeling clay.
Greg Polutanovich, *Aftermath*, 2002.
Modeling clay, 15" x 15" x 11" (38 x 38 x 28 cm).

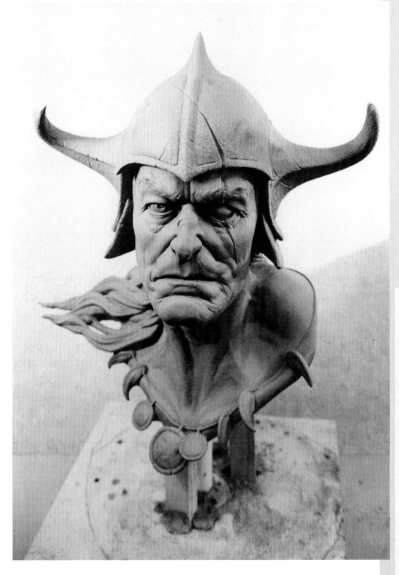

<div style="float:right">

For Your Sketchbook

Each person has a cultural heritage. It may have roots in Europe, Africa, Asia, Mexico, the United States—or a combination of several cultures. Talk to the people you live with and research the artistic traditions of your cultural heritage. Think about how you could express something about your heritage in sculpture.

</div>

Fig. 2–15. Coils of clay were used to make this modeling-clay portrait.
Lampo Leong, *Ed*.
Modeling clay, 12" x 9" x 8" (30.5 x 22.8 x 20.3 cm).

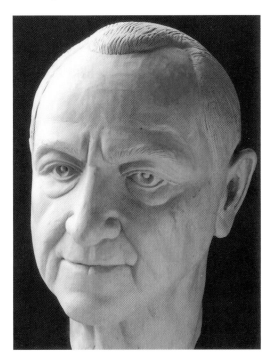

Water-Based Clays

Ceramic clay objects are sometimes the only record available from an early civilization. Even dried, unfired clay pieces have survived from as long ago as 12,000 BC. Modeling was done by hand with few tools. When it was discovered that clay could be baked (fired) to achieve hardness and permanence, clay became a mainstay for cooking and storage vessels. As a result, the durability of fired clay has provided records of peoples and activities that would not otherwise exist.

Ceramic clay is frequently used as a modeling medium, though it does require special care to avoid hardening and cracking during the modeling period. Its

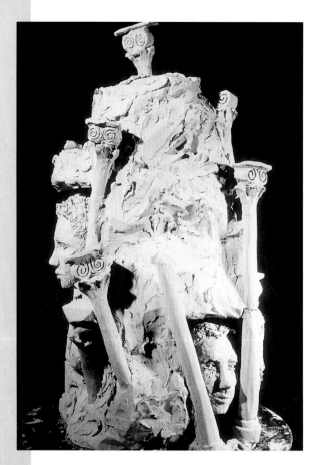

Fig. 2–16. Clay works can involve a variety of hand-building techniques. Can you tell what different kinds of techniques were used in this work?

Erik Jacobson, *Three Self-Portraits in Environment*, 2002.

Ceramic clay, 24" x 12" x 12" (61 x 30.5 x 30.5 cm).
Washington Township High School, Sewell, New Jersey.
Instructor: Bob Duca.

initial plasticity makes it a preferred material. In addition to the simple hand modeling that is done with oil clays, water-based clays permit other modeling methods, such as coil, hollowing, slab, and wheel work. Unlike oil clays, ceramic clay materials can become strong, permanent, and colorful forms. This section will detail some of the ceramic-clay sculpting methods.

Since clay is found as a natural mineral in the earth and shaped with little difficulty, it is a preferred three-dimensional material. However, not all clay can be successfully fired; it depends on the minerals found in the clay. Some clays are more plastic than others.

Terracotta, stoneware, and earthenware are clay bodies predominantly used for sculpture. Terracotta, frequently chosen for modeling, is reddish-brown as a result of its iron oxide content. It possesses a coarser texture than clays like stoneware or *porcelain,* which are typically used for wheel throwing. Sculptors often use terracotta mixed with a clay additive called *grog.* Grog is previously fired, pulverized, and ground clay. Heavily grogged clay shrinks less and dries at a faster and more even rate than pure terracotta, and also creates a rougher surface texture.

Stoneware and earthenware clays are typically found at school studios, because they are prepared for wheel throwing and sometimes hand-building. Earthenware has some characteristics of terracotta, such as a relatively low firing temperature. However, it can be more easily glazed with colorful low-fire glazes. Stoneware is the choice of wheel-throwing ceramists, since it is a more plastic clay that is less porous than many other clays.

Preparing Clay

Clay is available premixed, or you can mix it by hand. Hand-mixed clays allow the sculptor to design a formula for color, texture, plasticity, or shrinkage. If you hand-mix your clay, allow at least a few days to set it aside, covered, in order for it to "homogenize." Store clay in an airtight container or plastic bag. Plastic garbage containers are good—they are even better if you line them with plastic bags tied beneath the lid for extra protection.

Safety Note Clay dust contains silica, which is harmful to the lungs. If mixing dry clays, wear a respirator. Even premixed clays produce dust as they dry, and as they are cleared from a workspace and crumble underfoot. Limit your exposure to clay dust by wearing protective clothing and a dust mask, and using a sponge rather than a brush to clean work areas. Wet mop the floor rather than sweeping.

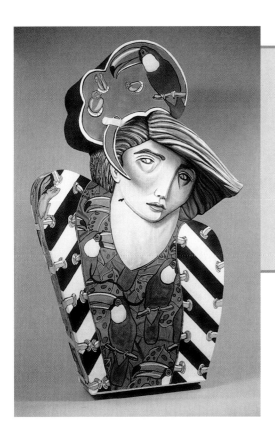

Line

Sculptors must think about using line—the actual outline of the sculpture itself (more often called planes in sculpture)—to guide the viewer's gaze. You can describe line by the way it looks—straight, curved, or broken, for example. A pyramidal structure will draw the eye upward, whereas one that has a serpentine outline will create a feeling of winding or twisting.

Fig. 2–17. The careful use of line can make the difference between a dull artwork and an exciting one. How would you describe the use of line on the surface of this work?

Jean Cappadonna-Nichols, *Whose Side Are You on with Demons on the Loose and Ties That Bind?*

White earthenware, underglazes, paint, 43" x 27" x 16" (109 x 68.5 x 40.5 cm).

Whether commercially mixed or hand-mixed, your clay should not contain air pockets or hard spots. The moisture content should be even throughout. You can hand condition the clay body with *kneading* or *wedging* techniques. Kneading is best suited for small amounts of clay. Roll clay into a loaf shape, compacting it by pressing down with your palms. Wedging is useful for larger pieces of clay. Turn and push the clay in a spiral motion. For both processes, cut the clay into separate pieces and throw (slam) them back together, then repeat until no air pockets remain.

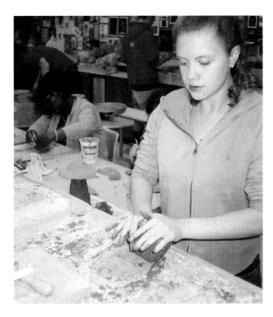

Fig. 2–18. Student Beth Connolly kneads clay in preparation for modeling.

South Mecklenburg High School, Charlotte, North Carolina. Instructor: Ellen Estes.

Fig. 2–19. Wedging clay. Notice the "folds" in the clay as the clay is rolled into itself.

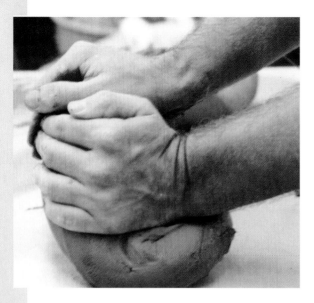

Fig. 2–20. Wedging clay. It takes strength to press or compress the clay together.

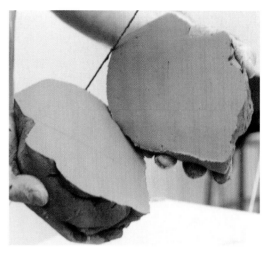

Fig. 2–21. Wedging clay. It is cut into two pieces by use of a tight wire above the wedging table. This is done to examine for air pockets and to better integrate the clay into a homogenous mass.

Commercially available clay is usually pre-wedged or "de-aired." You can recycle clay scraps, but be sure to carefully hand condition the clay for overall consistency.

Note It A pug machine, especially a de-airing one, can replace wedging as a form of clay preparation. Many ceramists combine both processes.

A sculptor's clay-modeling tools are the same as those used by potters. These include wire-ended tools, potters' needles, different-shaped wooden modeling tools, a cutting wire, and small sponges. Kitchen and found-object tools such as table knives and spoons are common. Because clay is easily manipulated, the sculptor's hands, fingers, and thumbs are the most practical tools. Many sculptors use tools exclusively for hollowing or cutting, not for the primary sculpting. Some develop favorite tools for specific marks or individual uses.

Try It Recycle your clay scraps. Mix them with water and pour the mix onto a plaster slab, which will absorb some moisture. Wait until the surface water has evaporated and then wedge or knead the clay into a workable consistency.

Sculpting with Clay

Clay hand-building techniques can be combined in a single work, although each has a special function. Pieces of clay can be joined using **slip,** a mixture of clay and water. As you plan your work, keep in mind that clay shrinks significantly as it dries and again when it is fired.

One hand-building technique is the *pinch method.* Simply stated, it is the

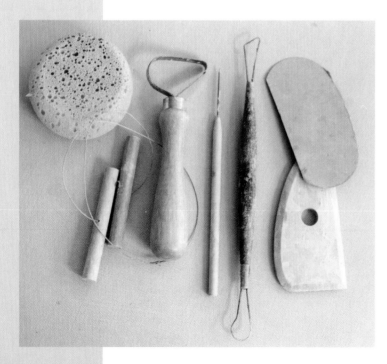

Fig. 2–22. Ceramic clay modeling tools.

Fig. 2–23. Tiffany Fisher is completing a clay piece after using the pinch method. The parts have been pinched out into a definite shape.

Mendham High School, Mendham, New Jersey. Instructor: Jessica Perry.

Fig. 2–24. Student Yong Li is working with clay coils as part of the design. In sculpture, however, coils are usually smoothed together until they are no longer recognizable. Compare this to Fig. 2–15, where the coil method was also used.

pinching or compressing of a clay lump between the fingers and thumb to a desired thickness. Potters refer to this method as "making a pinch pot."

The *coil technique* involves rolling the clay into long thin "snakes" and then layering them sequentially to raise walls.

Proportion and Scale

Scale is a primary consideration: how large will the sculpture be? The work's setting or environment is one factor that determines its scale. Another is the message or intention of the artist. You may want to create a small-scale work to evoke a sense of intimacy and invite close inspection, or one on a large scale to arouse a feeling of awe and grandeur.

An artwork's proportions— the relationship of a part of something to the whole—can also greatly affect the way it is perceived.

Fig. 2–25. This coil-built form creates a larger-than-life scale with great exaggeration. Why do artists manipulate the normal size, scale, or proportion of things? What effect does the distortion here have on the viewer?

Fred Yokel, *Mr. Belpet*, 1999.
Raku, 19" (48 cm) tall. Photograph: Roger Dunn.

You can add coils atop a scored base that is created separately. If coils are soft, they may be joined without scoring the edges. Smooth the coils inside and out to create a permanent bond when the clay is dried and fired. You can flatten coils to form a uniform wall with no indication of the original coils. If a large work is desired, you can use larger coils at the base, allowing them to partially dry as, working upward, you add more coils with score-and-slip technique (see page 40 for details of this technique). Large works should be allowed to dry slowly and evenly, or the coils will separate.

Use the *hollowing technique* to remove an interior mass of clay in order to ensure an even thickness. This is necessary so that the piece can dry and be fired without cracking. Wire loop tools are often used for hollowing, since they are thin

Fig. 2–26. Student Rachael Chapman is working in clay using the slab technique.
Mandeville High School, Mandeville, Louisiana. Instructor: Mary Elaine Cash Bernard.

and can pass through the clay with minimal resistance. The clay needs to be in a somewhat dry, rigid state, but not yet *leather-hard*. (Leather-hard is when the clay is firm, colder than room temperature, but not dry. It can crumble if mishandled.) Scoop out the excess clay, leaving an even thickness for the wall. To join pieces, score and add slip (see page 40). Be sure to leave a small hole so that air can escape during the firing process.

The *slab technique* involves shaping clay into broad, flat, thick pieces or strips. Use a slab rolling machine, a rolling pin, or a dowel to evenly flatten the clay. You can cut slabs to size, let them dry a bit, then score and place them together with a coating of slip between them. If you spend time carefully smoothing the clay, you can hide the seams.

Soft slabs can be used for press molding. You can add a press-molded part (discussed in chapter three) to a clay sculpture by scoring the clay and adding slip around the edges of the molded piece to strengthen the bond. Slip-cast parts (discussed in chapter four) can also be added but with extreme care—they are a thinner, different clay body. It is best to design slip-cast pieces that can be fired separately. After firing, you can fit them onto or into your sculpture.

Note It If a ceramic wheel is available, you can throw cylindrical forms and add them to clay bodies. (They should always be from the same clay.) Or you can design thrown shapes as finished sculpture with little or no modification.

Fig. 2–27. Student Chase Mitchell is using a straightedge to cut ceramic slabs for a work.

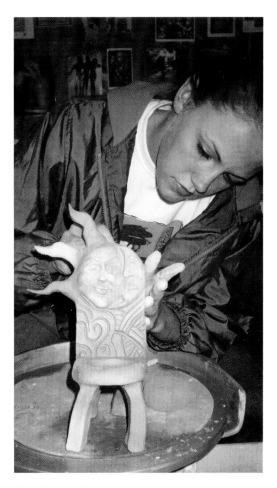

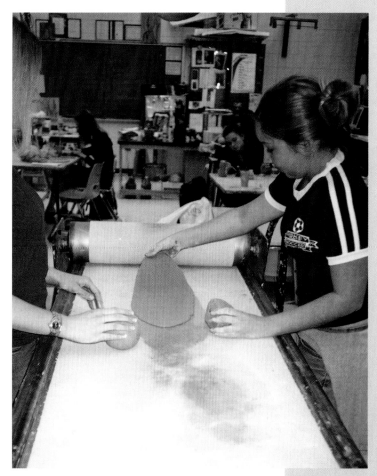

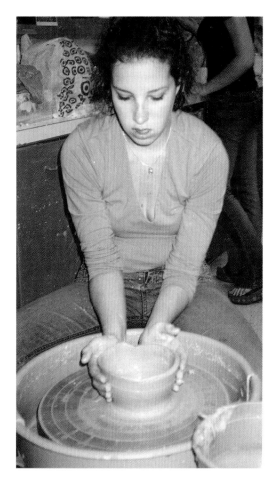

Fig. 2–28. Chelsea Grady is completing a clay sculpture by using a combination of hand-building techniques.

South Mecklenburg High School, Charlotte, North Carolina. Instructor: Ellen Estes.

Fig. 2–29. *(Above, right)* **High school students Emily McKnight and Britt Hayes are using a slab rolling machine.**

South Mecklenburg High School, Charlotte, North Carolina. Instructor: Ellen Estes.

Fig. 2–30. *(Right)* **Emily Gibson is working on the ceramic wheel. Thrown clay can be added to other techniques to produce a clay sculpture.**

South Mecklenburg High School, Charlotte, North Carolina. Instructor: Ellen Estes.

Join Two Pieces of Clay

The slab, coil, and sometimes the pinch method depend on your ability to join clay pieces into a new or larger form. Clay slip, the consistency of thick paste, is invaluable for this process.

❶ Score (scratch) the surfaces that are to be joined. The pieces can be soft clay or in the leather-hard state. Use a fork or a rib with a serrated edge.

Fig. 2–31. A serrated-edge metal rib scores the two surfaces that are to be joined.

❷ Apply slip with a flat wooden tool or a brush.

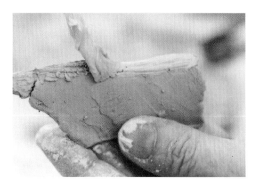

Fig. 2–32. A soft brush is used to add slip to the two joint edges.

❸ Lightly press the pieces together. If desired, roll out a clay coil and press it into the seam.

Fig. 2–33. The pieces to be placed together are lined up.

❹ Smooth the edges with your fingers. Try to completely hide the joint. Allow the work to slowly dry.

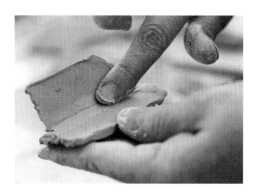

Fig. 2–35. The surface is smoothed with the fingers.

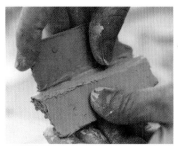

Fig. 2–34. The clay pieces are joined. Sometimes a small bead of clay is added to the joint to strengthen and flesh it out.

Fig. 2–36. Glaze can greatly enhance and brighten a work.

Nanja Mushin, *Ice Cream Sundae*.
Clay. Wakefield High School, Arlington, Virginia.
Instructor: Wendy Singer.

Finishing: Glazing and Firing

After the sculpture is formed, it dries to a leather-hard state. At this point, it no longer has plasticity and should be handled only minimally. However, this is when you can burnish areas using a hard object such as a piece of stone, glass, or metal. Carefully rub the object against the surface, compressing the clay until it shines. The result will be a shiny area where you burnished. Be aware that the clay can crumble if undue pressure is exerted.

Fire your sculpted greenware (unfired clay works) to create a ceramic piece. This is called a *bisque* firing, and is preliminary to a higher-temperature, glaze firing.

You can glaze sculpture, as pottery typically is glazed, or choose a different surface decoration. Larger sculptures are often sprayed to secure an even coat of glaze. When glaze is fired it fuses to the clay, forming a glassy permanent surface. However, sculpture clays are often stained or left unglazed for effect.

Note It Be aware of the effects of ornamentation and surface embellishment. Surface decoration should enhance the sculpture's form.

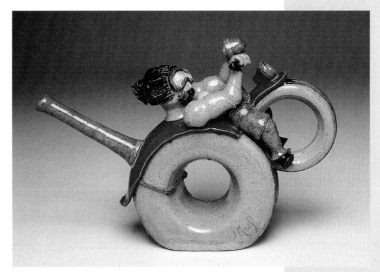

Fig. 2–37. Glaze-fired sculptures can use a combination of techniques. Can you identify the wheel-thrown parts on this sculpture?

Jim Neal, *Motorcycle Teapot*.
Stoneware, wheel thrown, extruded, hand-built, 9" x 14" x 3" (22.8 x 35.5 x 7.6 cm). Photograph: Michael Noa.

Fig. 2–38. Sometimes artists prefer to add color after the firing. How does the color scheme lend definition to this work?

Tasha Fisher, *#25*.
Ceramics and acrylic paint, 10" x 8" x 6" (25.5 x 20.3 x 15 cm). Canyon View High School, Cedar City, Utah. Instructor: Jared Ward.

Safety Note Glazing involves the use of chemicals, some of which may be hazardous to your health. Good ventilation is a necessity. Know your glaze chemicals and heed all manufacturers' warnings. Wear a respirator or mask when you work with dry chemicals, spray glaze, and cleanup chemicals. Wear rubber gloves when you mix glaze, and when you dip or sponge glazes.

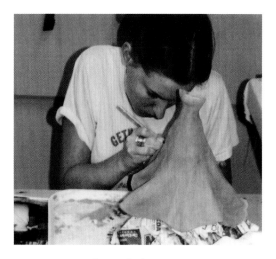

Fig. 2–39. Student Alisha Lee Payne is working on an earthenware sculpture.

Firing setups can be as primitive as a wood-fueled pit in the ground or as sophisticated as a computer-programmed fully insulated structure. Most studio setups include electric or gas kilns. Electric kilns are simple to operate and easy to manage. They are used for a range of low and high firing temperatures. Gas kilns are used for a multitude of temperatures, but especially for larger or high-temperature firings. For sculpture, double the recommended pottery warm-up time to allow thick or uneven walls to heat slowly. Otherwise, joints may open, and pieces can crack. The cooling time should also be lengthened.

Fig. 2–40. Alisha's hand-formed clay work is glazed and fired. Notice how her use of graceful, curving lines helps to create a flowing rhythm.

Alisha Lee Payne, *Pink Prom Dress*, 2002.

Clay and glazes, 14" x 13" (35.5 x 33 cm). Northwest Cabarrus High School, Concord, North Carolina. Instructor: Carmella Jarvi.

Fig. 2–41. A self-hardening clay was painted with acrylic and mounted on a red-brick base in this piece. Notice how the use of color makes this work seem natural and lifelike.

Eli Gold, *Lizard Metamorphosis*, 2001.

Self-hardening clay, acrylic, brick and mortar. Instructor: Arthur Williams.

Fig. 2–42. In order to achieve a predictable glaze color, all clays and all chemicals have to be carefully selected and weighed according to established formulas.

Safety Note Good ventilation and respirators are necessary for many kiln applications. Protect eyes with goggles when looking into a hot kiln. Because many kilns are gas fired, a knowledgeable operator is necessary to ensure a good and safe firing.

Fig. 2–43. Where do you see positive shapes in this piece? Where do you see negative shapes? How are they balanced?
Bryan Hively, *Gold Hoop*, 2000.
Clay, glazes, 25" x 26" x 10" (63.5 x 66 x 25.4 cm).

Safety Note Always double-check to be sure that students do not fully close off interior spaces. Gases must escape during the firing. If they can't, the sealed work could explode, causing damage to the piece and other work surrounding it.

Fig. 2–44. Visual and tactile sensations abound in this piece, which demonstrates the intricacy and strength of polymer clay.
Aurelia Rose, *Skeletal Goblet*.
Polymer clay, mixed media. Liberty High School, Bealeton, Virginia. Instructor: Kathleen Willingham.

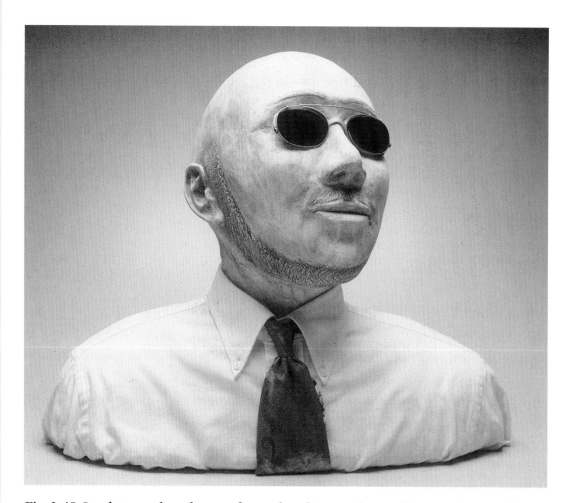

Fig. 2–45. In what way does the use of everyday objects enhance this ceramic portrait?
Jared Ward, *He Knows More Than You Could Ever Imagine*.
Ceramic and fabric, 14" x 16" x 6" (25.4 x 40.5 x 15 cm).

People as Subject Matter

The human figure in sculpture is one of the most explored subject forms. Parts of the body, hands, and especially the head have inspired the work of many sculptors.

Portrait Busts

One of the most common forms of sculpture is a sculpted head, better known as a **portrait bust.** Some feature a neck and shoulders, while others portray only the head. Portraits can be found lining the

Fig. 2–46. A terracotta portrait features glazed and unglazed clay. What effect does this technique produce?
Marcia Polenberg, *Portrait of a Lady*.
Slips, glazes on multifired terracotta, 17" x 9" (43 x 23 cm).

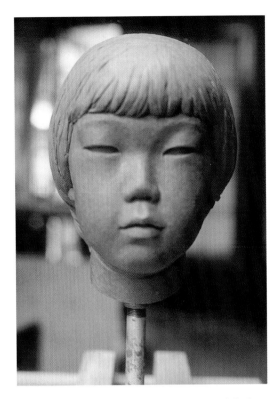

Fig. 2–47. Portrait busts may be modeled in wax on a metal-pipe armature.
Mary Lewis, *Emily*.
Wax, life-size.

Fig. 2–48. Alyssa Dane Smith starts to model a white earthenware portrait bust. Notice the sketch she made as a first step.

Fig. 2–49. Her final portrait bust appears very lifelike. How did the artist achieve this effect?
Alyssa Dane Smith, *Sylvia*, 2002.
Clay and articles, 13" x 24" x 10" (33 x 61 x 25.5 cm). Northwest Cabarrus High School, Concord, North Carolina. Instructor: Carmella Jarvi.

halls of historic buildings because they have often been used as an artistic memorial of a great or loved person.

The size of the bust will determine the exact modeling procedure. If the bust is to be life-size or larger, it needs an inner support called an **armature**. An armature is a skeleton-like structure used for support of modeling material. If the bust is small—handheld—then a support is not necessary. A life-size work has the advantage that the artist can measure one-to-one for exactness of size and features. A smaller bust has the advantage of economy of material, space, and time. The process is similar, regardless of size.

Note It *Calipers* are precision devices that enable the user to directly transfer measurements from one object to another. Use **proportional calipers** to accurately increase or decrease the scale of the bust you make from a live model.

Fig. 2–50. Calipers. The smaller caliper is used for exact measurements. The larger caliper is called a proportional caliper because it can perfectly proportion a larger or smaller measurement.

The type of modeling material will determine the exact process. The two most common are oil-based modeling clay and water-based ceramic clay. While ceramic clay is more easily manipulated, it also requires more care to prevent drying out while work is under way. Its greatest asset is that it can be fired into a permanent state without creating a mold.

You can apply clay over an armature. If you are making a portrait bust, consider an armature made with an upright pipe that has been mounted on a flat-based surface. Attach a Styrofoam wig model to the base as a way of quickly adding bulk that can then be covered with modeling clay. Or, if using ceramic clays, apply over an armature with flexibility so that the clay can dry without fracturing. Wadded newspapers may be used for the interior mass, for example.

Note It Armatures that are very solid or with the "stuffing" too close to the surface will impede design changes, since some corrections cannot be made without damage to the armature.

The Human Figure

Along with our faces, the human figure is the most universally recognized subject matter. Throughout history, the figure has been depicted in various ways. Today, we exercise more freedom of expression with the figure than ever before.

Model life-size figures, or even smaller ones, on armatures. A simple armature can be created from

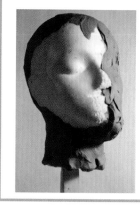

Fig. 2–51. The plastic quality of clay allows the artist to model a relaxed figurative pose.
Win Peterman, *Untitled*.
Terracotta.

Create a Portrait Bust

The following demonstration applies to both ceramic and modeling clay. The primary differences are the initial application of the material, and its care and storage.

① Obtain photographs—front, back, right and left profiles—for the best likenesses. (The model cannot always be present.)

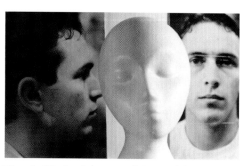

Fig. 2–52. A photographic profile of the model is compared to the Styrofoam mannequin wig head that is used for an armature.

② Mount a Styrofoam armature on a wooden pole (2" x 2") that has been firmly anchored to a strong, flat base (2" x 12") by use of long countersunk screws from the bottom up into the pole. You can file down areas of the armature to comply with the shape of the model's head. Add modeling clay by pressing small strips or pieces onto the surface until the entire armature is covered.

Fig. 2–53. The Styrofoam mannequin's armature is covered with clay. Notice that the clay has been extended down below the chin because of the mannequin's smaller shape.

3 Model the basic shape of the head, which you have proportionately measured to the subject using calipers. Measure and mark horizontal lines for the location of the eyes, brows, bottom of nose, lips, and ears (normally aligned top and bottom with eyebrows and end of nose). Hair is not a factor at this time. Make a vertical line straight down the front center of the head, ensuring that all features are balanced.

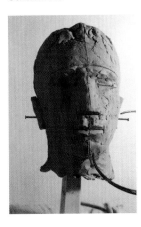

Fig. 2–54. The proportions are checked for correctness. Colored nails have been placed in three key locations. Calipers are used to be certain of key distances from feature to feature.

4 Locate and begin to model the ears, and indicate the eye sockets. A heart-shaped slab can be cut in half to represent the ears. Be sure the eyes are not too far apart—imagine three eyes joined in a row, then eliminate the middle eye. Model the cheekbone structure.

Fig. 2–55. The ear is roughed out.

5 Model the nose and lips. Accuracy here is critical to obtaining a likeness. Study the model's nose profile, noticing sharp or rounded edges, and the planes. Be careful not to make the nose too thin. Study the lips. Notice their roundness, and how they form the corners of the mouth. The upper lip has one central, rounded form surrounded by two longer, outer forms, whereas the lower lip has two larger, more solid forms.

Fig. 2–56. The mouth and nose are modeled.

6 Model the eyes. Scoop out sockets and place spheres into them. Notice that the upper eyelid protrudes more and is heavier than the lower eyelid. To represent a dark pupil, dig the center out deeper; for a light pupil, etch a line and remove only the center.

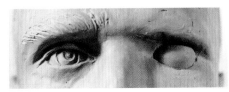

Fig. 2–57. The eye is placed into the socket *(right side)* **and then modeled** *(left side).*

7 Observe the hairline. You can use clay coils to add bulk to the head where hair is present. Add hair in correct proportion to the face, not as an ornament but as a significant part of the anatomy. Model locks of hair as complete forms before detailing by cutting grooves. Make deeper cuts for dark hair and shallow cuts for light hair.

8 Refine and check all the details. If a likeness is not achieved, it is often because of a misplaced or a distorted feature. Assuming that the basic shape is correct, it should not be difficult to fix. While details help, too many or too fine details can actually detract from the likeness.

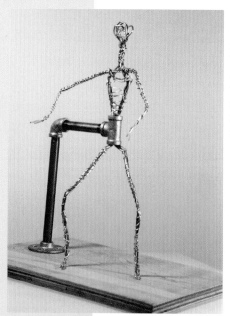

Fig. 2–58. A figurative armature is used for modeling clay. The soft wire is flexible to allow adjustments. It can be worked on in an upright position because it is supported by a rear steel pipe.

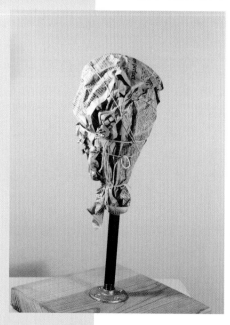

Fig. 2–59. This is a typical armature designed for a water-based (ceramic) clay portrait bust. A steel pipe is firmly mounted on a wooden base to allow support. The top of the pipe has wadded newspapers that will be covered with ceramic clay. The clay will shrink as it dries, but not crack, because the newspaper will give, allowing for shrinkage.

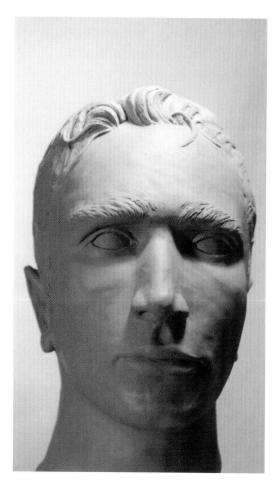

Fig. 2–60. Modeling clay has been placed on a simple armature to create a portrait bust.

plumbing pipe mounted on a board. Securely insert stiff wire into the armature arm. The wire must have some flexibility in order to be formed into a shape, but also rigidity to retain that shape.

While it is easier to model a figure straight and upright, keep in mind that a slight twist or bend, or weight shifted onto one leg, creates a more interesting pose. However, do not attempt a pose in which the model is strained. The overall figure should be modeled prior to adding details. Proportion the head to the rest of the body. Sculpt the head features last, only after ensuring that all body parts are proportionally correct.

Note It Observation is the best teacher for figure anatomy. Spend time looking at a live model. While you can do many things from memory, a live human figure needs to be used as reference. Spend significant time studying your model.

Sculpting Animals

Many sculptors are better at modeling animals than humans. While snakes appear to be easy to model, they require careful observation and work. This is true of all living things. An armature is often needed if the model is of much size. Perception and observation are key to animal modeling: the keener the observance, the better the understanding.

Model an Elephant

Artist Patz Fowle demonstrates a straightforward method to create elephant forms. She calls it her "easy-to-learn process." How might this technique be adapted to sculpt other animals?

1 Patz "balls" her clay parts into different sizes. She adds holes to the larger balls for the animals' legs and head.

2 She refines the form of each part, making tapered cylinders for legs and modeling the basic head structure.

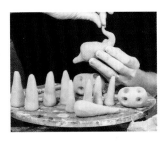

3 Using the score-and-slip method for adhesion, she inserts parts into the bodies.

4 Smoothing the seams strengthens joints as it contributes to a better finish.

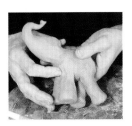

5 To add texture, Patz presses a sheet of plastic into the work while creating "wrinkles" with her finger-nails.

6 She models eyes and eyelids, adding small bits of porcelain for a "whiter" eye. The clay has now become leather-hard, so she hollows out the large body forms, then carefully patches them. With a toothpick she makes holes in the bottom to vent moisture and gas during firing.

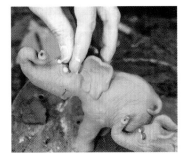

7 She fires her completed sculptures to cone 5 (oxidation) without a glaze. Notice the elephants' expressive character.

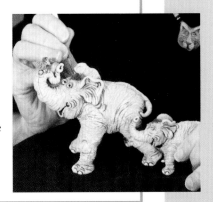

Studio Experience
An Expressive Self-Portrait Bust

You will create a portrait bust of yourself with particular attention to your expression. The size of the work will be determined by the material, available time, and working space.

Every morning you look at yourself in a mirror. You know what you look like—or do you? Most artists need a constant reference to the subject matter in order to convey a sense of realism. For this studio work you can use a mirror and photographs of yourself for reference.

Before You Begin

• Study your face and head. Draw yourself from different angles. Do studies of all your features, making different expressions. Choose an expression you would like to capture in your portrait bust.
• Review the modeling demonstration on pages 46 and 47.
• Consider ways to create accurate proportions. Do you have photos of yourself that you can work from? Can you locate a class member with a similar head shape? It is good to have a "live" model in front of you for reference points. Even so, we are not exactly the same. As you plan your portrait bust, refer to your sketches, checking for your personal "signature" differences.

Fig. 2–61. Notice the features to measure and make notations.

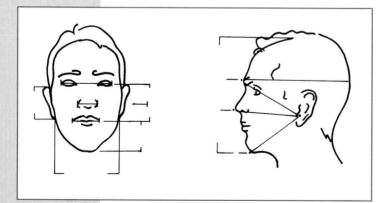

You will need:
• clay, either oil- or water-based
• modeling tools: handmade or purchased
• an armature, handheld or on a stand (depending on the size of the work to be done)
• a handheld mirror
• calipers

Create It

1 Begin with the armature. If it is to be upright, make sure it is sturdy enough to hold all of the clay necessary to finish. If it is to be handheld, be sure it can still be placed down on a separate surface while you are adding finer details. A handheld armature can be one of a solid clay mass without other materials. You can insert a rod into the clay for ease of handling or temporary mounting.
2 Add clay to cover the armature, paying attention to the overall proportions. Make corrections as necessary. Continue to measure yourself, noting the eyebrow, ear, and nose locations. Step back and view your work from different directions.
3 Some sculptors prefer a smooth-surfaced bust while others prefer a rough or heavily textured one. Your personal working methods will help determine the finishing technique. Stand back and look carefully at the sculpture. Does it need

Fig. 2–62. Student Jonah Blum poses with his modeling-clay portrait bust. To give his piece interest, Jonah purposely sought an unusual expression.
Instructor: Arthur Williams.

more or less visible texture? Be consistent in your approach.

Check It Does your sculpture look like you? If not, why not? Ask your fellow students: Is it a basic shape problem or location problem? Millions of people share similar proportions, all with two eyes and two ears, a nose and a mouth—how is it you can tell one person from another? Is it the nose, eyes, hair, jaw, chin, or cheeks that are most different? Have you successfully captured a facial expression?

Sketchbook Connection

Make two sets of sketches to portray yourself as you imagine you are seen by yourself and different friends or family members. Draw different angles and perspectives to show the three-dimensional aspects of your face. How are the two sets alike and different?

Fig. 2–63. This portrait of Albert Einstein demonstrates how effective natural clay color can be. How did the artist add expressive elements to his piece?
David McCanless, *Einstein*, 2002.

Clay, 12" x 10" (30.5 x 25.4 cm), Sequoyah High School, Canton, Georgia. Instructor: Kim Gratton.

Rubric: Studio Assessment

4	3	2	1
Personal Insight • Expression • Accuracy of proportion • Detail • Scale • Texture			
Pose/expression, accurate proportion, important and subtle detail, selection of scale and texture choice strongly contributes to insightful self-portrait. Perceptive, insightful, convincing	Pose/expression, fairly accurate proportion and details create a recognizable self-portrait; selection of scale and texture enhance personal expression. Satisfying, competent, recognizable	Pose/expression creates a recognizable self-portrait; *however,* proportion and use of detail need more refinement *or* use of texture needs more thought and care. Needs work but on track	Pose/expression generic or not related to self (i.e., depicts fantasy creature); *or* problems with proportion, detail, and/or texture overwhelm personal expression. Significant problems
3-D Composition • In the round • Movement • Line • Form (planes in space)			
Sculpture interesting from all angles; sensitive and expressive use of line and planes in form create movement and convincing liveliness or spirit. Effectively 3-D, unified, sophisticated	Sculpture interesting from all angles; use of line and planes in form create movement and sense of liveliness. Effectively 3-D, satisfying, competent	Sculpture resolved from most angles; use of line and planes in form need more development or editing (too much or too little). Needs a bit more observation and practice	Sculpture resolved from only 1 or 2 views; line and planes randomly placed or unrelated to real features. Unresolved, incomplete
Craftsmanship • Armature • Technical construction • Physical balance • Tool use			
Armature sturdy enough for scale; sculpture well constructed and balanced; highly effective selection and use of tools to create desired effect and sense of finish. Highly skilled, controlled, appropriate	Armature sturdy enough for scale; sculpture adequately balanced; a range of tools tried and used to create desired effects and sense of finish. Competent, practiced, appropriate	Armature or construction problems lead to lack of balance or cohesiveness; *or* limited practice with tools detracts somewhat from sense of finish. More practice indicated	Sculpture very unbalanced or poorly constructed; limited or haphazard use of tools noticeably detracts from sense of finish. Rudimentary difficulties
Work Process • Observation/Exploration • Sketches • Iteration of idea • Refinement of idea • Reflection			
All products and time on-task; exhibits strong personal interest and independent drive. Exceeds expectations, independent	Most products and time on-task meet assignment expectations; some independence exhibited. Meets expectations, satisfactory	Uneven effort in products and/or time on-task—lacks some steps of the process. Needs prompting, hit and miss	Products and/or time on-task minimal; lacks many steps of the process. Disengaged, inattentive

Web Links
To learn more about Maria and her work, visit:

www.maria-alquilar.com

There are many Web sites dedicated to the clay arts. Two leading magazines that offer online experiences are *Ceramics: Art and Perception* and *Ceramics Monthly.* Compare the two sites to determine the differences and potential uses:

www.ceramicart.com.au

www.ceramicsmonthly.com

Career Profile
Maria Alquilar

Photograph: Janjaap.

Born in Brooklyn, New York, to Russian and Spanish parents, Maria has had a varied career with public art. She received a BA in humanities at Hunter College. She then moved to California and began her career as a teacher. Now a full-time artist, Maria has had her work exhibited widely from Mexico to Italy and from California to Washington, DC. She is known for public commissions in clay.

When did you realize that you had abilities as an artist?

Maria: They used to have little figures in the newspapers; I would cut them out and then draw my own little clothes and things for them. I was really pretty young. In school I was always the one that did the murals for history or social science class.

I personally have been very influenced by my life in Brooklyn. The Brooklyn Museum is fantastic. They have wonderful medieval and Egyptian sections. I went every Saturday with my mom when I was nine years old. I started doing painting and ceramics and entered the exhibits at the museum. It took off from there.

How did you get started with public commissions?

Maria: A new person in public art in Sacramento hired me to do a bathroom alcove for her. She really liked my work; after that I started getting my commissions in public art. You have to get a toe-hold by doing a commission that might not amount to so much. Then, eventually, once you get that first one, things start moving along. People get to know you . . .

What do you enjoy the most about your work?

Maria: Satisfaction when you finish it. It's almost like a miracle . . . like somebody is guiding your hand. . . . How did I do this? Just let me do one more, God, and then after I finished that I think, well, just one more! One more! That's what I have been doing with these commissions. I think, just one more . . .

Fig. 2–64. This large ceramic mural was constructed by using a series of smaller clay squares.
Maria Alquilar, *The Travelers Come to San José*, 1991.
Ceramic, 17' x 5' x 10' (5.2 x 1.5 x 3 m).

Chapter Review

Recall List the steps involved in joining two pieces of clay together.

Understand What is the difference between the coil and the slab technique in clay sculpting?

Apply Take two pieces of unwedged ceramic clay and wedge one for a few minutes, but do not wedge the other one. Afterward, cut the two pieces in half. Look at the cut surfaces. What differences do you see?

Analyze Review the self-portrait bust you created in this chapter. Write a critique of your work. Include comments on your intent versus the actual results. List the strengths and weaknesses of your creation.

Synthesize Oil-based clays and water-based clays have many things in common. Name some. How might it be possible to combine modeling clay and ceramic clay into one form?

Evaluate Explore the elements of proportion and scale in Maria Alquilar's *Travelers Come to San José* on page 52. How has the artist manipulated scale? Which figures are larger than others? How does the artist's use of scale and proportion create humor or surprise? In your opinion, does her use of proportion and scale work? Why or why not?

Fig. 2–65. Tiffany is completing her modeled clay sculpture.

Tiffany Fisher, *Figurative Vessel*.

Stoneware. Mendham High School, Mendham, New Jersey. Instructor: Jessica Perry.

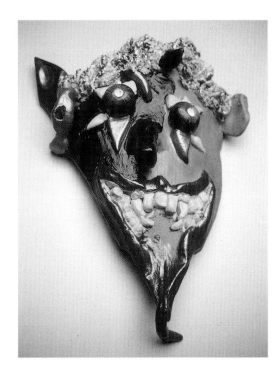

Fig. 2–66. Acrylic paint can be added to a clay work for more detailed color. Notice how the artist has broken down the parts of the face into distinct geometric forms.

Bobbi Jo Barney, *Mask*.

Clay and acrylic paint, 11" x 8" x 2½" (28 x 20.3 x 6.3 cm). Canyon View High School, Cedar City, Utah. Instructor: Jared Ward.

Writing about Art

Select three examples of sculptures done by students in this chapter. In two or three paragraphs, describe the work of these students in terms of the elements and principles of design. What feelings do you get from these pieces? Which do you think was done the most skillfully? The least skillfully? Why?

For Your Portfolio

Include a range of different types of art in your portfolio. Keep a written reflection about each assignment, including what message you were trying to convey, what you learned by creating the art, and why you decided to save this particular artwork. Over time, your portfolio will have much more meaning to you, your teachers, potential employers, and college admissions officers.

Key Terms

molding
mold
undercuts
release agent
alginate

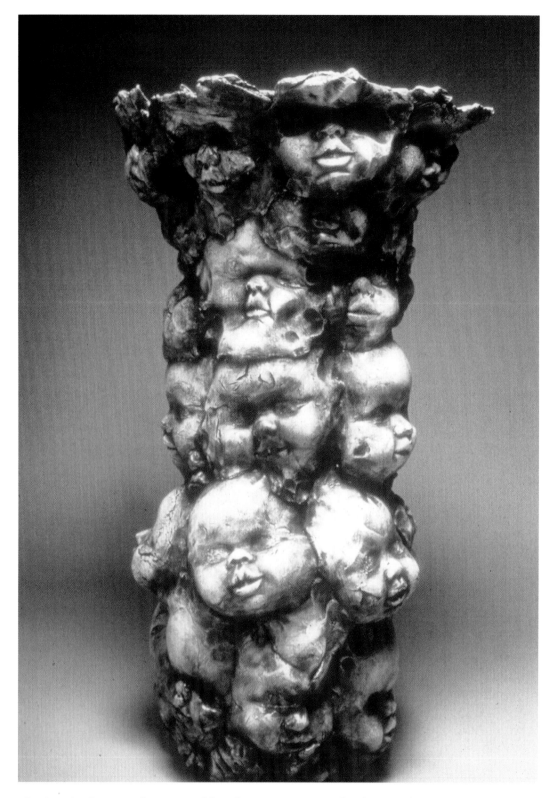

Fig. 3–1. Sculptors today use mold making to create works that are durable and long lasting. Shannon Calhoun's work demonstrates the use of press molds to create a complex form.

Shannon Calhoun, *Tree of Souls*, 1998.

White stoneware clay, 12" x 4" x 4" (30.5 x 10 x 10 cm).

3 Molding

As you learned in chapter two, artists find it useful to construct small-scale models before creating the final, large sculpture. For these small models, artists may choose a highly plastic material, such as wax, that is easy to work with, but it may also be impermanent. For example, would you create an outdoor sculpture out of wax? Probably not, for it would quickly deteriorate. You must choose a hard, durable material for your final sculpture, a material that can withstand time and the elements—in short, one that will endure while on display.

So how does the sculptor achieve a permanent artwork in materials such as bronze, resins, cements, and plasters? The answer is to create a mold. **Molding** is the process of securing an impression, and molds (hollow forms) provide the method for materials to take on and retain shape. In the casting process—which you will learn about in the next chapter—an artist duplicates a form using a material that is different from the one originally used for mold making. Artists have been making molds for centuries, from the small clay seals of ancient Sumer and India to the molded relief sculptures of the Assyrians. Sculptors today use mold making to create both large- and small-scale works in durable, lasting materials.

molds

In this chapter, you will study the differences between hard and flexible molds and discover how each is used. You will also learn what factors to consider when creating your own mold to ensure that it is successful. An introduction to molding the human body, coupled with the work of George Segal, will inspire you to explore the exciting technique of mold making.

mold design

life molding

Fig. 3–2. Officials used these early molded clay seals from Pakistan to stamp (or "sign") documents written on tablets of damp clay.
Four seals from Mohenjo Daro (Indus Valley culture) depicting a bull, a rhinoceros, an elephant, and a horned tiger, 3000–2000 BC.
Karachi Museum, Karachi, Pakistan. Photo courtesy Scala/ARS, New York.

Molds

A **mold** is a hollow, negative (reverse) form into which a malleable or liquid substance is pressed or poured. Molds are necessary to hold substances in a specific shape as they change from a liquid to a hardened form. You can create a mold from just about any material—wood, clay, stone; however, the mold must not stick

Fig. 3–3. The artist painted the surface to create a lifelike sculpture. How would you describe the mood of this piece?
Carole A. Feuerman, *Angelica*, 1994.
Cast and painted vinyl, 35" x 24" x 16" (88.9 x 61 x 40.6 cm).

to the final substance you choose to put into it. Molds may be flexible, using a material such as latex, or hard, including piece, waste, or press molds. Plaster is the primary material used for molds. Each type of mold has its own merits, and they often all achieve the same results. However, one method may be better suited for a particular purpose or casting material because of the ease of use or the product or techniques involved.

Today many sculptors make molds of heads, torsos, hands, and even the full human figure. With proper techniques and materials, such molding is not difficult to do. But before it can be done safely, molding needs to be thoroughly understood.

Hard Molds

Hard molds are usually made of plaster, although they can be made of other rigid materials including fiberglass, metal, epoxy, and even wood. They remain rigid as they are filled with casting substances. To maintain strong, rigid molds, the sculptor learns to divide the mold into removable pieces that either can be reused or are destroyed in the process.

Piece molds can be made of plaster or flexible materials. They are intended for repetitive use. The mold is divided into sections (pieces) designed for easy assemblage and removal from a cast object. While it is a reusable mold, it does leave seam lines between the pieces.

Waste molds are designed for onetime use. Once used, the mold is so disturbed or distorted in the process of dislodging the casting that it is not reusable—hence, "waste" mold. The original model is usually of a softer substance than the mold material. This allows the waste material to be placed about the original. The original is then dug out or removed in parts or pieces without affecting the mold, which is usually in one piece of plaster. A cavity is left. A harder substance is then poured into the cavity to harden (set up). The mold is then broken off. Sometimes the mold can be for a temporary onetime use,

Fig. 3–4. The clay head of this doll was carefully cast into a hard plaster mold using slip. Does the addition of clothing and jewelry affect your appreciation of this piece? Why or why not?
Pam Phillips, *Nizhonii* (Navajo for "Beautiful").
Cast porcelain, clothes, jewelry, wig, headband, 24" (61 cm) tall.

such as an impression in sand, a cardboard box, modeling clay, or ceramic clay.

Press molds, also known as *slump molds,* are made by placing the selected pliable material onto a predesigned or selected shape and pressing it onto the surface in order to achieve the intended shape. The mold itself can be an original design or found object. The press mold is reusable but limited to fewer castable materials. Ceramic clay slabs are commonly used for the casting material.

Hump molds, also known as *drape molds,* are useful when you will be working on the outside of your piece. For example, you might drape a slab of clay over a soft support in order to create a form for a mask.

Note It Some castable substances require specific molding materials in order to withstand heat, chemicals, or hard repetitive use. The sculptor must always be aware of the mold-material manufacturer's specifications and cautions.

Flexible Molds

Flexible mold materials include *latex, polyurethanes,* and *silicones*. A flexible mold is primarily used because of its easy removal from the cast object. Since the mold is flexible, it can stretch over a difficult shape, around a protrusion, or be literally "peeled" away from a surface. This allows more complicated, multifaceted art objects to serve as originals for casting. While all retain their shape by yielding, some are more resilient and easier to use than others.

Since latex is applied by brush in thin coats to air-dry, it takes longer to achieve a layer thick enough to hold a substance. Polyurethanes can be applied by brush or liquid volume. The material comes in two parts. Once mixed, it chemically hardens to form a permanent molding surface that can be repeatedly used. Silicone is much the same. It is more expensive, but generally does not require a separating agent.

Fig. 3–5. With new mold material and skill, a work like this can be reproduced exactly as the artist created it.
Morgan Watkins, *Untitled,* 2002.
Bronze, 7" x 11" x 41". Courtesy of the artist.

When using flexible molding materials, always consult the Material Data Sheet (MDS) that comes with the materials. Flexible molding products require good ventilation. Gloves and eye protection are also good precautions. A chemical respirator is not normally required, unless there is a ventilation problem. Never ingest materials or place them on bare skin. Follow all manufacturer's safety precautions.

Discuss It Can you identify mass-produced objects that have been made from molds? Coins and bottles are two such objects. How many more can you name?

Plaster

Not only is plaster used as a primary modeling, casting, carving, and construction material, but it is the chief molding material. Plaster must be understood before the sculptor can attain a successful mold.

Plaster (calcium sulfate) is found as a gypsum or as an alabaster. It is refined into a powder and heated to exacting standards as it is prepared for sculptural use. Setting plaster causes heat to build up. However, this is not a problem unless plaster is applied to the skin in multiple layers or in thicknesses exceeding one-half inch.

While several plasters are available, white molding plaster, casting plaster, and art plaster are recommended. The term "plaster of paris" applies to all

of these, but generally represents a construction plaster and, sometimes, art plaster in small quantities.

No. 1 molding plaster is readily available from building suppliers. It is a good modeling, mold-making plaster though somewhat porous. No. 1 casting plaster is excellent as a casting material. It dries with a hardened surface that is easily painted.

White art plaster is the purist white of all plasters. It is less porous than molding plaster but possesses a harder surface. It is not as hard as casting plaster. It is also the most expensive.

Mixing Plaster

Mixing plaster is easy in small batches. The amount of water in the mix determines the setting time and strength. Approximately 3 minutes of mixing will create a strong mix with a good working time of 5 to 30 minutes, depending on the amount of water used and the humidity. Less water creates a stronger mix but greatly reduces the working time. Too much water not only weakens the plaster but can make it virtually unusable. Cold water retards the setting time, while hot water definitely speeds up the curing process. However, the hot-water mixture allows only a little time to hand work the plaster. Always *sift,* or mix, the *plaster into the water.* Never add water to plaster because it will greatly weaken it. The mixture must be thoroughly blended; avoid getting rapid gulps of air into the mix. Adding premeasured plaster to water may be desirable, but it is seldom practiced because very few tasks require a known volume.

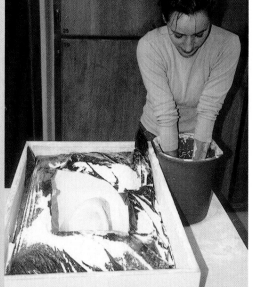

Fig. 3–6. Student Janice Pearson is mixing plaster. The height of the table is designed to allow a student to reach down into the mixing bucket easily. Notice the box containing the plaster.

Wear a dust mask when working with plaster. Work in an area with good ventilation. Some may prefer a tight-fitting rubber or latex glove if prolonged exposure to liquid plaster is necessary, since it can dry out the skin. However, a good hand lotion can soften the skin after plaster mixing.

Mix Plaster

Supplies you will need to mix plaster include a plastic container (bucket), rubber gloves (if sustained mixing is necessary), and a respirator if good ventilation is not possible.

1 Fill the bucket about one-third full with room-temperature water. Then quickly sift the plaster through your fingers over the water. Always sift swiftly in order to avoid a prolonged setting time. Do not "dump" the plaster into the bucket. The plaster cannot absorb the water.

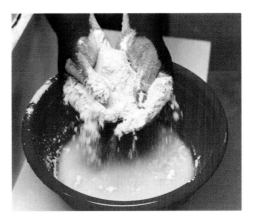

Sift the plaster through your fingers.

2 The plaster will gradually begin to sink as it is incorporated into the water. Let it sink, then slowly add more plaster until it does not sink on its own. After that, do not add any more plaster.

The plaster is absorbed into the water.

3 Let the plaster soak for about 2 minutes. Then mix the plaster and water with your hands for about 3 minutes until it is smooth and there are no lumps. It should be squeezed between the fingers as necessary.

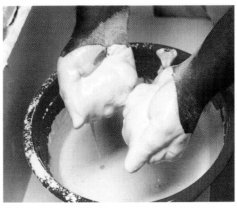

Squeeze out any lumps.

Note It Testing for thickness: If the plaster can coat your hand with *no* hint of the skin showing through, it is good. If it is too thin, it will set slowly and be a weak mix. If it is too thick, it will harden too quickly, sometimes even before it can be used. Plaster must be added until the correct "creamy" (not "milky") mix is achieved.

Stages of Plaster

Mixed plaster appears in six distinctive stages. Each stage involves a different working approach.

- The liquid stage occurs immediately after mixing plaster. The liquid stage lasts from 5 to 20 minutes (depending on the mix). Plaster in the liquid stage can be poured, brushed, thrown, and dripped.
- The putty stage is a thicker mix appearing like whipped cream. For only a very brief time, the mix can be troweled and scooped with a spatula or putty knife into a quickly modeled shape.
- The rigid stage occurs after the mixture has begun to slightly set. The plaster can be trimmed, even cut, but it is easily broken in this frail stage.
- The set stage demonstrates a heat buildup as the plaster hardens. For a brief time, the plaster can be worked with Surform or plaster rasps as it hardens.
- The cure stage begins once the plaster has set and lasts until it is completely dry. During this time, hard metal tools are required to work the plaster. Open-mesh metal screen wire will smooth the surface, though the screen will clog if it is not constantly shaken, flexed, or cleaned with a steel brush.
- The dry stage is just that: dry. The plaster is brittle but strong. It can now be smoothed with sandpapers or painted.

Try It Take a small amount of plaster, about a spoonful, and mix it with water on a plastic sheet. Notice the thickness as you add plaster, how much plaster you can add, the workability of the plaster, the heat generated as it sets up, and how rigid it becomes.

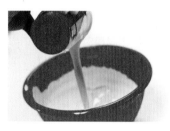
Liquid stage.

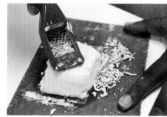
Set stage.

Putty stage.

Cure stage.

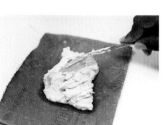
Rigid stage.

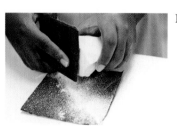
Dry stage.

Note It Cleanup is easy, if precautions have been taken prior to beginning the work. Newspapers or a plastic sheet on a tabletop almost eliminates cleanup work. Surfaces can be scraped with a putty knife and wet spots can be eliminated with paper towels. Never wash hands, tools, or containers in a sink; rather, wash them in a bucket of water. When plaster settles in the bucket, pour the clear top water off and scoop out the plaster into a lined trash container. Never pour plaster down the sink. Plaster can, and will, set up underwater, whether in a bucket or a drainpipe.

Tools are selected for specific uses when working with plaster. Putty knives, paint-stirring paddles, plaster spatulas, and common table knives are the most useful tools for stirring and application. Rasps, files, window screen, and sandpapers are the best abrasive tools.

Mold Design

Molds can be quite simple, since even a plastic drinking cup can serve as a mold. However, when the mold is to hold unique shapes for specific purposes, several other factors have to be considered. The following are the chief concerns:

• A *draft*, or mold taper, enables the mold to be released from the casting. This allows for plaster expansion as it hardens and avoids mold breakage. Plan your taper mold angles to avoid tight-fitting parts within the mold. Divide the mold into parts that will allow easier removal.

• **Undercuts,** or protrusions, obstruct the removal of the mold. The division of molds is required in order to avoid undercuts. The easiest way to eliminate undercuts is to view the model from one vantage point and draw a line around the silhouette edge. This line becomes the parting line. To ensure the line is correct, the model should be turned around and viewed from the reverse side. If the silhouette line is the same, then there should be no undercuts. If the line is

Value

Value refers to the lightness or darkness of a color. Each color has a range of values from light to dark tones. Your eye perceives three-dimensional forms by seeing highlights and shadows. Light values are seen as highlights, and dark values as shadows. Since highlights and shadows are created by light, sculptors must think about the light source and how it will affect the way the viewer sees the sculpture. They must also think about the color of the sculpture itself. White and light-colored objects show shadows best and therefore can be a good choice for sculpture.

Fig. 3–7. Value is the range of light and dark seen in an artwork.
Richard E. Prince, *Venus and Mars*, 1998.
Wood, plaster, paint, 36" x 24½" x 7" (91.4 x 62 x 17.7 cm).

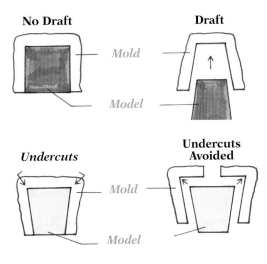

different, then adjustments need to be made as the process is repeated. Sometimes, additional mold sections are required if an undercut cannot be eliminated.

• The *parting line* is the dividing line required to eliminate undercuts. The parting line should allow easy draft with as few pieces as possible.

Parting Line Properly Located

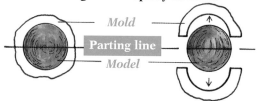

Parting Line Improperly Located

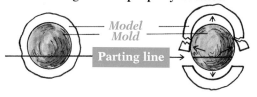

• *Shims*, or dividing walls, are placed at the parting line to serve as a fence (wall) in order to ensure that the mold pieces remain separate during the molding process. Shims are made from thin strips, usually metal, and inserted into the surface of the model directly in the parting line just far enough to remain during the process. Clay dividing walls are placed on one side of the parting line of hard surfaces for the same purpose.

• *Keys* are a matching set of three-dimensional marks made in the mold seam or wall. They are usually V-shaped grooves in shims. In soft dividing walls, they are often half-round dimensions. After the mold is finished, the matching keys readily line up. This enables an easy registration process for the individual mold pieces while ensuring that the mold fits tightly together.

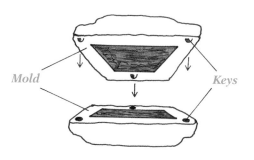

• A *pouring duct*, or opening, needs to be left in the mold if it is to be filled with a liquid. With many molds, this is the open bottom and nothing else needs to be done.

Incorrectly located pouring duct traps casting **Pouring duct split to allow removal of casting**

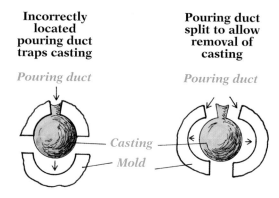

• *Mold bindings* of bungee cords, straps, rubber bands, and so on, are placed about the mold pieces to temporarily fasten them securely together into one unit.

Mold Bindings

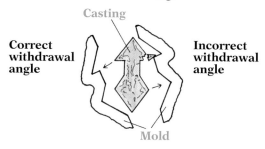

• The *withdrawal angle* is the direction of the mold as it is removed from the casting. If improperly removed, the casting could be broken.

Bound Mold Ready to Pour

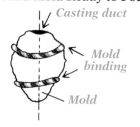

• The **release agent,** or separator, is placed on the inside surface of the mold to keep the casting from adhering. Petroleum jelly is commonly used as a release agent for plaster.

Note It Release agents can be many different things, from motor oil to waxes, silicone sprays to water. It all depends on the use of the mold. Oily or waxy surfaces will keep plaster from adhering to plaster, just as water-soaked molds will prevent wax from sticking to a plaster mold. Silicone sprays are good on a hard, nonabsorbent object.

Hard Piece Molds

Hard or rigid plaster piece molds consist of two or more pieces. This allows access to a model with undercuts. Throughout history, plaster piece molds have been used to create extremely large works like equestrian statues. However, with the increased use of flexible molds, today's hard piece molds are seldom large or as complicated.

• Using an apple as a model, the artwork (apple) is prepared for the mold. If the work does not provide a base for an opening, then a location for a pouring duct is determined. Withdrawal angles are calculated. Parting lines are located to split the mold in ways to eliminate undercuts.

• Locate and place a pouring duct.

• If the model is soft, such as modeling clay, metal shims can be inserted directly into the mold parting line. Remember to add keys and a pouring duct. A release agent is added. Since the shim material is so thin, plaster can be added to both sides with each plaster mix. If the mold is large, burlap or hemp can be included in the second coat of plaster.

• "Flick" the plaster onto the model for the face (first) coat. After it has firmed up, immediately add more plaster. When possible, apply plaster from the bottom up, being careful not to overload shims or create a plaster weight overbalance resulting in a collapsed shim or overturned model. Afterward, a putty knife can smooth out the thickened surface mix.

• Let the mold harden past the set stage and cool, then remove the model.

Fig. 3–8. Placing shims.

Fig. 3–9. Making keys.

Fig. 3–10. Adding release agent.

Fig. 3–11. Flicking plaster.

Fig. 3–12. Final mold.

Fig. 3–13. Removing model.

Molding **63**

• To finish with a plaster casting, add a liberal amount of petroleum jelly for a release agent. Bind the mold back together. A bungee cord works nicely. Place the mold upright.

• A casting can be completed by pouring the plaster. After the heat cycle is complete and the mold has cooled down, the mold can be opened.

• Remove the mold by gentle prizing with a wooden prize bar along all the edges. The mold is now cleaned. The release agent is cleared. If the mold is subsequently to be used for clay or wax, then all traces of release agent must be removed.

Discuss It The traditional technique for applying plaster to a model is the throwing method, or to flick it from the hand by the use of finger and wrist action. When done properly, every detail can be completely covered in a systematic manner. Some prefer to dip a soft-bristle brush into plaster and flick it from the brush, while others have learned to use a brush to "paint" on the first layer. Which will be the best method for you? Why would one work better than another?

Note It The artwork and molding material will often form a tight surface. The resulting "vacuum" must be broken by allowing air between the two surfaces. This vacuum is strong. It grips the mold so tightly that the mold can be broken during removal if it's not carefully handled.

If the model has a hard wall that is not easily penetrated or should not be damaged, clay wall "shims" are used. The thin clay wall is placed touching the model on one *side* of the mold parting line. Remember to add keys. A release agent is added to the opposite side (side without clay wall). Plaster is applied by first brushing, then throwing, or by a combination technique. Afterward, it is patted on to achieve the desired thickness. A putty knife is a good tool to use. If the mold is a large mold, burlap or hemp is included in

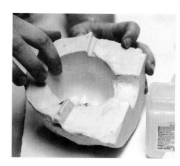

Fig. 3–14. Applying release agent.

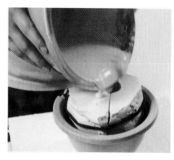

Fig. 3–15. Pouring plaster.

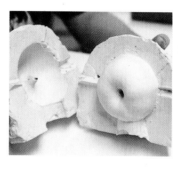

Fig. 3–16. Opening mold.

the second coat. After this side has dried, the clay wall is removed, and a release agent is applied to the newly exposed seam. The mold is half done. Situate the work where the unfinished side can be finished. Add release agent and plaster in the same manner as was done to the opposite side.

Discuss It For easiest cleanup, prepare the working space prior to applying plaster. Strategically place plastic wrap and newspapers. Clean up the surrounding mold base areas between layers. Keep tools clean. Can you think of other ways to save on cleanup time?

Flexible Molds

Flexible molds allow more complicated shapes to be cast with fewer problems than with traditional plaster piece molds.

The selection of mold materials, such as latex, polyurethanes, or silicones, is based on cost, ease, and use. Most are two-part mixtures that mix by volume, one part equal to another, or by measured weight. Follow the manufacturer's instructions.

There are two basic methods of applying flexible material. One is to pour it over the model, submerging it in a prepared container. The other is to brush it onto the model surface. The brush-on method is the more frequently used one, since it can be used on larger models.

Brush-On

The model is prepared for brush-on just as the plaster two-piece mold is with shims or clay. The mold release agent is determined by the selected mold-material manufacturer's requirements.

• The mold material is prepared by proportioning and mixing according to the manufacturer's recommendations. It is then brushed onto the model. The surface, or face, coat is carefully applied.

• Once the face coat is tacky or hard (following the manufacturer's instructions), the second, and usually top, coat is applied. This is done with a brush or spatula. This coat is a thickened mixture, with thickeners supplied by the mold company.

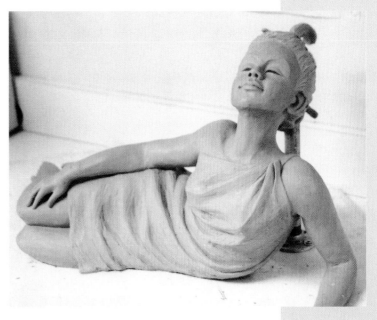

Fig. 3–17. A modeled clay sculpture by BaBa Scaturro is on a pipe armature ready for adding mold material.

• A thickened wall is placed along a proposed parting line. Shims with keys are inserted. The flexible material is allowed to cure. This takes from 12 to 24 hours, depending on the material.

• Do not remove the flexible mold until a plaster mother mold is added. A mother mold is a strong, rigid mold that surrounds the softer, more flexible mold. Without it, the flexible mold might collapse or deform during the casting

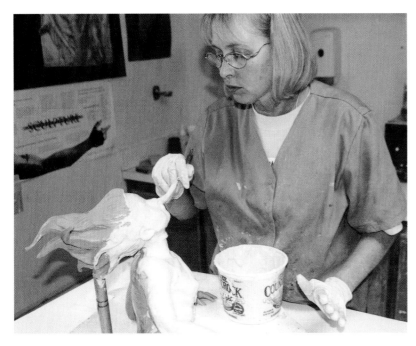

Fig. 3–18. BaBa Scaturro applies the first coat of a brush-on mold material onto her sculpture.

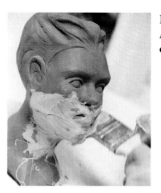

Fig. 3–19. Applying brush-on.

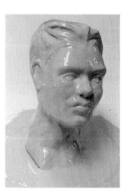

Fig. 3–20. Completing first layer.

Fig. 3–21. Completing final layer.

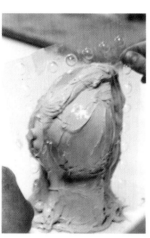

Fig. 3–22. Adding shims.

Fig. 3–23. Applying mother mold.

Fig. 3–24. Final mold.

process. Since it is the flexible mold that retains the model's details and undercuts, the mother mold is easily removed from the flexible mold after casting. Make a point of applying the correct release agent prior to adding plaster. Apply plaster for this mold in the same way that you would for a regular plaster mold. Do not disturb the original flexible mold until the mother mold has hardened.

• The last step is to remove the mother mold. The shims are removed and the parting line is cut or leveled down to the model. After that, the flexible mold can be removed by peeling it back in much the same way as removing rubber gloves.

Note It The brushes used for molding compounds are "throwaway" ones. They cannot be reused once the mold material has hardened. Inexpensive bristle brushes about 1–2 inches in width are best.

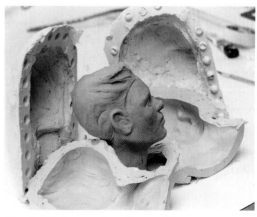

Fig. 3–25. Cutting open parting line.

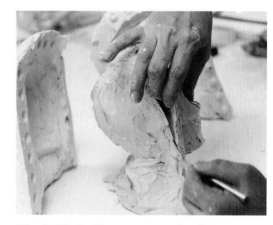

Fig. 3–26. Removing the mold.

Pour-On

The pour-on method is primarily used on small works, especially heavily undercut models. The model needs to be placed securely in a container. Although the mold made on small models can be cut out afterward with a sharp knife, the model is usually equally divided with a clay wall on one side. (Remember to make keys.) The top side has the proper release agent applied. The flexible material is poured on. After curing, the clay is removed. (The mold material is not disturbed.) The exposed model side and the mold-material seams are prepared with release agent. The pour-on is added and allowed to set. If the mold is solid enough, a plaster mother mold is not needed. Excessive pour-on makes this molding process extremely expensive.

Press Mold

This type of mold is usually used for ceramic purposes. The mold can be a plaster or found-object shape prepared for a ceramic clay surface. It is of utmost importance to eliminate undercuts and to use a release agent in keeping with the casting material. No release agent is required for ceramic clay, although a finely powdered talc may be applied to a completely dry mold surface. The mold surface can also be draped with a plastic wrap prior to adding the clay for shape. A slab of evenly rolled clay is pressed firmly into the mold in **Fig. 3–27.** What is

Fig. 3–27. Lifting ceramic clay off a concave hump mold.

Balance

Sculptors strive to create balanced artworks so that all of the parts have equal visual weight and the structure itself is stable. Balance may be symmetrical (both sides are the same or very similar), asymmetrical (the two sides are different), or radial (the parts radiate from a central point). Works that are symmetrically balanced appear calm, peaceful, and formal. Why is symmetrical balance a good choice for the subject matter of the work shown in **Fig. 3–28?** Asymmetrically balanced works have a feeling of dynamism and movement. Remember that when you are trying to achieve asymmetrical balance in a sculpture, all the parts should have equal visual weight or interest. For example, a large, dark form may be balanced by a group of small, brighter ones. Such planning will create a successfully balanced sculpture.

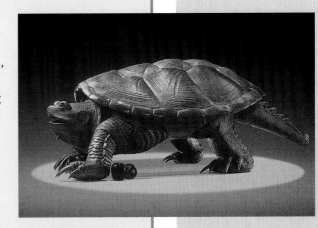

Fig. 3–28. Examples of symmetrical balance can be found in nature, which was the inspiration for this piece by André Harvey. What other examples of symmetrical balance in nature can you think of?
André Harvey, *The Apple Thief.*
Cast bronze, 6' x 39" x 25" (183 x 99 x 63.5 cm).

difficult is removing the clay without tearing the surface. Some drying needs to be done but is limited to the necessary workability required of the clay once it is removed. Too much drying results in a cracking of the casting.

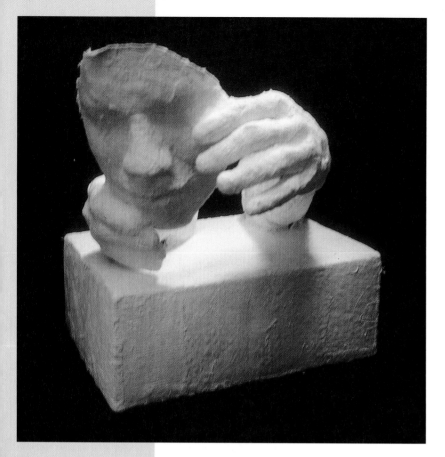

Fig. 3–29. There are many ways of using plaster casts of human forms. This student used the plaster cast of his face and hands as his final piece. Other artists prefer to use casts as an accent or starting point.

Juan Vera, *My Other Self,* 1999.

Plaster gauze, life-size. Corrigan Camden High School, Corrigan, Texas. Instructor: Jann Jeffrey.

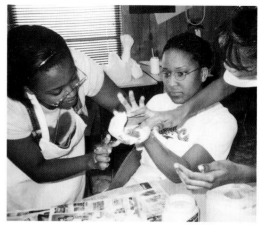

Fig. 3–30. Quita Reagle and Goddess Freeman apply plaster gauze to Anisha McCord's hand.

Corrigan Camden High School, Corrigan, Texas. Instructor: Jann Jeffrey.

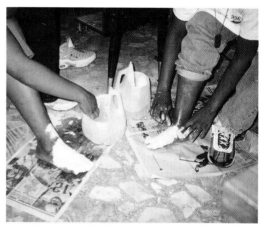

Fig. 3–31. Anisha and Quita apply plaster gauze to their own feet.

Corrigan Camden High School, Corrigan, Texas. Instructor: Jann Jeffrey.

Life Molding

Creating a mold from a live model is often a possibility. However, extreme care must be taken to protect the model. The work should be supervised by mold makers experienced in the type of material being used.

Safety Note Never attempt to do molds of the human form without at least two workers and a teacher present. Since the model is in a temporarily helpless state, often in darkness, he or she should never be left alone. You should communicate with the model often. With two workers, one can always be present to reassure the model or to secure special needs, if necessary.

There are three main materials for molding directly from the human form. These are plaster-impregnated surgical gauze, alginate, and liquid plaster.

Plaster gauze is one of the easiest methods of molding, especially from human body parts. The major thing to remember is to apply a heavy release agent (petroleum jelly) and provide an escape route for the model. The bandages harden quickly, usually within 10–15 minutes, and can be removed as they are still hardening.

Alginate is an expensive material used in small quantities by dentists for tooth impressions. In sculpture it is used when

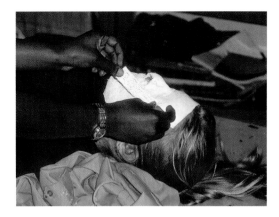

Fig. 3–32. Student Chauntee Aikeen makes a plaster-gauze mask.

Wakefield High School, Arlington, Virginia. Instructor: Wendy Singer.

the finest detail is needed. Usually, this is a face or head, hands or feet. Alginate is not toxic and is safe and quick to use. Although it is reasonably easy to apply, it must be done quickly. The resulting mold must be used within a few hours, or the alginate will lose its flexible quality and resistance to sticking.

Liquid plaster is the most available material but requires more preparation in order to avoid "entrapping" or burning the model. It is the least expensive method of body molding, although it requires the longest setting time and requires more cleanup. The major benefit

is that it produces a rigid, reusable mold of high accuracy and detail.

Plaster gauze can be found in medical supply houses, at hobby stores, or at professional mold suppliers. The widths vary, but 4-inch-wide rolls are common. A small amount of salt added to the warm water can shorten the curing time. The gauze should be cut in measured strips and placed in pairs so that two strips can be dampened at the same time.

The gauze is held by each end and quickly pulled through the water. The strips can be blotted between paper towels immediately for an even quicker hardening time. They are applied directly onto the release-agent-coated skin or object. The artist can press the shape and smooth the surface to conform to the model. Removal is quick and painless. Afterward, the mold should be allowed to continue to harden.

One way to body-mold without a living model is to use a mannequin. The process is the same, and the model stays still!

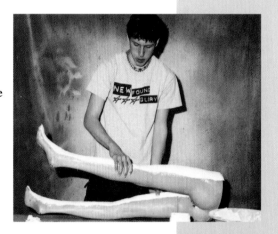

Fig. 3–35. Student Torre Finley applies plaster gauze over a mannequin's leg. Notice the parting line made by the bandage.

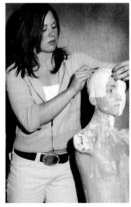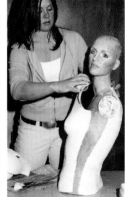

Fig. 3–33. Student Lyndsay Duncan applies plaster gauze over the head of a mannequin.

Fig. 3–34. Lyndsay removes a "body cast" from the mannequin torso.

White Hall High School, White Hall, Arkansas. Instructor: Chris Ellison.

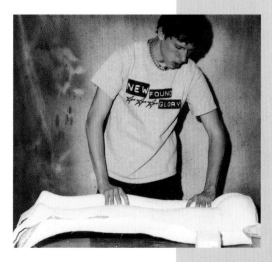

Fig. 3–36. He removes the plaster gauze from the leg. Notice where the mold separates on the parting line.

White Hall High School, White Hall, Arkansas. Instructor: Chris Ellison.

Use Surgical Gauze for Life Molding

Plaster-impregnated gauze has been used for body casts for many years. It is literally the casting wrap that medical doctors use for creating casts around broken bones. It is easy to use, not toxic, and hardens at a rapid rate.

Get all of the materials and the model ready. While plaster can be used to reinforce the mold, plaster-impregnated gauze is best. If gauze is used, you will need to precut the bandages in workable pairs of predetermined lengths. Rolls of gauze come in different widths. For the best beginning details, gauze 4–6 inches wide is best. Quick curing times are preferred for the model. This is to save time during application. The example we use here is arm casting.

Fig. 3–37. Applying release agent.

Fig. 3–38. Mixing and applying alginate.

Fig. 3–39. Alginate setting up.

• The release agent for the skin is crucial if the area has lots of hair. Most materials, especially plasters, require a thick release agent, such as petroleum jelly, that does not saturate the human form or run off. If special mold material is being used, consult the manufacturer's guidelines first as to safety and recommended release agent.

• Mix the alginate according to the manufacturer's suggestions. A power mixer is best, since the mixing must be quick and thorough within a 30-second period. This allows about 4–6 minutes of working time for the product.

• The alginate is so thick that it must be directly applied by hand or spatulas in "gobs." Quickly build up the hand, catching the runoff and reapplying it. Make the layer as even as possible. Alginate almost "snap sets," or sets without warning. Alginate will not adhere to itself after setting, so a second coat is futile.

• The water used for the gauze should be slightly warmer than room temper-

ature. It can have some table salt added as a catalyst in order to shorten the plaster gauze's setting time.

• The gauze should be quickly dipped into a shallow bowl of water and then pressed between sheets of newspaper to blot (remove) some of the moisture. Then it must be applied quickly.

• Immediately apply plaster gauze on the arm to create a strong, rigid mother mold along parting lines. Dip the bandages according to the manufacturer's instructions, usually for about 3 seconds. Avoid excess water.

• Check that the bandages are pressed flat on the arm. Fold the edges to make a

Fig. 3–40. Applying plaster gauze.

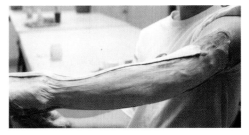

Fig. 3–41. Applying second half of mold.

Fig. 3–42. Removing mold.

Fig. 3–43. Removing alginate.

Fig. 3–44. Adding release agent.

more uniform parting line for the first half of the mold. It should also cover the alginate mold form.

- After the plaster gauze firms, apply a release agent along the edge where the second half of the mold will overlap. Clay slip is ideal as a release agent for plaster gauze.

- Apply the second mold section, overlapping the edge of the first section.

- Once the mold is complete, it is easily removed by gently prizing the edges with a putty knife. Remove the plaster gauze first.

- Slowly pull the hand out of the alginate mold. Normally, the alginate will not split.

- The molded alginate must be used in a matter of hours, or it will harden and become too stiff to be useful. Normally, a plaster casting is immediately made from it. (The plaster serves as a model for a more permanent flexible mold for other uses.) Place petroleum jelly on the inner surface of the bandage in preparation for the plaster. Do not place the release agent on the alginate mold.

- Pour in some plaster and slush it about to thoroughly coat the surface of the bandage and alginate. Watch for trapped air. Finish filling and then allow the plaster to set.

- Remove the gauze. The alginate is then peeled with ease and broken off, being removed as a waste mold.

- Using the same basic method, heads and feet can easily be cast using alginate.

Fig. 3–45. Slushing completed mold.

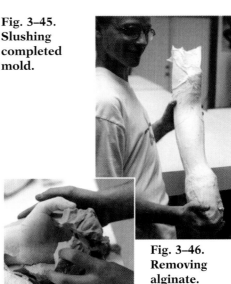

Fig. 3–46. Removing alginate.

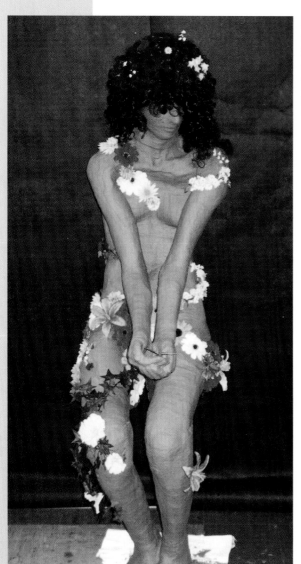

Fig. 3–47. As the final stage in her process of life molding, student Deborah Schoelwer painted the body molding flesh color and decorated her piece with flowers and a wig.

Deborah Schoelwer, *Earth Girl*.

Plaster gauze, 16" x 21" x 56" (40.6 x 53.3 x 142 cm). Wakefield High School, Arlington, Virginia. Instructor: Wendy Singer.

Body Molding

Using liquid plaster to mold live human body parts requires a lot of planning and a model who can withstand a warm coating on body parts. The result offers more detail than the plaster-gauze method.

Safety Note *Never* attempt to create a mold from a live model unless there are at least two workers available, one of whom has had experience working with plaster. If plaster is applied incorrectly, the model can be trapped, burned, or even suffocated!

Prepare the materials and model. The plaster needs to be at hand, the mixing container nearby, and cleanup paper towels handy. The model must be good-natured and not claustrophobic. He or she must trust the applicator and know that an assistant will be present at all times to comfort and help when needed.

- Select a flat cardboard sheet large enough to allow about 10 inches in every direction about the model's face. Draw and cut out an opening the same size and shape as the face. The model needs to be lying on a table at a comfortable working height, preferably with a firm pillow or pad for comfort (see **Fig. 3–53**). If a shower cap is not available, a plastic wrap can cover the hair with a masking-tape band on the forehead edge for strength. Place the cardboard around the

Note It Alginate definitely produces an excellent casting, though its purpose is to make a onetime positive (hard casting), since it cannot be reused. (A positive is the product from a mold; the mold itself is the negative.) Professional sculptors usually work with the positive and remold it with a molding material more suited to the project or for an edition number.

Safety Note No hairy part of the body should be molded without a protective covering of plastic cloth or other nonporous material prior to bandaging. Never cover open eyes, mouth, or nose. Do not encase fingers or other body parts where the bandage cannot be safely removed by simply lifting it off or cutting it loose.

Fig. 3–48. Model's face situated.

George Segal

After George Segal (1924–2000) graduated from New York University's School of Education with a teaching degree in 1949, he purchased a chicken farm to make a living. It did not work out, so he began teaching English and art in a local high school. Later, he converted the chicken house into his studio.

In 1959 he displayed his first rather crude plaster "globbed" figures on a wire and wood armature as part of an exhibit. They were a continuation, or extension, of the ideas he presented on the flat canvas. In time he would abandon painting in favor of his newfound plaster figures.

He rapidly improved with his work in plaster. In 1961 he exhibited his first plaster-gauze-soaked bandaged figure using a table as a prop with the appropriate title *Man Sitting at a Table*. He had begun his trademark human figures wrapped in bandages. All early forms were displayed in stark white plaster gauze caught up in everyday life with the immediate props included. Although he occasionally made a relief, he always went back to the full figure.

As time went on he began some polychrome figures; they, too, were usually in a stark, single color that was in direct contrast to the background.

His work used a simple technique, one that had been overlooked by others as a "finished" product. With the plaster-gauze bandage, he could display a desolate form, a figure forever frozen and trapped in time. The exact images or personalities were not important, just the pose or art of life was. He considered each setting a private drama that he chose to make public. He perfected and refined the

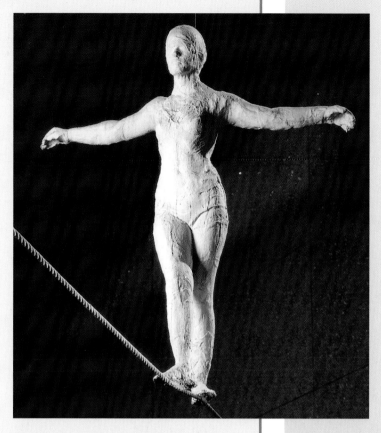

Fig. 3–49. In this composition, what mood does Segal create?
George Segal, *The Tightrope Walker*, 1969.
Plaster and rope, 65" x 60" x 204" (165.1 x 152.4 x 518.2 cm). Carnegie Museum of Art, Pittsburgh; Fellows Fund and National Endowment for the Arts.

technique but never to the point of finished realism. He once said, "I love to deal with abstraction. I love to probe and examine, but I feel that it has to be rooted in reality."

Back when Segal tried to operate a chicken farm, he grew to hate it, but the facility became a great place to work. His converted-chicken-house studio was perfectly suited for his plaster work. Well-known people did not hesitate to allow Segal to drape plaster gauze on them and wrap it about them as they intently posed during a three-hour session.

face with strong, rigid supports (perhaps books) beneath the cardboard for it to rest on and hold the weight of the plaster. Seal between the cardboard and the face with soft clay in order to avoid leaks. (It is best if the model's neck and torso are covered with cloth or plastic.)

• Use petroleum jelly or another release agent. Apply it liberally, including the surrounding cardboard. All facial hair, including eyebrows, eyelashes, and sideburns, must be thoroughly coated with petroleum jelly with all hair pressed tightly to the skin. *Gently* place two soda straws in the nostrils.

• Mix the entire batch of plaster at one time. A large paint bucket with about one-third of the container filled with water ready for plaster should do. Use room-temperature or warm water without additives. (It needs to be comfortable to the model.) The mix should be normal, *never thin*. Apply the plaster to the edges of the face first, then move inward.

• The eyes are done next to last, the last item being the nostril holes with stiff, not runny, plaster. Try to keep the mold thin, never more than 1-inch thick on the face. Too much will cause the face to be pressed down, distorting it. Less plaster is much more comfortable, with less weight and heat.

• The plaster will go into the set stage, but once firm, it should be removed while warm. Be careful with the withdrawal angle. *Remove the straws first!* Then tilt the mold toward the chin and slowly remove it. This avoids nose and chin undercuts.

• Immediately provide the model with paper towels and water; help him or her remove the residue.

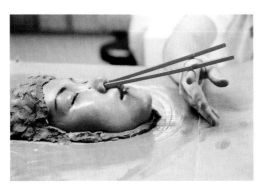

Fig. 3–50. Release agent added.

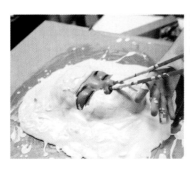

Fig. 3–51. Plaster is added.

Fig. 3–52. Plaster cast completed.

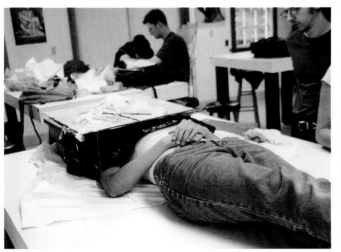

Fig. 3–53. Straws removed.

Note It While hair can be saturated with petroleum jelly and pressed flat, the model may prefer a shower cap. In face casting, you need to insert soda straws into air-breathing passages; these will be removed prior to mold withdrawal. Clothes will need to be covered, preferably with plastic garbage bags.

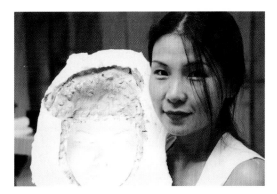

Fig. 3–54. Model with mold.

• The final mold is a duplicate of the model, clay rim, and flat surface. It can easily be trimmed.

• The mold can be used for many kinds of casting materials including clay slips, clay slab press molds, and casting wax. The details are good, but the eyes are closed. Notice the wax casting alongside the model in **Fig. 3–55.**

Safety Note Plaster heats up as it sets. Never cast a layer on a human model that will exceed 1 inch because the thicker the casting, the more the heat. The model should not stay in the mold a second longer than necessary in order to avoid burns. The artist needs to be experienced enough to do the molding with only one layer of plaster and to remove the mold at the earliest possible time.

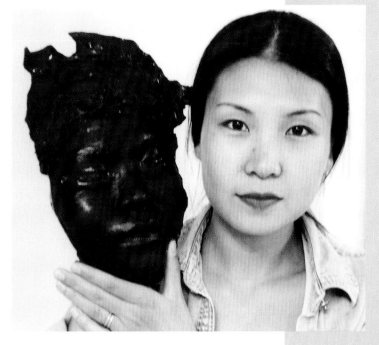

Fig. 3–55. Model with wax casting.

Discuss It Why is it a good idea to make body moldings? What are some of the problems with doing such a molding? What do you see as the most difficult aspect of serving as a live model? Would you do it? Why or why not?

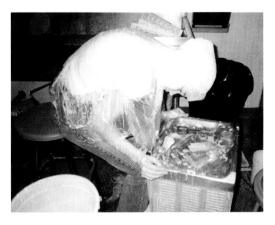

Fig. 3–56. Model is covered in plastic wrap as plaster-impregnated gauze is applied.

Fig. 3–57. Model Piper Tobias poses with the finished life-size plaster sculpture.
Matt Straka, *Piper at the Fountain*, 2000.

Plaster-impregnated gauze, life-size. Manchester High School, Manchester, Indiana. Instructor: Debra Schuh.

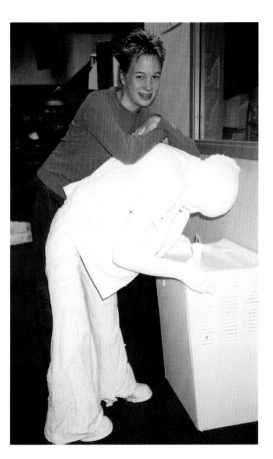

Rodin's Hands
by Art Sherwyn

Before You Begin

• Study different hand gestures; hands that are lively, hands at rest, hands that celebrate, hands of pain, hands of a composer, hands of a boxer, etc. Using your own hand as a model, sketch a variety of different hand positions and gestures.

• Select a hand position that best represents you for your sculpture. You can use only one side of the hand: the back side or the palm. Draw your proposed hand.

You will need:
• pencil and sketch paper
• newspaper to cover the tables
• warm water in a shallow container
• petroleum jelly
• scissors
• a sheet of plastercraft
• acrylic paints
• paintbrushes

Create It

The Individual Hand

1 Precut strips of plastercraft for the fingers and some square pieces for the large parts of the hand. Individually dip the plaster strips in water and place them on the hand with the thicker side of the plastercraft up. Rub the plaster into the hand until it is fairly smooth, yet do not over-rub. Place the plastercraft on the hand with the thick side up; it gives you more plaster to blend. Your hand should be completely covered with petroleum jelly prior to applying the plastercraft; this serves as a release agent and aids in easier removal of the cast.

2 Working with a partner, take turns plastering each other's hand; one partner per class period. Start putting some of the finger pieces on. Make sure you plaster over the fingertips about 1 inch. Enclose about 3/4 of each finger leaving a space

on the back so that the hand will be able to slide out.

3 Continue to place plaster strips on the fingers and the large part of the hand. Make sure there are at least three to four layers of plastercraft on the entire hand. The perimeter of the hand must be well reinforced when the plaster is pulled off.

4 When the plaster is completely hard, gently loosen each finger, releasing it from its bonds. After the fingers are released, grab the plaster hand from a strong point near the wrist, and slowly slide the finger cast off. The student in the cast must try to keep his or her fingers still and rigid as the case is pulled off.

5 After both partner's hands are complete, each student is to return to their individual hand and trim the rough edges with a pair of scissors. Using smaller pieces of plastercraft, reinforce any weak areas, or joints, and place another layer around the perimeter of the entire hand.

Stacking the Hands

1 (You will need at least three large tables. You might want to reserve the library for this day.) Start with the "mingle." You and your fellow students walk around positioning your hand with one other student's hand, rotating them and talking about the different levels of communication they portray. Continue to rotate to other students and do the same.

2 Divide yourselves into three large groups. If you are a class of thirty, you will be in groups of 10 students each. Each group should have their own table for stacking their sculpture. Sculpture oftentimes reflects the time period that it was made in.

You are going to take these hands on a trip through history. Stack your hands to reflect the following time periods: the roaring twenties, the depression,

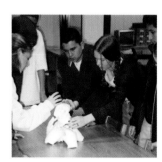

Fig. 3–58. Start with small stacks of two and three hands.

World War II, the 1960s, and the technology age.

3 You will now take a turn at painting your hand with acrylic paints. Add color and design to your hand to reflect yourself and your personality.

Fig. 3–59. Stack all the hands one by one, keeping the foundation stable.

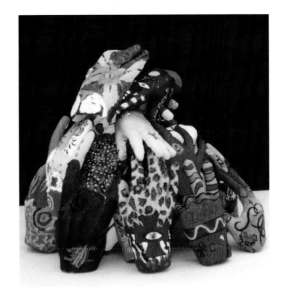
Fig. 3–60. The final composition.

4 Now as a whole class, stack all your hands one at a time as high as you can stack them, but make sure the foundation is strong enough to make the stack secure. Walk around the sculpture and take note of what types of messages it communicates to you.

Check It Has the sculpture been improved by adding color and design? Is it as effective as the unpainted sculpture? Which has the stronger impact?

Sketchbook Connection
Can you think of other ways in which you could use these techniques again? What other themes would lend themselves to this type of group sculpture. Think of other shapes and forms that could be used successfully. Sketch ideas for some ways you might utilize them in another sculpture.

Rubric: Studio Assessment

	4	3	2	1
Expressive Quality • Pose • Expression of feeling or concept	Hand pose interesting and clearly expresses chosen emotion, feeling, or concept. Dramatic or nuanced	Hand pose sufficiently suggests chosen or related emotion, feeling, or concept. Communicates idea	Hand pose somewhat expressive; needs livelier pose to communicate a particular feeling or concept. Indecisive or hesitant	Hand at rest or flat-palmed with splayed fingers—some as child's outline of a hand. Low-risk or lack of effort
Teamwork • Safety rules • Follows directions • Technical construction • Willingness to help	Followed safety rules without mishap; used triple-layer construction and covered only half of partner's hand; worked smoothly and efficiently with partner throughout process. Competent, helpful, prepared	Followed safety rules with few mishaps; used triple-layer construction and covered only half of partner's hand; worked smoothly with partner for most of process. Careful, helpful, prepared	Followed most safety rules with only 1 or 2 mishaps; followed construction directions somewhat *or* had a few arguments with partner over process. Needs to communicate better	Followed some safety rules but needs to be more careful; followed construction directions poorly *or* had disagreements with partner over process. Rudimentary difficulties
Work Process • Observation/Exploration • Sketches • Iteration of idea • Refinement of idea • Reflection	All products and time on-task exhibit strong personal interest and independent drive. Exceeds expectations, independent	Most products and time on-task meet assignment expectations; some independence exhibited. Meets expectations, satisfactory	Uneven effort in products and/or time on-task; lacks some steps of process. Needs prompting, hit and miss	Products and/or time on-task minimal; lacks many steps of process. Disengaged, inattentive

Web Link

For more information about Carole Feuerman and her work, go to her Web site at: www.feuerman studios.com

Career Profile
Carole Feuerman

Carole Feuerman is one of the best-known contemporary sculptors in the world. A book was made of her work by renowned photographer David Finn.

Carole's earliest recollection of her work was when she was five years old.

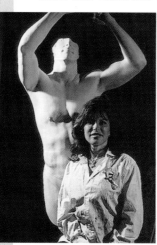

She used shoe polish to paint a mural on the kitchen floor. (It wouldn't come off.) Carole's mother asked her if she wanted art lessons. Years later she received a BFA from the School of Visual Arts.

Photograph: David Finn.

How did your art lessons help you?
Carole: One day when I was in the sixth grade, I was teaching a bunch of kids how to draw in the back of the room in my English class. I was drawing naked ladies. I was thinking of them as "classical nudes." At any rate, the teacher saw me doing some-

thing and called me to the front of the room. She took a look at what I was doing. I think she misunderstood this; she sent me to the principal, who thought the drawings were really good. He said that I could teach drawing to the class—but I had to do animals. That's when I started teaching art to my sixth-grade class once a week. It was so successful that I had three classes coming in once a week. I always knew that I wanted to be an artist.

Tell me about your first successful showing.
Carole: It was my first show at the Hanson Gallery in New York. I worked three years to get ready for that show. It was a three-week show. Two weeks went by without a sale. Nothing. I was starting to get really upset. Then Malcolm Forbes came to the gallery and introduced himself to me. He bought my entire show. That was the beginning of a very good friendship. After that, when I finished a work, he sent his limo to take the sculpture to his home with this comment: "I will send a check or send the sculpture back."

What advice do you have for younger artists?
Carole: Get in the environment of other artists. You have to believe in yourself regardless of what people say.

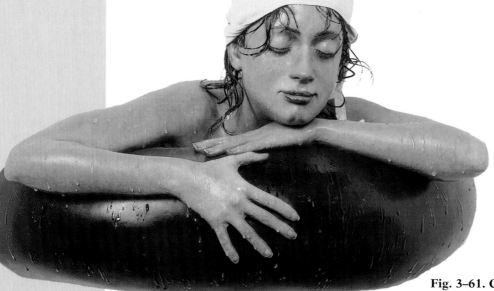

Fig. 3–61. Carole is known for her lifelike sculptures cast in resin.

Chapter Review

Recall In mixing plaster, how do you test for proper thickness?

Understand Define what is meant by value in sculpture.

Apply Draw a symmetrically balanced design and then a similar design with asymmetrical balance.

Analyze Analyze the use of plaster for body molding as compared to alginate.

Synthesize Recall the differences between hard and flexible molds. What shape would be best for a hard mold? When should a flexible mold be used?

Evaluate Select a work of art in this chapter that you feel makes effective use of balance. Which of the three types of balance discussed in this chapter does it use? Discuss the reasons why you selected this work as a good example of balance.

Writing about Art

Think about under what conditions you would want to create a sculpture in plaster that would deteriorate in a short time. Is the idea more important than the material? Does working in a particular medium convey a particular message for you? Are you looking for flexibility rather than permanence? Write several paragraphs on your ideas concerning this question.

For Your Portfolio

Organize a sequence of photographic images about the progress of a piece of art you are creating. Photograph your work in various stages and in final form. Write a brief description of the materials and techniques you used for each photographic sequence. Document your piece with title, date, and size.

Fig. 3–62.
Scott Zubowski, *Sitting by Myself* (with student), 2000.

Plaster-impregnated gauze, life-size. Manchester High School, Manchester, Indiana. Instructor: Debra Schuh.

Key Terms

casting
aggregate
cast stone
slushed
patina
cement

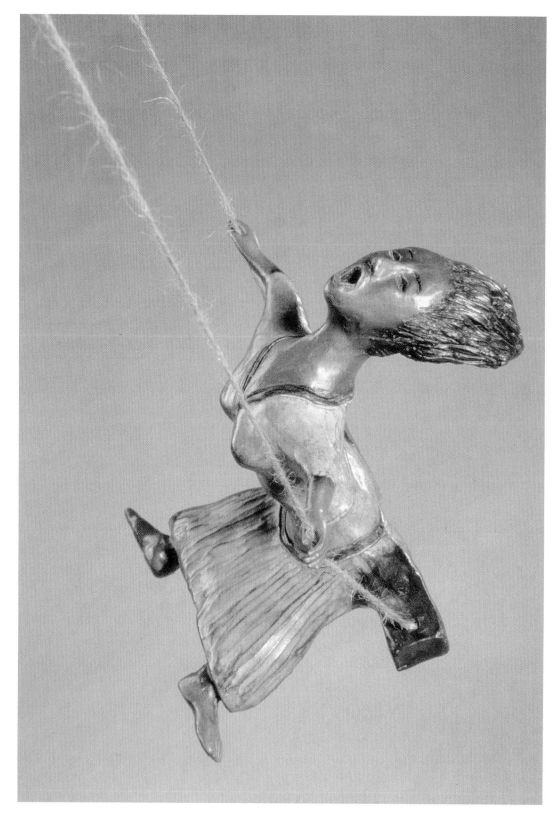

Fig. 4–1. Sculptors have been casting forms into bronze for thousands of years, and contemporary artists continue to explore this medium. How has the artist created a sense of movement in this playful sculpture?

Janice Kluge, *Swing Figure*, 1998.

Cast bronze, 20" x 8" x 6" (50.8 x 20.3 x 15.2 cm). Photograph: Lee Isaacs.

4 Casting

Now that you have learned how to create a mold, you are ready to try your hand at the exciting technique of casting. **Casting** is the process of filling a mold with a liquid material that will then harden. It is the replacement of one material (the original) with another, and it is used to create sculptures in bronze or other metals, cement, glass, plaster, resins, or any other material that can exist in a liquid state and then set in a hard state.

Sculptors have practiced the technique of casting for millennia. In the past, the most common cast objects were of bronze. Scholars believe that by about 2000 BC, cultures in the Near East were using earthenware molds to cast bronze. Many of these early sculptures of gods and goddesses were solid and therefore small in size. Cultures throughout the ancient world, from Greece and Rome to China, and from India to Africa, refined the technique of casting in bronze. During the Renaissance, bronze casting reached new heights with the work of such artists as Donatello, Andrea del Verrocchio, and Benvenuto Cellini. In addition to working in bronze and other metals, sculptors today experiment with a wide variety of new synthetic materials, such as polyvinyl, resins, and plastics.

plaster

In this chapter, you will study different types of materials for casting, including cements and plasters, and the effects they create. You will also learn about the ancient technique of bronze casting. All this will prepare you to create your own cast-plaster relief sculpture.

cement

bronze

Fig. 4–2. Artists in the kingdom of Benin in Nigeria mastered bronze casting by the ninth century. This mask or plaque of a snarling leopard was probably displayed on a royal palace.

Benin, Nigeria, *Head of a Snarling Leopard*, a plaque that decorated the palace of the Kings of Benin, anonymous.

Bronze. Museum fuer Voelkerkunde, Staatliche Museen, © Werner Forman/Art Resource, New York.

Unity/Variety

Unity is the feeling that all the parts of a design work together in harmony, whereas variety adds visual interest by providing different things to look at. So while an artwork should be unified to appear whole, diversity also contributes to its success. In sculpture, unity may be achieved through the use of a single material, form, or surface treatment (color, pattern, texture, and so on). In the work shown in **Fig. 4–4,** the artist created a sense of unity through the use of a limited color scheme and geometric forms. He introduced variety by contrasting these elements with one gold object. How else did the artist add diversity?

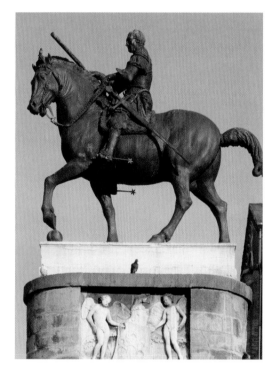

Fig. 4–3. The Renaissance sculptor Donatello revived the difficult technique of casting large-scale figures in bronze. His *Gattamelata* statue was the first larger-than-life horse and rider created since ancient Rome.

Padua, Italy, from the Piazza del Santo, *Equestrian Gattamelata*, 1445–1453.

Bronze, 11' x 13' (3.4 x 4 m). Tate Gallery, London © Tate Gallery, London/Art Resource, New York.

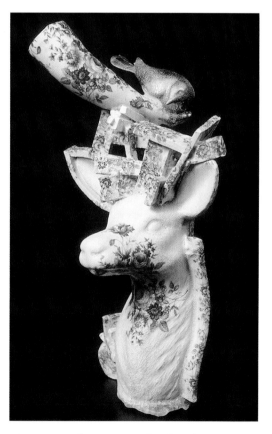

Fig. 4–4. A slip casting that has been cast in parts, then combined to form a work. Would you say the artist's use of unity and variety here is subtle or dramatic? Why?

Jeff Schmuki, *Trophy*, 2002.

Porcelain-slip casting, 17" x 8" x 7" (43 x 20.3 x 17.7 cm)

Casting Cements and Plasters

There are many cements and plasters available for casting. Plaster is used for sculptures that will be displayed indoors, while most cements can be used for sculpture that will be displayed outdoors. USG (United States Gypsum) is the most universal brand for art plasters and cements. USG publishes demolding times (how long a casting material must set prior to removal from a mold), set times (the time required to harden), and the expansion range (the percentage of swelling of the casting within the mold—too much expansion can make a casting difficult to remove). Some casting mixes have an aggregate added. An **aggregate** can be any hard substance such as rock, granite, crushed marble, or even glass. Aggregate is used for color and/or strength.

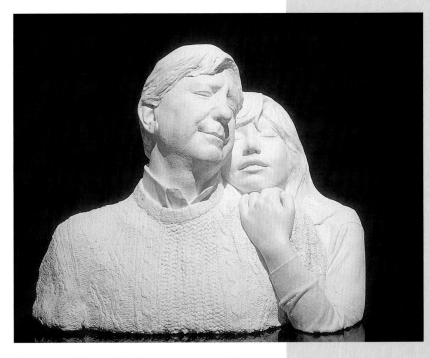

Fig. 4–6. This casting incorporates resin and was created using a flexible mold.
Carole A. Feuerman, *Special Time*, 1989.
Resin and oil, 18" x 32" x 15" (45.7 x 81 x 38 cm)

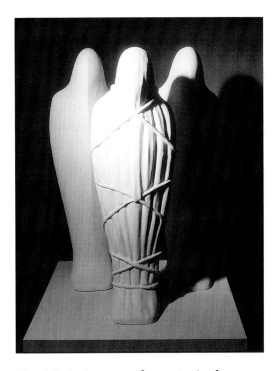

Fig. 4–5. Artists over the centuries have been interested in the effects of dark and light. Cast plaster produces a beautiful white surface that can be used to highlight the dramatic contrast between light and dark shadows.
Enrico Pinardi, *Jury*, 1985.
Cast plaster, 28" x 17" x 17" (71 x 43 x 43 cm).

- Casting Plaster (USG No. 1) is often used by artists and produces a hard eggshell-like surface. The casting expansion is less than 0.21%, and the set time is about 27–37 minutes. It is for indoor castings only.
- Hydrocal White Gypsum Cement (USG) is known for its bright white color and handling characteristics, which are similar to those of plaster. It is a good slip-casting product with a strength about 2½ times that of plaster. The set time is about 25–35 minutes, and the casting expansion is less than 0.39%. Though it is strong, it is not an outdoor product.
- Hydrostone (USG) offers fine detail, though it does not allow the artist to rework the surface. It is about 5 times as hard as plaster and snap sets (no warning) in about 17–20 minutes with a setting expansion of 0.24%.
- Fast Cast Exterior Gypsum Cement (USG) has the gray color of cement but sets in about 25–35 minutes. It must be mixed with clean sand for durability at approximately a fifty-fifty mix. It is an exterior product with extremely fast demolding characteristics with a setting expansion of only 0.10%.

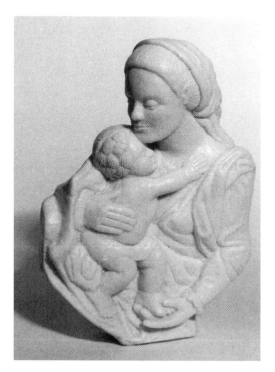

Fig. 4–7. A soap carving, as intricate as it is, will not last indefinitely unless it is molded and cast into a longer-lasting medium.

Jim Boyd, *Madonna and Child.*

Carved soap, 2¼" x 4" x ⅞" (5.7 x 10 x 2.2 cm).

Fig. 4–8. This carved-soap form was cast into a permanent material—silver. Notice how the use of a patina seems to give added depth to the piece's forms.

Jim Boyd, *Madonna and Child.*

Cast silver, 2¼" x 4" x ⅞" (5.7 x 10 x 2.2 cm).

Fig. 4–9. Artists consider bronze the favorite metal for casting pieces that will be displayed in public places. How does this bronze piece "pull" the viewer into its space?

Lea Vivot, *The Secret Bench.*

Cast bronze, 8" x 5" (2.4 x 1.5 m). Location: Parliament Hill National Archives Library, Ottawa, Ontario, Canada.

• Gardencast Gypsum Cement (USG) is ideal for outdoor casting with its uniform white color. It has a rapid setting time of about 25–35 minutes and can be removed from the mold within an hour. It has the same strength as Fast Cast and the same setting expansion of 0.10%. It is mixed to a fifty-fifty ratio with a clean, dry sand.

• Portland Cement is a light gray cement used throughout the construction industry because of its strength and consistency. Portland white cement is a favorite of professional sculptors, especially when aggregates are added. The resulting mix highlights the aggregate. Commercially produced color tints can also be added to achieve a specific look. The setting time varies and can be up to 12 hours. After casting, the cement should be kept moist and should not be demolded for at least 3 days (preferably longer).

• **Cast stone** is the name given for Hydrostone and similar products or concretes in more refined uses. This includes the additives of marble dust or aggregates

Fig. 4–10. Cast resin, combined with pigments, possesses a stonelike appearance. Can you see the influence of classical sculpture traditions in this piece? What does the artist do to imply a sense of creation in his work?

Brent Coffman, *And God Created Man*, 1995.

Cast pigmented resin, 17" x 10" x 6" (43 x 25.4 x 15.2 cm). Instructor: Arthur Williams.

of various sizes and makeups. These mixtures can take on an appearance of natural stone and are sometimes marketed with names such as "imitation stone," "marble stone," or "cold cast stone." The longevity of the product depends on the cement and mixture used. Some are outdoor mixes, some are not.

Plaster Casting

Plaster and cast stones (cements) require similar processes for casting, but the different materials pose different problems. Plaster sets fast, but some cements require a prolonged time to set up. Rapid setting requires the sculptor to work at a quick pace but also enables the work to be finished more quickly with an often easier-to-work surface. Slow-setting cement allows more detailed surface work prior to setting.

Plasters and cements are cast in either solid or hollow masses. A solid casting can be cast with or without reinforcement. A hollow casting can be **slushed** or laid-up by hand. A *slush mold casting* is a hollow casting. It is created by pouring a liquid casting substance into the mold, allowing it to partially set, and then draining the surplus. This leaves a thin surface coat resulting in a lighter, more manageable casting. A *laid-up mold casting* is also a hollow casting, but one created by adding casting material directly by hand or by brush to the interior mold surface. This is used for molds with openings large enough to reach into. Solid casts are much heavier and often stronger, but not always practical due to weight and material costs. Hollow casts are weak unless reinforced. However, with good reinforcement, a hollow cast can be strong. The size of the mold and the opening into the casting area help determine the casting method.

Solid casting in plaster is done using a mold with a good release agent applied to the mold pieces before they are assembled. (Petroleum jelly is the preferred release agent for plaster casting.) Line up

Fig. 4–11. A plaster casting takes on the appearance of an actual shoe. What details make you feel you could put this on and walk in it?

Jennifer Plummer, *Plaster Shoe*, 2002.

Plaster, 10" x 6" x 4" (25.5 x 15.2 x 10 cm). Illinois Central College, Peoria, Illinois. Instructor: Jennifer Costa.

Ken Little, *Boss*, 1992.

Bronze, 36" x 112" x 49" (91.4 x 284.5 x 124.5 cm).

the mold sections and fasten or clamp them together. The ties should be strong enough to assume all the weight of the material involved. Check that the mold does not have gaps or holes where the liquid casting material can escape.

Try It Petroleum jelly is the commonly used mold release agent for many products, plaster in particular. However, if applied too thickly, it can cause surface indentations. Question: What will happen if you "glop" on the release agent, or leave visible fingerprints in the application? Experiment. Place a thick release agent on a surface and smear your name into it. Pour plaster over it and allow it to harden. Did your name appear? How does a thick application affect the release agent on molds?

Mix the casting plaster. Check that the mixture is of the correct consistency. Slowly pour the fluid into the mold, avoiding splashing. It is wise to continuously vibrate the mold as it is filled. If possible, rotate and dip the mold while pouring.

Allow the mold to set for at least 1 hour (for plaster and some cements) prior to

Fig. 4–13. A wax piece was slush cast in preparation for the final bronze mold. Notice the seam lines on the arm and other parts that need to be removed before the final process.

Diane van der Zanden, *A Song for My Sister*.

Wax, 10¼" x 8½" x 7" (26 x 21.6 x 17.7 cm).

removal. Some products take a considerably longer time. Study the manufacturer's recommendations before using a product.

Note It Keep in mind the drying/strengthening time of the casting plaster (this information is supplied by the manufacturer). To remove a mold too soon may damage the image. The casting will break. If it is removed too late, after all the moisture has left, the casting will tend to stick to the mold, and removal will be difficult. Also, if the surface needs reworking, a damp casting is easier to patch and will come nearer to matching surface quality and color.

How to Slush Cast Plaster

The hollow mold is treated with the correct release agent for the casting material prior to mold assembly. Assembly should include tight, nonmovable joints. It is best to patch any potential holes or possible areas for leaks on the outside. All seams must be snug.

Properly mix the plaster, remembering that it must remain a liquid in order for it to correctly slush. Enough must be mixed to deposit a ¼- to ⅜-inch coating on the surface. The liquid plaster is poured into the mold. The mold is rotated in as many directions as possible until the plaster begins to build up and adhere. After the first coat has hardened into the set stage, a second coat with reinforcement should be added.

Molds with small openings (usually the base where casting material can be added or removed) that cannot be reached into with one's hand should receive a second slush coat with chopped burlap or hemp mixed into the liquid plaster. This adds reinforcement strength. This layer should be about ¼-inch thick.

Larger castings of plaster with large mold openings can be worked on from the outside. After the initial coating has been added by slushing and has hardened, more plaster is added. Then plaster-soaked burlap or hemp can be hand laid

Fig. 4–14. Slip castings can be combined to create a larger work. How has this artist brought variety to her artwork?

Shannon Calhoun, *Where the Heart Aches*, 2001.

White stoneware clay, surface wax, 8" x 12" x 5" (20.3 x 30.5 x 12.7 cm).

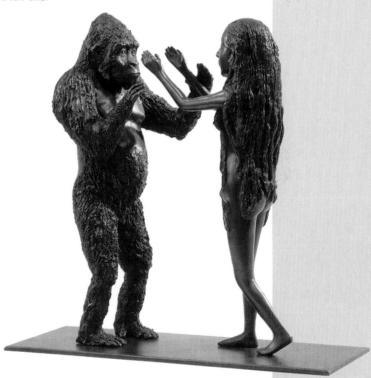

Fig. 4–15. Artist Kiki Smith explores themes of mythology in her bronze sculptures.

Kiki Smith, *King Kong*, 2001. art:21

Bronze, 20" x 21" x 8" (50.8 cm x 53.3 c); courtesy Pace Wildenstein, New York. Photo: Ellen Page Wilson.

Art:21 is a nonprofit organization that produced the Emmy-nominated series *Art:21—Art in the Twenty-First Century*. In addition to the series, Art:21 oversees national education programs and creates Educators' Guides, Companion Books, and a comprehensive accompanying Web site— www.pbs.org/art21.

Slush Cast Clay

Slush casting using ceramic clay slips is quite popular. Dry plaster molds are preferred. These molds can be in several parts in order to avoid undercuts, or they can be simple two-piece or even one-piece molds without undercuts. The following clay slip casting is demonstrated by Jeff Schmuki, Assistant Professor of Art, William Carey College on the Coast.

❶ The mold has been carefully designed to fit without gaps. Notice the mold keys. It is completely dry and clean. *Do not use a release agent.*

❷ The mold is placed together and tightly bound in preparation for the clay. This is essential.

❸ The liquid slip has been added and allowed to settle on the interior surface. The dry plaster sucks the moisture from the clay directly touching the wall, resulting in a buildup on the inner surface. After the desired thickness is obtained (about ³⁄₁₆ inch), the excess is drained off. The resulting clay wall is allowed to continue drying into a slightly shrunken leather-hard finish. Afterward, the mold is gently struck with a rubber hammer to loosen the clay prior to removal.

❹ The mold is removed, revealing the clay casting.

❺ The leather-hard artwork is trimmed as it is finished.

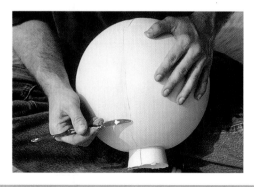

onto the wall to add strength through reinforcement. Only when the surfaces are covered and hardened is the mold ready to be removed.

Laid-Up Molds

Laid-up molds are primarily used for large castings that need to be hollow but are too large to properly maneuver. The process is to place casting material on the interior of the mold surface prior to joining the mold together. Often, metal or wire is added for reinforcement.

The mold should be preassembled in order to ensure proper alignment of the seams. A release agent should be applied to all parts, even the seams, in order to ensure easy removal. The mold interior is then brushed with mixed plaster or another casting material to at least a ¼-inch wall thickness.

The seams must be at an angle, or bevel, from the seam edge. The finished face surface should barely touch, leaving an open space on the inside. Do not overlap the edge or attempt to create a flush seam. The open seam will allow enough space for liquid plaster to be added (like caulk) between the two mold sections. This ensures a good fit and strong contact for seam strength as the seam is filled. After the first layer has hardened and the seam has been filled, a second layer is added with burlap or hemp to provide reinforcement. This layer should completely cover the interior, including the mold seams.

Note It Never add reinforcement materials to the surface mix. Doing so would result in these materials sticking through, into, and out of the finished surface. The reinforcement for larger works can still be burlap or hemp, but it is often wire screen cloth or steel rods. Any steel reinforcement that does not have a rustproof coating must be coated prior to adding plaster. If it isn't, the rust color comes through the plaster and spreads, creating an unsightly surface. Shellac is often used as a metal coating in order to avoid rust.

Fig. 4–16. This piece was cast directly into an open mold. How has the artist used negative and positive space in her work?
Carole A. Feuerman, *Still Standing, Evador Sphere with Rock*, 2002.
Cast bronze, 24" (61 cm) sphere.

Once the mold layers are at least ½-inch thick, the mold can be assembled. Take care not to separate the casting material from the mold. The mold should be carefully handled without stress on the interior wall. The plaster or other casting material can then be added down the seam lines by a brush. Reinforcement is lapped over the seam into the individual parts. Make sure the seam is slightly thicker than the other areas. This ensures reinforcement lapping.

Safety Note Do not use wood as a plaster reinforcement material. The wood soaks up the plaster moisture, possibly causing differences in the plaster structure. Plaster-soaked wood expands, causing the plaster to split.

Patina Plaster

Though many sculptors like to leave plaster in its natural color, a surface color may sometimes be preferred, this is called a **patina.** When bronze casting is not possible, plaster can be patinaed to a finish similar to that of aged bronze. All you need is a simple hobby-shop kit. The kit used for this demonstration includes a bottle of bronze powder in liquid suspension and a bottle of chemical solution (cupric nitrate) that reacts with the copper in the bronze powder for an antique finish. Arthur Williams presents the demonstration.

Fig. 4–17. The skillful use of patina captures the look of real leather in this bronze work. Why might an artist want to represent reality so precisely?
Jonah Blum, *Sandal*, 2000.
Cast bronze, 11" x 4½" x 3" (28 x 11.4 x 7.6 cm). Instructor: Arthur Williams.

1 The slipcast plaster has been dried and cleaned in preparation for the finish. Liquid copper is added by brush. The initial coating of color forms the basis for all other layers of materials. A good patina demonstrates different shades of color and values.

2 After the first coat of copper has thoroughly dried, a second coat is added and allowed to only partially dry. Since the paint is composed of fine particles of copper, it reacts very much like actual bronze when exposed to certain chemicals. Cupric nitrate is used to generate an antique blue when placed on a copper surface. The cupric nitrate solution is then added to the "tacky" stage of the bronze in order to hasten the reaction between the copper and the nitrate solution.

3 The sculpture is highlighted (wiped) with a paper towel while still wet and then allowed to dry.

Adding copper color to the plaster slip casting.

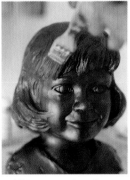

Adding cupric nitrate.

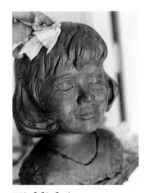

Highlighting.

4 Chemical changes continue for several hours before reaching the final patina finish.

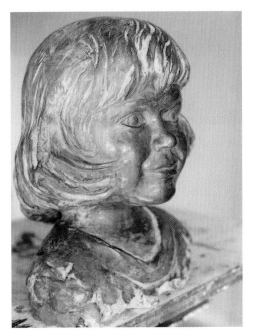

Achieving an "antique" look.

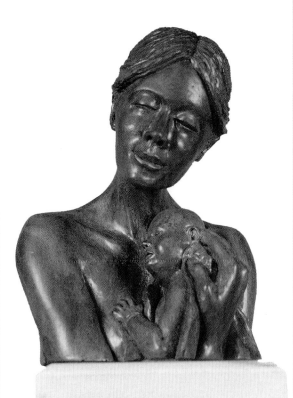

Fig. 4–18. The application of patina on polyurethane creates a look that is almost identical to bronze.

B. P. Barwick, *Precious*.

Cast polyurethane, 10″ (25.4 cm) tall.

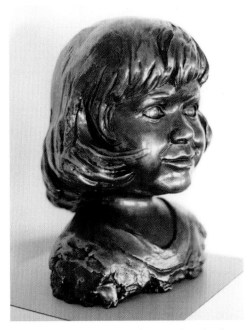

The same slip-cast sculpture finished with a darker bronze. A dark base color was applied and dried, and then a black gel was brushed on and wiped down to add accent.

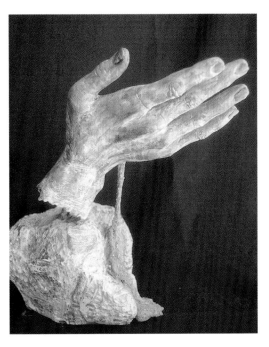

Fig. 4–19. Notice how the artist has used patina to highlight this form. How does the title help you understand the symbolism in this design?

Autumn BreAnne Martino, *Hands of Time*.

Plaster, copper patina, 12″ (30.5 cm) tall. Palm Desert High School, Palm Desert, California. Instructor: Kelly Lillibridge. Photograph: Storm.

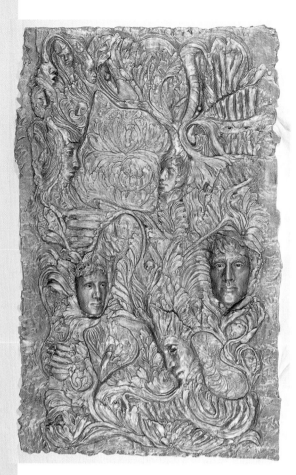

Fig. 4–20. The bronze finish here looks so real that the viewer may not realize the sculpture material is actually plaster.
Rita Dianni-Kaleel, *Transition*, 1999.
Bronze finish on plaster, 44" x 30" (111.7 x 76.2 cm).

Bronze Casting

The exact beginning of bronze casting is uncertain, though it dates back beyond 3000 BC in Chinese, Indian, and Babylonian civilizations. All early castings were small because they were cast solid. By about 2500 BC, the Greeks discovered how to cast with hollow forms, allowing much larger castings. The lost-wax method of bronze casting was refined by 1500 BC in the Chinese Shang dynasty; clay molds were used to withstand the hot-metal heat. When Rome became a world power, bronze was frequently used for official portrait works.

Bronze casting was practiced as an inherited craft until the middle of the twentieth century. This is when colleges and art schools began small teaching foundries, using much the same methods as those passed down from previous generations. In the 1960s a national sculpture conference was held to discuss metal casting.

Fig. 4–21. The cultures of India and Nepal have a long tradition of casting in bronze. This bronze seated lion from Nepal was cast to decorate an eighteenth-century temple.
Guardian Lion, Entrance portal of Bhairav Nath Temple, Bhaktapur, Nepal
Bronze.

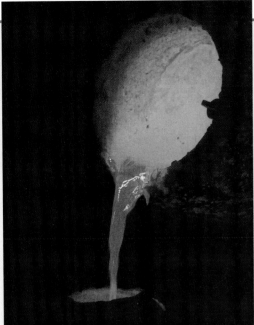

Fig. 4–22. It is difficult to describe the beauty of an actual bronze pouring. It is like liquid gold.

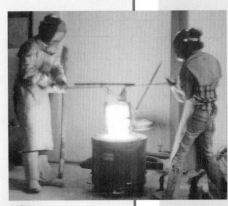

Fig. 4–23. Students carefully lift a crucible of hot, molten bronze out of the furnace in preparation for a bronze casting.

Here, artists and instructors first learned about the *ceramic-shell process,* which is the most widely used method by professional art foundries today. Although colleges still practice the traditional plaster investment (mold) method, many are now converting to the new ceramic-shell (mold) process. The difference is that the mold was traditionally made of plaster and sand, while the new process involves a more refined silica coating as well as higher heat.

The actual art of mold making and bronze casting has seen little change. It is still called "lost wax," because the wax artwork is lost in the process. A heat-resistant mold is formed around the wax sculpture. The wax is melted out, leaving a cavity that is filled with hot molten bronze. Once the metal solidifies, the mold is removed to leave a hard bronze surface. Then the casting is finished, sometimes with a surface patina. This process has been so well refined, especially with the ceramic-shell process, that the details on the wax are retained down to the fingerprints the sculptor may have left in it.

Fig. 4–24. Although known primarily as a painter, Edgar Degas also created sculpture. By incorporating real objects—slippers, tutu, ribbon—Degas helps us relate to the young girl and to become personally involved with the piece.

Edgar Degas, *Little Dancer Aged Fourteen,* 1880–1881.

Bronze sculpture. Tate Gallery, © Tate Gallery, London/Art Resource, New York.

Cement

Cement is a building material known for its hardness and durability. It is activated by the addition of water. Commercially sold in hundred-pound sacks, it is available from all building suppliers. Cement with building aggregates added is known as concrete.

Cement sculpture can be displayed outdoors; plaster cannot. Being much heavier and harder than plaster, cement is more stable and less susceptible to damage from the elements. For this reason, many sculptors prefer working with cement.

Though a light-gray Portland cement is the commonly used construction cement, white Portland cement is the cement of choice for large cast-stone sculptures. The white cement allows the aggregates to be seen in full reflective color. Smaller works are often created with Gardencast or a similar product.

Fig. 4–25. Casting cement can create a weathered look if it is patinaed (surface treated) to look aged.
Jonathan May, *Male Torso Study*, 1998.
Cement, 14" x 11" x 5" (35.5 x 28 x 12.7 cm). Instructor: Arthur Williams.

Gypsum cements contain lime, which is caustic. Wear sturdy waterproof gloves when handling and mixing them. Wear a mask over your nose and mouth when mixing powdered cements.

The use of aggregates achieves a stone-like appearance. A proper concrete mix includes cement, sand (preferably white sand), and various sizes of aggregates. Aggregates are added to the mix to strengthen and/or add color or design value. Strength, especially for outdoor or larger works, requires a variety of aggregate particle sizes. The strength is achieved by the different-size aggregate particles filling all the spaces so that no void is left between fragments. Consistency of color can be achieved by using aggregates of the same type of stone but in various sizes. An example would be using marble dust and small marble fragments, with larger marble fragments included. Aggregates are selected to be clean, durable, and not to react with the cement. Large aggregates are not necessary for smaller-art-casting products such as Gardencast.

Cements are sometimes colored with commercial pigments that are designed for that purpose. Although quite expensive, they can achieve interesting colors. Dry mixing the pigment with the cement in measured amounts is the best way to get the desired results.

Mixing cast stone is not difficult but should not be done with skin exposed. Gloves should be worn and simple mixing tools are needed. Moderate-size sculptures may require a shovel and garden hoe with a wheelbarrow for the mixing container. Larger mixes may require a portable cement mixer or even a special load of mixture provided by a commercial concrete company.

The mixture's ingredients are added proportionately. For smaller mixes, the cement and aggregates are dry mixed prior to adding water. Larger mixes are measured by shovelfuls of each mix. Although it is good to add exactly the correct amount of mix to a predetermined

Fig. 4–26. The studio of sculptor Carole A. Feuerman includes numerous castings as models for future works.
Photograph: David Finn.

water volume, it is not practical for most small cast-stone sculptures. Machine mixing requires a predetermined amount of water to be added first. Commercial construction mixes contain seven parts aggregates to one part cement. Using white Portland cement can mean as little as three or four parts aggregate to one part cement, while Gardencast is formulated to be a fifty-fifty mix with fine sand.

Note It Cements will set underwater. This means that hands and tools exposed to concrete mixes should always be washed in a separate container away from sinks. The remaining residue (in the container) should then be deposited in the trash and not thrown on the ground. It will set up on the ground surface and discolor it.

The best method of work is to add water after dry mixing. The water should be slowly added to the center of the mix, being careful not to overdo. If the mix is "soupy" or too runny, it will be weak, and the surface will have lime deposits. The aggregate will settle to the lower cavities. If the mix is too thick, it is difficult to work and often results in trapped air pockets. The best mix is one with less water, but enough to allow manipulation of the mix. If it is to be poured into a small mold, it should pour like a heavy, thick cream. If it is to be placed into a larger, more open container, it should be thick like a heavy paste. The exact mix

recommended by the manufacturer should be followed. However, sculptors using very fine aggregates will use a little more cement in the mix than is normal. It is best to vibrate the mold as the casting is being poured. A commercial vibrator is available and can be rented for larger works.

Once mixed, Portland cement mixes need to set without disruption for several days. The mold should be covered and kept moist. Though the cement appears to gain strength quickly, it does not reach full strength for some time. After 7 days it still contains much moisture, but can be worked on. It is about 75% of its possible strength at this point. In 27 days, it reaches about 98% of its strength.

Gardencast and other special casting cements require a very short time to set. Some can be taken from the mold within the hour. However, they also take several days to reach full strength and should be handled with great care until they have become stronger.

Sometimes reinforcement is needed for the sculpture in order to support thin areas or as a method of attachment to a base. Larger works can use regular steel

Fig. 4–27. A casting using pigmented aggregates.
Mark Oxman.
Plastic.

Fig. 4–28. Artist Dee Shaughnessy begins to create her small works by molding in plaster first. This technique allows her to capture fine details.
Sharon "Dee" Shaughnessy, *Vision Quest*, model.
Plaster and pewter, 9" x 2" x 23" (22.8 x 5 x 58.4 cm).

rebar sold at building supply stores. Smaller works can use welding rods, even coat hangers. A caution: Raw steel can cause rust spots to come through thin sections, especially if the mix is primarily a white, weathering outdoor work. Shellacking the steel should be considered prior to coating it with cement.

Molds for cast stone need to be stronger than molds used for plaster. This is because of the extreme weight of the mix, the intense vibration that is needed, and the tamping or ramming of the mix as it is added. Though Portland cement can be hollow cast using the laid-up method, this is difficult since it dries so slowly. If fine details are desired, then the aggregates need to be kept smaller.

Molds need to be sealed or coated with substances such as shellac and oil that will keep the mix from sticking or water from being sucked out.

The green cement (curing but not cured) can be worked with patches immediately after removal from the mold, if necessary. A commercial bonding agent should be considered for part of the mix. Ideally, any color or special dry mix should have been saved from the original batch just for this purpose. Curing surfaces can be wire brushed, etched with acids, ground, sandblasted, polished, and even waxed for special effects.

Note It The release agent should not cause a stain to remain on the casting. The casting surface could be permanently damaged or discolored. Dark oils or clays can permanently stain the final form.

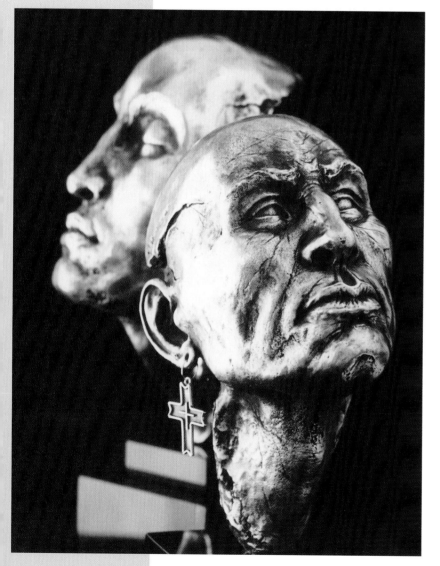

Fig. 4–29. Her finished piece is cast in pewter, one of the few metals that does not require a great amount of heat.
Sharon "Dee" Shaughnessy, *Guardian and Dream Catcher*.
Cast pewter, 11" x 5" x 5½" (28 x 12.7 x 14 cm) and 14" x 5" x 6" (35.5 x 12.7 x 15.2 cm).

Space

Carole A. Feuerman, *Still Standing, Evador Sphere with Rock*, 2002.
Cast bronze, 24" (61 cm) sphere.

Space refers to the area around, within, and occupied by a three-dimensional object, as well as the way these areas interact. The sculptor must consider the positive space (the sculpture itself) as well as the negative space (the area around and within the structure) when planning a sculpture. In Carole A. Feuerman's *Still Standing* (left, and **Fig. 4–16,** p. 89) negative space creates a dynamic relationship with the space around and, most important, within the sculpture. The area around the sphere defines the outer edge of the structure, whereas the voids created by the pierced form help define its volume. Compare this use of space with the negative space around the solid form shown in Janice Kluge's *Swing Figure* (**Fig. 4–1,** p. 80).

Discuss It When you visit a gallery and see a sculpture with the material listed as cast stone, what is the first thought that comes to mind? Is it truly stone? Why is it not just called a casting? Do you equate a "cast marble" sculpture with a marble carving? What if you see "cold bronze" (a casting substance partially made of bronze powder)? Can you equate this with a foundry bronze casting? What are the similarities and what are the differences?

Note It Always remember that the strongest reinforcement materials for sculpture forms should be placed in the casting near the outer surface. This affords strength and avoids cracks in the final work.

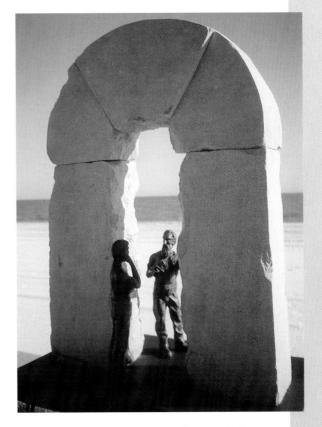

Fig. 4–30. Artists can manipulate scale in many ways. Because the photo was taken with the beach as a backdrop, the sense of scale is deceiving. How large is this piece overall?

Jonathan May, *The Philosophers*, 1999.

Cast bronze, limestone, slate, 33" x 28" x 16" (83.8 x 71 x 40.6 cm). Instructor: Arthur Williams.

Studio Experience
Plaster Relief Casting

You will create a one-piece mold for casting a relief sculpture. Since one-piece rigid molds are made without undercuts, the casting can be removed and the mold reused. Plaster is the type of mold often chosen for low relief. The mold is simple to make. The artwork can be in many different materials including found objects, just as long as all undercuts have been eliminated. The best relief material for this assignment, however, is modeling clay.

Before You Begin

- You will first study reliefs. Study a coin, perhaps a Lincoln-head penny, and notice how the relief does not have to be high or outlined to be effective. It is the modeling that creates the illusion of depth, not an outline.
- Light is necessary to cast shadows throughout the relief.

You will need:
- a backing to mount the modeling clay; it can be Masonite, plywood, or another product that can support clay and then be attached to a frame
- modeling clay for the relief artwork
- release agent, preferably petroleum jelly
- wood strips for framing the mold
- plaster and plaster mixing buckets
- soft-bristle brushes

Fig. 4–31. Modeling clay is pressed onto a sheet of plywood in preparation for a relief design.

Fig. 4–32. After modeling, the relief edges are carefully straightened with a slight taper out at the bottom to allow a draft for easier removal.

Create It

1 The relief area needs to be large enough for the relief itself and to allow a space large enough about it to place a plaster-retaining frame.
2 Model the relief. Do not allow undercuts. The relief needs to be at least ¾-inch thick. A good way to begin is to add clay up to a ¾-inch thickness and then model the relief within and on top of that.
3 Once the relief is finished and firmly attached to the backing, the frame is securely put on. All spaces between the frame and backing are sealed together very tightly with a small amount of modeling clay plugged into all the seams and cracks. The frame needs to be at least 1 inch above the highest point on the relief.
4 Liberally add the release agent to the frame and backing. Do not add release agent to the modeling clay.
5 Mix enough plaster for the entire relief and then brush (with a soft-bristle brush) the first layer on. Work quickly. Finish the mold by pouring the remaining plaster into the mold on top of the brushed layer.

Helpful Hints The plaster mold could have a small hole in the center leading out to the back. Before casting, it can be partially filled with clay. After casting, it is used to allow air in to break the vacuum created by the casting process, especially with plaster. This is done by blowing air into the hole. Also, when you sign the relief, sign in the positive (artwork). If

Fig. 4–33. A wood frame is placed around the anchored relief as a mold for plaster. Petroleum jelly will be placed on the inside of the frame and the relief backing board but *not* on the modeling clay. Then it is ready to cast.

you sign the mold, it will cast in the reverse.

6 Check the mold for details. You may wish to carve some additional work into it. Gently clean the mold with soapy water. Level it up. It is now ready for a casting material.

7 If plaster is to be used, then carefully and liberally coat the mold surface with petroleum jelly prior to casting.

8 If the mold is to be used as a press mold for clay, then it needs to thoroughly dry. Afterward, it can be lightly dusted with talc prior to casting. If any plaster remains in the clay, it will cause the clay to crack when fired.

Check It Let it set until the plaster has gone through the heat cycle and cooled, then take out the modeling clay. Notice if any clay wants to adhere to the mold as you remove it. This may be a sign of undercuts. If so, take a knife, or other tool, and trim the mold to eliminate the undercut.

Helpful Hint The correct plaster mix is extremely important. Too thin, and the plaster just runs off the mold material and results in a weak mold. Too thick, and the plaster will not fill fine details. Practice the mixing.

Sketchbook Connection

List all the steps in casting from a mold. Draw sketches of the process to demonstrate each step.

Rubric: Studio Assessment

4	3	2	1
3-D Composition • Unity • Repetition • Variety • Form • Value contrast			
Repetition of one or more elements creates unity; sufficient variety present to command interest; light/shadow contrast creates a strong sense of 3-D form. Unified, strongly 3-D, effective	Repetition of one or more elements creates unity; sufficient variety present to add interest; light/shadow contrast creates a good sense of 3-D form. Unified, effective	Repetition, variety *or* contrast of forms needs more attention and development to unify and add interest to final sculpture. Needs refinement, more time on-task	Repetition, variety, *and* contrast of forms need more attention and development to unify and add interest to final sculpture. Unresolved, disjointed
Media Use • Plaster techniques • Followed sequence • Followed directions			
Careful implementation of casting techniques and following of directions resulted in a strong, reusable mold and well-made sculpture—no physical weaknesses. Skillful, controlled, appropriate	Implementation of casting techniques and following of directions resulted in a sturdy enough mold and a satisfactory sculpture—only minor physical weaknesses. Competent, appropriate	Some carelessness; difficulty in implementing casting techniques and following of directions resulted in a problematic mold or sculpture—some physical weaknesses apparent. More practice or care indicated	Much carelessness; difficulty in implementing casting techniques and following of directions resulted in many technical problems—noticeably interfered with success of sculpture. Rudimentary difficulties
Work Process • Observation/Exploration • Sketches • Iteration of idea • Refinement of idea • Reflection			
All products and time on-task exhibit strong personal interest and independent drive. Exceeds expectations, independent	Most products and time on-task meet assignment expectations; some independence exhibited. Meets expectations, satisfactory	Uneven effort in products and/or time on-task; lacks some steps of process. Needs prompting, hit and miss	Products and/or time on-task minimal; lacks many steps of process. Disengaged, inattentive

Web Link

Visit André Harvey's Web site to learn more about his work as a sculptor: www.andreharvey.com

A good site to visit for additional information about casting: www.artcasting journal.com

Career Profile
André Harvey

André Harvey has a unique background as an artist. His work has been exhibited in Moscow, Russia; Paris, France; London, England; and even the National Academy of Design in New York. He owns Breck's Mill Studio and Gallery in Wilmington, Delaware. However, André was not formally trained as a sculptor. His BA degree from the University of Virginia was in English.

How did you get started in sculpture?

André: I was always searching for something. I liked mechanical things; I liked to work with my hands.

After working in publishing for three years and teaching for another three years, my wife, Bobbie, and I bought one-way tickets to Europe. While in France, I saw a shop window with welded sculpture and something just overcame me. I said, "This is what I want to do." I met the sculptor, and he didn't know any English except "grass" and "sky." My French was not great, but I told him that I wanted to work for him. He said that he didn't have any money. I said I would work for "lunches" (the French have big lunches). It was a great experience working with him.

When I came back [to the US] I had this tiny little studio, an old milk shed in a barn. I worked another year for lunches (bologna sandwiches) with sculptor Charles Parks, while Bobbie was working. I learned how to make molds and cast in fiberglass.

How did you get into bronze casting?
André: It was always my goal. I would actually do a painted patina on fiberglass. People thought they were bronzes. I graduated to doing real bronzes.

Why do you choose animals as subject matter for so many of your sculptures?
André: My father was a conservationist. I grew up in rural Pennsylvania . . . there was not a lot to do; you were way out in the sticks, so I got to know the turtles and frogs and the woods and things about nature from living in it.

What advice do you have for the younger artist who is interested in sculpture?
André: Learn all those things you are meant to know about sculpture . . . go get the clay . . . start easy and just make something, and when you make it and you are happy, go further.

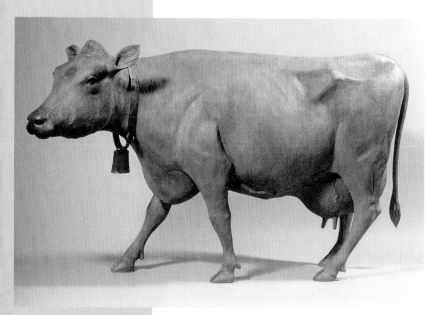

Fig. 4–34. The sculptor André Harvey is known for his realistic animal sculptures. He models, molds, and then casts them into life-size bronzes.
André Harvey, *Bertha*.
Cast bronze, 98½" x 54¼" x 31" (250 x 139 x 78.7 cm).

Chapter Review

Recall Aggregates are often added to cement mixes. Why?

Understand In your own words, explain the difference between positive and negative space.

Apply What elements in **Fig. 4–20** on page 92 suggest transition?

Analyze Why might an artist want to create disunity in a work of art? What feelings might such a work cause in its viewers?

Synthesize Use examples to explain two ways an artist can unify an artwork.

Evaluate Imagine yourself as a judge at a sculpture contest. Choose three cast sculptures from this chapter and recommend that they be awarded first, second, and third place. Include comments with your decisions explaining why you ranked each one as you did.

Fig. 4–35. This is an example of three different paper castings combined into one work. Where do you see positive shapes? Where do you see negative shapes? How are the shapes balanced?
Connie Herring, *From the Past*, 1992.
Cast paper and pastel, 18" x 11" x 6" (45.7 x 27.9 x 15.2 cm).

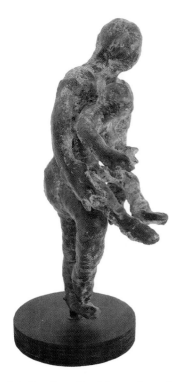

Fig. 4–36. Student José Pantaleon has finished his plaster casting with a coat of patina.
José Pantaleon, *Father and Son*.
Plaster, 21" x 8" (53.3 x 20.3 cm). Northeast High School, Oakland Park, Florida. Instructor: Marion Packard.

Writing about Art
Select two sculptors, one from before 1900 and one contemporary sculptor who use the casting method in their work. Through the library and the Internet, investigate these artists' work. Write about the similarities and differences in their work in terms of subject matter, material, form, and design elements.

For Your Portfolio

Photograph the plaster relief sculpture you created in Studio Experience. Write a statement about the construction of your work. Explain why you chose this design and why you decided to use the materials you did. Note your sources of inspiration. Be sure to document your object's title, date, and dimensions.

steatite
sandpaper
vermiculite
laminating

Fig. 5–1. A combination of woods creates beautiful natural colors in this life-size sculpture.

Philip John Evett, *Maisy Willoughby #2.*

Maple and mahogany, 74" x 36" x 20" (25.4 x 91 x 50.8 cm). Photograph: Ansen Seal.

5 Carving

Of all the methods used to create sculpture, *carving* has endured with the fewest changes. Sculptors today carve in much the same way as those working thousands of years ago. Some tools have been improved, new tools and materials have been developed, yet the process remains essentially the same—cutting away material to reveal the desired image. This *subtractive* process requires much foresight and planning because once material has been removed it is impossible to restore.

Carved works in stone, bone, and shell survive from prehistoric cultures. People worldwide have carved common materials they came across every day, transforming these substances into personal sculptures with complex meanings often known only to them. The surfaces of many 3,000-year-old Egyptian carvings in granite and other stone are nearly unchanged since the day they were created. The colossal carved stone heads of Easter Island in Polynesia, large-scale stone figures of pre-Hispanic Central and South America, and monumental wooden totems of native North American peoples are testaments to the sculptural traditions of sometimes lost cultures. The explosive power of carving is also exemplified in the work of Renaissance artist Michelangelo Buonarroti, whose remarkable marble carvings, both finished and unfinished, are an expression of the philosophies and ideas of his time.

In this chapter, you will learn about and experiment with a variety of materials, from wood to marble and other types of stone. Each material is unique and requires a different approach. Through a careful study of carving tools and techniques, you will learn the characteristics of each material and the best method to use to attain success as a carver.

plaster

wood

stone

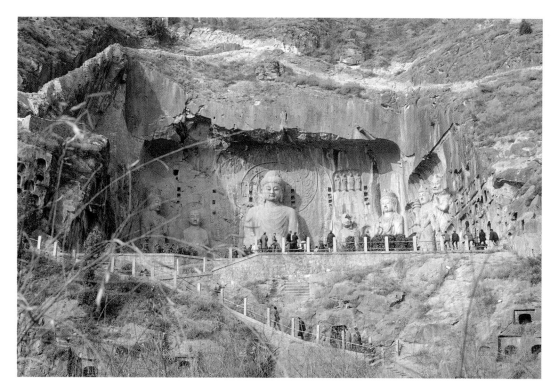

Fig. 5–2. These statues at Lung Mên in Honan, China, are carved out of the living rock of the hillside and date from the fifth and sixth centuries. There is a great sense of drama and power in this work.

China, *Lung Mên Shrines*, Loyang, 675 AD.

The Art of Carving

Carving involves cutting, hitting, flaking, chipping, and rubbing. It can be fun to do and requires few tools, depending on the material you choose to carve. Even the hardest stone can be carved with little more than a hammer and chisel. Indeed, there are few substances that cannot be carved, but some are better suited for the process than others.

Common bar soap is probably the easiest, most predictable manufactured material to carve. Just like hardened plaster, it can be carved with a pocketknife. Wood is often carved (whittled) by means of a pocketknife, while large sculptural wood works require wooden mallets and razor-sharp chisels. When it comes to stone, the most common beginning stone is **steatite**—a soft stone also known as *soap-*

Fig. 5–3. In this piece you can clearly see the smooth surfaces that artists can achieve with marble.

Sarah Sweetwater, *Maya*.

Marble, 26" x 14" x 11" (66 x 35.5 x 28 cm).

Shape and Form

In art, shape is a two-dimensional element that has height and width but no depth. In sculpture, shapes can be drawn, painted, or otherwise applied to a surface. Shape can also refer to the outline, or silhouette, of a sculpture. Form is a three-dimensional art element; it refers to a solid mass that has height, width, and depth. Creating sculpture is about working with three-dimensional forms, since sculpture is made up of forms, and the sculpture itself is also a form. Both shapes and forms can be geometric or organic, curved or angular. Notice how the artist of the work shown in **Fig. 5–4** used shape and form.

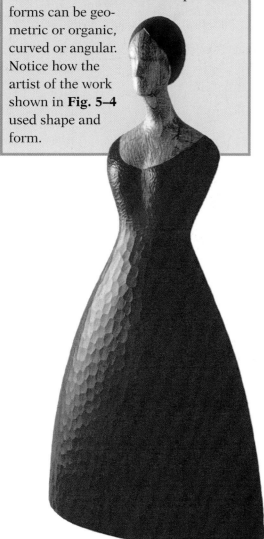

Fig. 5–4. David Hostetler paints his carved wood sculptures with bold, carefully planned colors. How would you describe the use of shape in this work?

David Hostetler, *Folk Goddess III.*

Hackberry wood, paint, 53" x 31" x 18" (134.6 x 78.7 x 45.7 cm). Photograph: Lynthia Eiler.

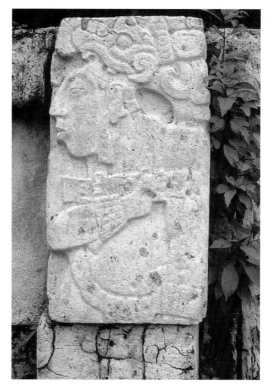

Fig. 5–5. The Mayan person carved on this relief sculpture wears a complex headdress. What other details in the artwork might suggest this person's role in society?

Palenque, Mexico, Priest or Ruler, East Court of Palace, 720–783 AD.

Courtesy Davis Art Images.

stone because of its slippery surface. It is easy to carve and finish. It can also be carved with a pocketknife. Marble, limestone, and alabaster are carved with hammer and chisel. Granite, commonly used for tombstones, requires extremely hard tools with carbide tips or a thermal torch that uses heat to shatter the stone into small fragments. By adding electric or pneumatic tools, other materials such as plastic and even metal can be carved.

The process of carving is simple: know what shape you are looking for and then remove all the material about it. When asked how he carved, Michelangelo replied that he was trying to free the figure from within the stone. This involves using hammers and chisels to remove large pieces and abrasive tools such as files and rasps to remove smaller particles. **Sandpapers** are used to achieve a fine finish. Tools keep removing particles

Fig. 5–6. This student's work demonstrates how a highly polished surface can contrast with a coarser, unpolished surface.

Gilbert Perez, *Untitled*, 1992.

Soapstone, 16" x 16" x 22" (40.6 x 40.6 55.8 cm). South Mountain High School, Phoenix, Arizona. Instructor: George Reiley.

from large to small; rasps to files and grits of sandpaper from coarse to fine. Some of the stone may be left in a rough or unfinished state.

Try It Secure several grits of sandpaper from coarse to fine. Take a piece of soft wood (such as pine) and test the sanding abilities. Start with the coarser grit, then go through succeeding finer grits, in order, until a very smooth surface is left. Notice that each new grit of sandpaper "scratches" the surface marks left by the previous grit. In effect, each finer grit reduces the marks into smaller scratches, then removes them with even smaller grits. In the end, the grits can be so fine that they leave no visible sign of the original scratches.

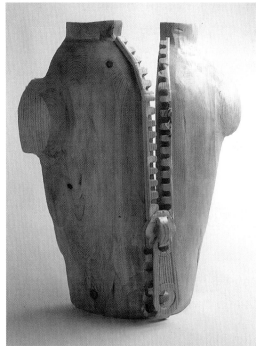

Fig. 5–7. How would you describe the sensory and expressive qualities of this work?

Morgan Watkins, *Zipped Up?*, 2000.

Wood, 22" x 18" x 8" (55.8 x 45.7 x 20.3 cm). Courtesy of the artist.

Fig. 5–8. Laminating—gluing thin layers of wood together—is a technique artists use to create variety in wood sculpture. This wood piece was then accented with copper and bronze.

James Mellick, *Messengers*, 1991.

Walnut, curly maple, copper, bronze, 30" x 36" x 12" (76.2 x 91.4 x 30.5 cm). © 1995 James Mellick, private collection, Amsterdam.

Carving Plaster

Before you start to carve, plan your work by making models and sketches. A clay model is an ideal reference model for a plaster carving. It allows you to visualize all sizes and proportions. Drawings from your sketchbook will also help, especially if you can visualize all sides of the work.

Carving tools such as X-acto knives, pocketknives, and even kitchen knives work well with plaster. If available, wood carving gouges are good to use (if they arc not to bc uscd on wood again). Hammers and chisels are not advised, because plaster is easily fractured or broken,

Fig. 5–10. Plaster can be applied to an armature and then carved down.

Ann Lott, *Used Pocket Knife*, 1994.

Plaster, 24" x 12" x 10" (61 x 30.5 x 25.4 cm). Instructor: Arthur Williams.

Fig. 5–9. A clay model was created for this plaster carving. For beginning sculptors, it is helpful if the model is the same size as the planned piece.

Fig. 5–11. A relief is being carved from a cast block of plaster by Courtney Loesche.

Ocean Springs High School, Ocean Springs, Mississippi. Instructor: Andres Hill.

Fig. 5–12. Color was added to the plaster to create this expressive scene. Notice the shadows cast by the deep relief lines.

Courtney Loesche, *Egyptian Carving*, 2002.

Plaster and acrylic, 18" x 30" x 1" (45.7 x 76.2 x 2.5 cm). Ocean Springs High School, Ocean Springs, Mississippi. Instructor: Andres Hill.

Fig. 5–13. Student Amir Freeman is carving in plaster using a wire-ended modeling tool.

Varina High School, Richmond, Virginia. Instructor: Gretchen Behre.

especially if the tool "wedges" into the work. A Surform rasp, a rasp with a hole in it, is ideal for working damp plaster, while steel files and rasps are better for working dry plaster. Regular window screen wire easily sands damp plaster because it allows the plaster to fall through the screen mesh as it is being rubbed. Sandpaper from 80 to 200 grit can be used to finish the dry work.

• Using the normal mixing techniques for plaster from the chapter on casting, small containers such as drinking cups can be filled with plaster to be hardened into carving shapes. Larger plaster pieces can be more easily carved if **vermiculite** (small particles of a lightweight, hydrated silicate mineral that are used in nurseries to help aerate the soil) has been stirred into the premixed plaster prior to pouring it. (Vermiculite will leave a porous rough surface.) Larger molds can be paper milk cartons or plastic bottles. Mold containers must be impervious to moisture, strong enough to hold the required amount of plaster without distortion, yet easily removed. Small cardboard boxes or other molds can be used if they are lined with a plastic garbage bag to prevent moisture saturation.

Safety Note Plaster dust and vermiculite dust can be harmful to the lungs. Wear a mask or respirator and work in a well-ventilated location.

• Carving should begin as soon as the plaster is firm enough to remain solid (the set stage). Large amounts need to be removed as quickly as possible, since the plaster is growing harder by the minute as it is continually setting up. Refer to sketches or models prepared ahead of time. Keep working as long as practical in order to enjoy the ease of the fresh, softer plaster.

Fig. 5–14. A cup of plaster is used for the carving project.

• As the plaster continues to cure, it becomes stronger but also more difficult to carve. This allows the artist to secure a more fragile form and greater detail. Scraping with a hard object can smooth the surface, while rubbing the plaster with a section of screen wire serves as the beginning of the sanding process. Regular sandpapers just tend to clog up, becoming useless, when attempting to sand wet plaster. Plaster must have circulating air or open space in which to dry. If it's stored in a tight locker, the slow drying will result in mold. If it's set in the sun, the plaster will dry faster, but unevenly, sometimes warping larger works.

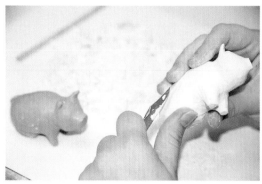

Fig. 5–15. A pocketknife is used for carving. Notice the clay model used for reference.

Fig. 5–16. A small plaster sculpture has been carved from a cup-cast piece.

Andres Hill, *Hammerhead*, 1994.

Carved plaster, approx. 5" x 4" x 1" (12.7 x 10.2 x 2.5 cm). Instructor: Arthur Williams.

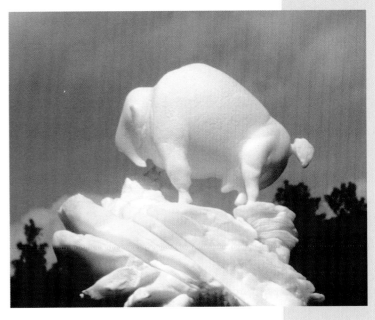

Fig. 5–17. A student's first attempt at hand carving in alabaster produced a work of depth and intricacy. How did the student arrange the composition to create balance?

Andres Hill, *Buffalo*, 1994.

Alabaster, 10" x 10" x 5" (25.4 x 25.4 x 12.7 cm). Instructor: Arthur Williams.

• Once the plaster has reached the dry stage, files, rasps, and sandpaper can be used without clogging. While plaster can be painted, many prefer to keep it in a pure white stage to best exhibit the form.

Note It Brushing the tool cutting surfaces with a wire brush is a great way to keep plaster-working tools clean and cleared of plaster particles, especially if the plaster still contains moisture.

Carving Stone

Stonework is one of the oldest forms of sculpture. Stonehenge, the imposing stone circle created on the Salisbury Plain in England, was erected more than 4,000 years ago. Stones range from soft to extremely hard, from white to black with most colors in between, and from a pure simple color to a multitude of colors and textures within the same stone.

Kinds of Stone

• Steatite is one of the easiest stones to carve because it is one of the softest stones available to a sculptor. The colors are usually in the gray or green range, though many other colors are available.
• Alabaster is a preferred carving stone because of its beautiful range of colors. Depending on where the stone comes from, it can be translucent or opaque

white, pink, red, green, orange, or brown and is often veined. The finish can be very fine. In fact, alabaster is sometimes mistaken for marble.
• Limestone is usually in shades of buff or gray, though the color can range from white to faded black. Its best carving quality is its predictability because of seemingly little grain to the stone. Since most limestone is rather porous, the finishes are seldom reflective.

Fig. 5–18. How did the artist use texture and value to create a dramatic composition?

Arthur Williams, *Split Seed*.

Serpentine and alabaster, 12" (30.5 cm) diameter.

Fig. 5–19. Using mechanical saws to cut the base parts adds to a carving.
George Montano, *One on the Mountain*.
Stone/adobe, 14" x 8" x 8" (35.5 x 20.3 x 20.3 cm).

necessary for carving granite is expensive and is best left for large works. The color range is tremendous; they can vary from white to pure black with reds, blues, grays, and many other colors as well.

Safety Note When working with stone, you should always wear a respirator. Good ventilation is necessary. Goggles should also be worn. If power tools are used, gloves are needed to protect your hands.

Discuss It How important is it to sign your work? Not only did Michelangelo state his name, but he identified himself as "the Florentine" on his *Pietà*. Did you know that galleries will refuse to take contemporary sculptures without the artist's signature on them? Should the name be legible? How would you inscribe your name on a work?

• Sandstone is an unusual stone to carve; it tends to break into large pieces along fissures in the stone. Good sandstone is moderately difficult to carve. The colors vary, but are usually a red, buff, or rust. Sandstone contains a large amount of free silica and should never be carved without a respirator.

• Marble is the most preferred carving stone because of its favorable carving characteristics, its strength, the colors available, and the fine finishes that can be obtained. Carving in marble is relatively slow as compared to alabaster, but much more predictable. The range of colors seems unlimited with nearly 300 varieties available in the United States alone.

• Granite is the hardest stone and the most difficult to carve, but it is the most impervious to weather. The equipment

Fig. 5–20. White marble is an excellent medium to emphasize form.
Sarah Sweetwater, *Maya* (closeup), 1990.
Italian alabaster, 26" x 14" x 11" (66 x 35.5 x 28 cm).

Michelangelo

Throughout history, there have been many great stone carvers. While we admire and respect the carvings found in the Egyptian tombs, the artists remain unknown. Only in more recent centuries have artists begun to sign their work. One was Michelangelo Buonarroti.

Michelangelo (1475–1564) began as a painter's apprentice at about the age of fourteen in Florence, Italy. Soon he realized his love for three-dimensional work, so he became a sculptor. He lived where beautiful white marble was quarried, even to this day. He enjoyed going out early in the morning to look at the brightness of the freshly quarried stone and to hit a new block to hear the "ring" when the stone was flawless.

Michelangelo was a remarkable artist. He finished a *Pietà* in marble when he was only twenty-three years old. The work was carved from a single block of marble. The folds of the drapery and the feeling of flesh are superbly handled. It was immediately installed in St. Peter's Basilica in Rome. Afterward, Michelangelo stood back to enjoy the comments of the viewers—but they did not know who carved the sculpture. Some guessed various artists, but no one knew of young Michelangelo. That night, by lamplight, Michelangelo returned to the chapel and boldly carved across Mary's robe sash, "Michelangelo Buonarroti, the Florentine, made it."

Michelangelo's sculpture is remarkable for its balance and sense of tension and movement. Some of his other works, including his *David* (**Fig. 1–10**, p. 8), are among the best-

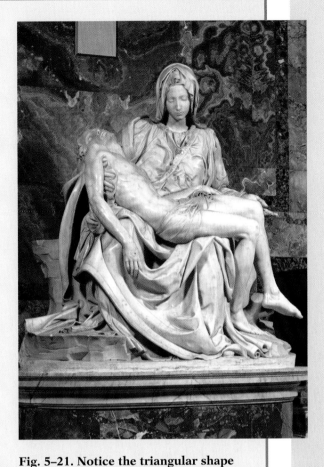

Fig. 5–21. Notice the triangular shape made by Michelangelo's arrangement of the figures. How does the overall shape create a feeling of stability and calm?
Michelangelo, *Pietà*. 1498–1500.
Marble, 5' x 8½' (1.5 x 2.6 m), St. Peter's, Vatican, Rome, Italy. Photo Credit: Scala. © ARS, New York.

known Renaissance sculptures in the world. He influenced many later artists, including Géricault and Rodin.

Michelangelo's tools were very similar to those used today. They included various sizes of hammers and a selection of tempered chisels, beginning with a "point," progressing through tooth chisels, and ending with flat chisels. He sanded his work with gritted powders of various sizes from coarse all the way up to extremely fine powders for polishing the work.

Carve Marble

Carving stones of greater hardness, such as marble, requires hammers and chisels. These can be operated pneumatically, electrically, or by hand. T Barney is the chosen demonstrator.

The stone is roughed out with a hammer and point.

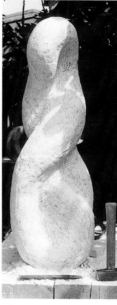

The sculpture is refined with a tooth chisel and mallet.

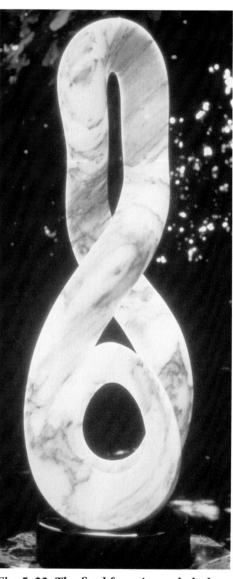

Fig. 5–22. The final form is sanded, then polished.

T Barney, *Moirae*.

Carrara marble, 36" x 18" x 12" (92.3 x 46.2 x 30.8 cm).

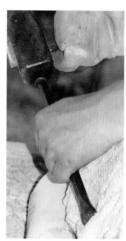

A tooth chisel is used to clear the point marks.

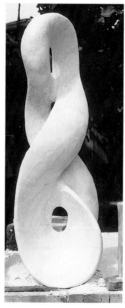

The shape is thinned with flat chisels before sanding.

Texture

Texture is the way a surface feels to the touch. Sculptors work with actual textures of materials, whether the coarse grain of wood or the smoothness of chrome metal. The sculptor can manipulate these textures through the use of tools; for example, smoothing a normally bumpy surface or roughing up an even texture. To maximize textural qualities, the sculptor must also think about light, which defines textures through highlights and shadows. The artist may also emphasize textures through the use of contrasting materials or colors, as in the work shown in **Fig. 5–8**, p. 106.

Carving Wood

Wood carving has a long tradition in sculpture. Many hand tools have remained the same over the centuries. However, power tools have added a new dimension with the saving of time and effort that enables the professional wood carver to complete works at a faster pace.

Wood is an inherently beautiful material. Because it was once alive and growing, it is part of our everyday environment. Wood imparts a warmth through its multicolored growth rings. It invites us to touch it, to enjoy this natural, unassuming material.

Wood is used in many different ways by sculptors. It can be left in its natural state, stained, or even painted. It can also be laminated. **Laminating** is gluing or pegging pieces of lumber together, either for artistic design or to create a larger piece of wood to carve. It is pleasant to

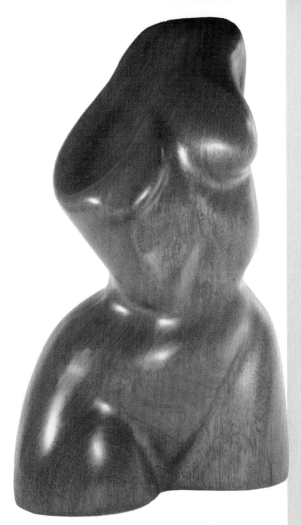

Fig. 5–23. A laminated mahogany figure exhibits the natural beauty of wood.
Elisa O'Neal, *Figure*, 1999.
Mahogany, 17" x 11" x 7" (43.2 x 28 x 17.8 cm). Instructor: Arthur Williams.

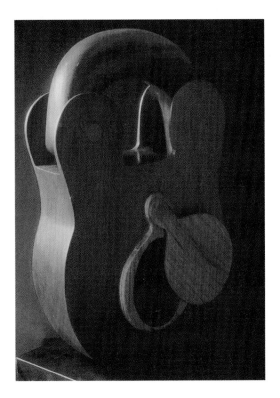

Fig. 5–24. Sculpture that has moving parts like this lock requires careful planning and sharp tools. Notice how light reflects off the curved shape of this piece.
Lisa Milhollin, *Antique Lock*, 2000.
Mahogany, 23" x 6" x 16" (58 x 15.2 x 40.5 cm). Instructor: Arthur Williams.

For Your Sketchbook

Stone usually requires that the form be rather solid in order to avoid breakage of appendages. Assign the students to sketch several ideas that could be carved in a more solid form as opposed to a linear form. If their forms are figurative, encourage students to keep the arms and legs tightly connected to the body.

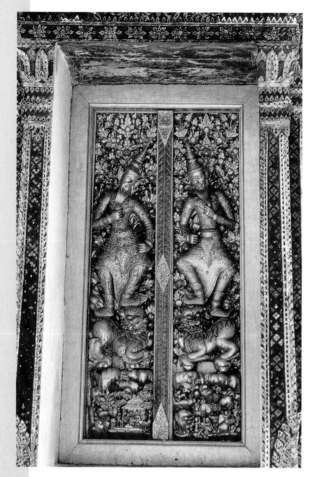

Fig. 5–25. These gilded wooden doors were carved for the palace of Wat Phra Keo in Bangkok, Thailand.

Bangkok, Thailand, *Royal Chapel Door,* Wat Phra Keo, 1800–1880.

Courtesy Davis Art Images.

Fig. 5–26. Student Lance Labadons begins to oil a wood carving. See how it brings out the darker color.

work with the many varieties of wood. Their different characteristics lend themselves to special uses. Oak is known for its hardness and beauty; it is an excellent wood for cabinet-making. Balsa is known for its light weight and ease of use; it allows model airplane makers to design planes that are lightweight, quick to build, and can immediately fly. Bass wood is treasured for its ease in carving and whittling. Several woods are often combined to create even more beauty, such as is found in a hand-built violin.

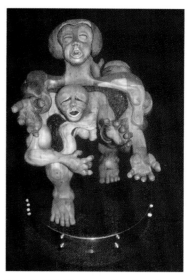

Fig. 5–27. Various laminations create an expressive sculpture.

Wayne Forbes, *Clonal Scream.*

Laminated wood, 30" x 30" x 36" (76 x 76 x 91 cm).

Sharpening Wood Tools

Wood tools must be kept close to "razor sharp" in order to carve without tearing the wood. Do not attempt to sharpen a wood tool on an electric grinder, or it will lose its "temper," or hardness of edge. Heat causes the metal to soften: overheating prevents the metal from holding a sharp edge for long. The tools must be sharpened on a sharpening stone, the best being a combination stone (coarse on one side and fine grit on the other side). A lubricating oil can be used with these stones to make the process smoother and quicker.

Sharpening gouges is the hardest to do, but with practice it can become second nature. Start on the rough side of the stone and drag the tool edge across the stone while gradually rolling the tip.

Fig. 5–28. Sharpening a gouge on a sharpening stone requires practice. The technique is to roll the gouge cutting edge along the sharpening stone.

Carve Wood

Wood carving involves using gouges, chisels, files, rasps, and sandpapers. This demonstration uses a large piece of walnut.

The carver, T Barney, is pictured with a large gouge as he roughs out the form.

The work is further carved. Notice the yellow drawing on the wood.

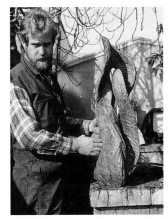

Once the basic shape is defined, the sculptor begins to cut through the wood.

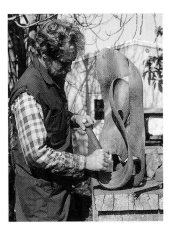

The basic form is refined further with a Surform rasp.

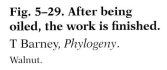

Several grits of sandpaper are used to smooth the surface.

Fig. 5–29. After being oiled, the work is finished.
T Barney, *Phylogeny*.
Walnut.

Always keep the cutting angle the same. Repeat this until the edge is straight and sharp. Sharpening oil can be added during the process. Turn over the stone to the fine grit side and repeat. A burr (thin turned-up tool edge) may form. If so, gently drag it across the stone edge to remove it and then continue. Get into a habit of periodically stopping your carving to touch up the tool edge with a sharpening.

Studio Experience
Steatite Carving

You will carve a small piece of steatite as a handheld tactile piece. Steatite is a versatile stone that is easy to carve and easy to finish. It is available in a multitude of colors from different parts of the world. It has a soapy feeling, because it contains so much talc. Though steatite is harder than plaster, it can still be carved with most of the same tools. This would include the X-acto knife, pocketknife, files, rasps, even table knives. One benefit of steatite is its ability to take a fine finish resulting in a polished final form. Your sculpture should not have a flat base, since it is designed to be handheld. It should be designed so that it fits comfortably in the hands, being about the size of a hardball. The idea of a tactile piece is one of enjoyment by the hands.

Before You Begin

• First, make a model (in clay) that can be held comfortably in your hand, no larger than a hardball, but about the same size as the projected carving.
• Make at least one hole or entrance into it (but not more than three) where the thumb can fit.

You will need:
• some modeling clay
• a piece of steatite
• a knife or other small carving tool
• files, rasps, and sandpapers
• a finishing wax
• a face mask or respirator

Create It

1 Using the clay model as a guide, begin by roughing out the stone shape, corners first; then slowly realize the shape of the model. Holes should be completed last in order to maintain strength in the stone as it is carved. Carving should be from all sides, all over the stone. The stone should not be struck; internal damage could result.

Carving with a pocketknife.

2 Once the shape is realized, it can be rasped, filed, even scraped, and then sanded with 60–600 or higher grits. Sanding with the lower grits (60–80) *must* be complete prior to using higher-number grits. What is missed with a low grit will be extremely difficult to fix with higher grits. Beginning with 220 grit, the stone can be wet sanded with wet-or-dry papers using water as a cleaner and lubricant. This keeps fine dust particles down.

Using a coping saw.

3 The final work can be waxed with a hard paste wax such as colorless carnauba (Tree Wax brand). It is used to enhance the finish. It will produce a beautiful shine. Waxes will also cause stone surfaces to become extremely slick. Take care in handling them.

Sanding the stone.

The finished work.

Check It Does the shape fit comfortably in your hands? Have you eliminated all of the jagged edges?

Note It When finishing with sandpaper, stone needs to be dusted (cleaned) off after each paper grit. Otherwise, just one small remaining particle can get under the paper of a higher grit and continue to scratch (sand) the work.

Fig. 5–30. This student's nile green steatite handheld sculpture uses organic, free-flowing shapes.

Chris Cornett, *Green Tactile*, 2002.

Nile green steatite, 5½" x 3" x 2½" (14 x 7.6 x 6.3 cm). Instructor: Arthur Williams.

Safety Note Steatite carving produces a fine powder that can cause serious respiratory problems. Respirators should be used when steatite is carved in a confined area. Spilled dust is so slippery that it can cause serious accidents if not completely removed.

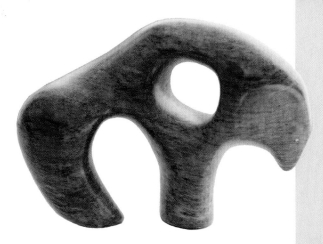

Fig. 5–31. A simple but effective form demands attention.

Jett Leake, *Buffalo*, 1999.

Steatite, 4" x 6" x 2" (10 x 15.2 x 5 cm). Instructor: Arthur Williams.

Sketchbook Connection

Sketch several ideas before carving. Draw a box around them to show how they would fit into a solid material such as wood, stone, or plaster. While some stones can be acquired in geometric dimensions, most stones are irregular in shape.

Rubric: Studio Assessment

4	3	2	1
Touchability • Fits in hand • No base • Nonobjective • Use holes or Impressions • Texture			
Sculpture comfortably palm-size; no base, nonobjective; uses impressions or holes and smooth textures that invite and delight the sense of touch all over the surface.	Sculpture comfortably palm-size; no base, nonobjective; uses impressions or holes and smooth textures that invite and delight the sense of touch over most of surface.	Sculpture palm-size and/or fairly nonobjective; uses impressions or holes and smooth textures but feels unfinished (rough or jagged) in some areas; seems to have a base.	Sculpture needs much more hand interactivity—too hard to hold/feel with whole hand; not enough depth in impressions; may have definite base or very unfinished surface texture.
Highly tactile, inviting	Tactile, pleasing	Needs work but on track	Significant problems
Craftsmanship/Tool Use • Finished quality • Respected Pproperties of stone • Safety Awareness			
All of the time—tools and carving methods used safely and appropriately resulting in an unmarred surface; work area and tools kept in clean, safe condition.	Most of the time—tools and carving methods used safely and appropriately resulting in a smooth, finished surface; work area and tools kept in clean, safe condition.	Some of the time—tools and carving methods used safely and appropriately; work area and tools kept in clean, safe condition; some technical flaws visible on sculpture's surface.	Infrequently—tools and carving methods used safely and appropriately; work area and tools kept in clean, safe condition; noticeable technical flaws on sculpture's surface.
Controlled, skillful, appropriate	Careful, appropriate	More care and practice indicated	Unsafe working methods, poor technique
Work Process • Observation/Exploration • Sketches • Iteration of idea • Refinement of idea • Reflection			
All products and time on-task exhibit strong personal interest and independent drive.	Most products and time on-task meet assignment expectations; some independence exhibited.	Uneven effort in products and/or time on-task—lacks some steps of process.	Products and/or time on-task minimal; lacks many steps of process.
Exceeds expectations, independent	Meets expectations, satisfactory	Needs prompting, hit and miss	Disengaged, inattentive

Web Links

There are many sites where you can purchase and learn more about stone. These two are recommended:

www.sculpt.com

www.montoya sculpture.com

Career Profile
Enzo Torcoletti

Enzo Torcoletti was born in Italy. Though he studied art there, he majored in English literature at the University of Windsor in Canada. He was intrigued by stone carving, so he decided to take a sculpture class. In his own words: "And before I knew it, I was kind of hooked." He finished his English degree and then returned to obtain a BFA in sculpture. Wanting to learn even more about sculpture, he went on to receive his MFA at Florida State University in Tallahassee. He has been creating sculpture and working at Flagler College in St. Augustine, Florida, ever since. It

Photograph: Walter Coker/Folio Weekly.

wasn't long, however, before he was again spending time in Italy. Now he has a house and studio near Urbino, Italy, where he goes every summer to "recharge my batteries."

What is your favorite stone to carve?
Enzo: I use whatever I can find in stone. I use marble; I even use some granite. Granite has such durability. It really resists you. I like marble, the crystallizing, gristling quality. I can do so much with it in terms of details.

How do you begin one of your works?
Enzo: I start out with the figure as a reference, but then sometimes they become very abstract. I first do sketches, then Styrofoam models.

What advice do you have for younger sculptors?
Enzo: Do the images that you love to do and the materials that you love to do, regardless of what your friends are doing. Don't chase after what is fashionable. You are going to have to do your own thing. Develop your own audience, your own signature [work] and do it because you love it, not because you think you are going to get wealthy or famous. That should be a secondary thing. Keep producing a lot of art.

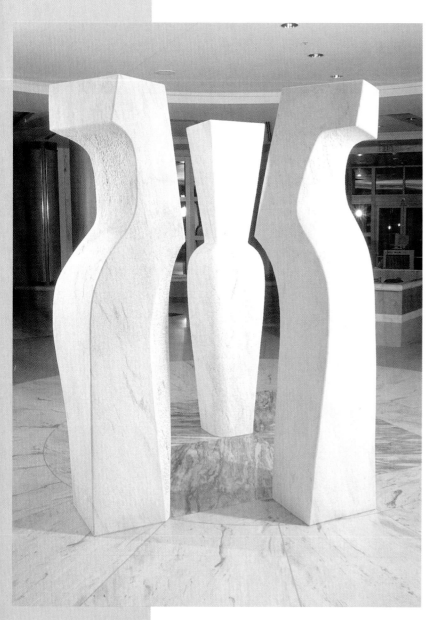

Fig. 5–32. The artist here used a simple form to suggest many possible meanings.
Enzo Torcoletti, *Concurrence Gateway*, 1999.
White Georgia marble, 10' (3 m) high. Photograph: Ken Hawkins.

Chapter Review

Recall What should be added to pre-mixed plaster to make carving larger pieces of plaster easier?

Understand What is the difference between a two-dimensional form and a three-dimensional one?

Analyze Select an artwork from this chapter and describe the forms as simple or complex, geometric or organic.

Apply Explore textures by touch only. With your eyes closed, let your hands identify objects and surfaces by the sensation delivered to your fingertips. Group together objects that have different textures. Then study what creates these textures.

Synthesize Compare wood carving to stone carving. What are the similarities? What are the differences?

Evaluate Sculptor Enzo Torcoletti believes that "in sculpture—or any human activity—we cannot forget the past. We are part of the past, the present, and the future." Have students study Torcoletti's *Concurrence Gateway* (**Fig. 5–32**). Discuss how his work has been influenced by historical sculpture traditions. What aspects of current sculpture traditions or movements has he incorporated into this work? If students think his work is a combination of the two, do they think it is a successful combination? Why?

Writing about Art
Imagine that you are on a committee to purchase artwork for your school. Select one of the artworks from this chapter to present to the whole committee. Write why you chose this particular piece and explain why you think it would make an appropriate choice for a certain location in the school.

For Your Portfolio

Document in slides or photographs your different carving experiences in plaster, wood, and stone. Indicate title, date, and the size of the different pieces. Write a description of the technique you used for each and include it with your slides or photographs.

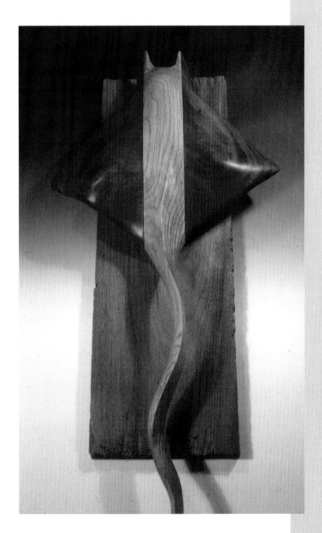

Fig. 5–33. Laminating various woods can create a dramatic effect.
Michael Adkins, *Manta Ray*, 1997.
Oak, walnut, oiled, 13" x 42" (33 x 106.7 cm). Instructor: Arthur Williams.

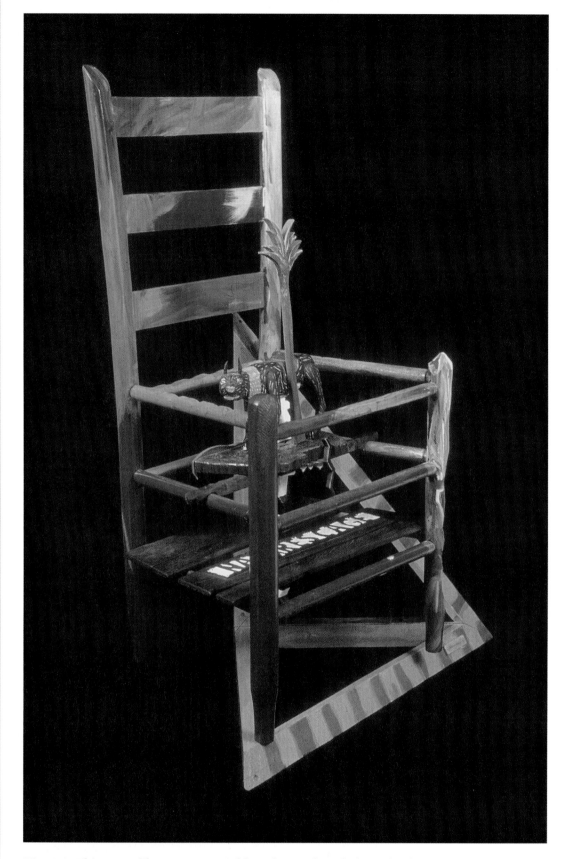

Fig. 6–1. This assemblage was created by taking a found object (a chair) and combining it with the artist's own carving. What unifies this work of many individual parts?
Ted Ramsey, *Nature's Cage*, 2000.
Carved wood, enamel paint, 37" x 20" x 17" (94 x 50.8 x 43 cm). Photograph: Patrick Young.

6 Construction and Assemblage

n previous chapters, you learned about centuries-old sculpture processes, such as modeling, carving, and casting. Now you will explore more recently developed methods of creating sculpture.

The early twentieth century saw drastic changes in sculpture. Rather than using traditional carving, modeling, or casting processes and materials, sculptors began using new materials in revolutionary ways. They began building sculptural **constructions,** artworks made by joining together components of one or a variety of materials (mixed media). Artists began experimenting with natural and industrial materials, including plywood, sheet metal, and plastics, to create sculpture. They used factory methods, such as welding and soldering, to construct large-scale metalworks.

Other sculptors turned to everyday, common objects and natural materials, which they built into thematic, often small-scale compositions called **assemblages.** By stripping familiar objects of their practical use, removing them from their usual surroundings, and juxtaposing them in innovative ways, artists imbue these materials with new meanings. Such works alter our perception and experience of ordinary items. Artists today use nearly any material to construct three-dimensional artworks of myriad shapes and sizes.

metal

In this chapter, you will find inspiration in a variety of materials as you learn to work with various construction tools and techniques. You will gain experience with such versatile media as wood, wire, paper, and papier-

paper

wood

mâché. Creating your own assemblage, using found materials, will allow you to put into practice your understanding of this inventive sculptural process.

New Materials, New Processes

Today, sculptors have at their disposal a wide range of diverse materials to use in creating three-dimensional works. They can choose literally any material to explore as an art medium and often invent new processes to join these objects into a successful sculpture. This chapter will explore the two types of construction—heavy and light—as well as assemblage. It will highlight the materials, tools, and techniques common to each method. Many of the materials you will work with, including wood, metal scraps, and wire, can be used in both construction and assemblage processes, so do not limit yourself!

Fig. 6–2. The unusual combination of papier-mâché, PVC piping, and a found skull was used to create this piece. How is this sculpture different from a traditionally carved or modeled animal?

David McCanless, *Hard Winter*, 2002.

Sequoyah High School, Canton, Georgia. Instructor: Kim Gratton.

Fig. 6–3. Keeping all the found objects the same color unifies this work composed of several diverse parts.

Michael Fong, *Metallic Wonder*.

Found objects, 16" x 14" x 8" (40.6 x 35.5 x 20.3 cm). Northeast High School, Oakland Park, Florida. Instructor: Marion Packard.

Fig. 6–4. Assemblages do not have to be difficult. They can be constructed quickly once the form takes shape. How would you describe the various shapes used in this work?

Perci Chester, *Boneman*, 2001.

12" x 6" x 6" (30.5 x 15.2 x 15.2 cm).

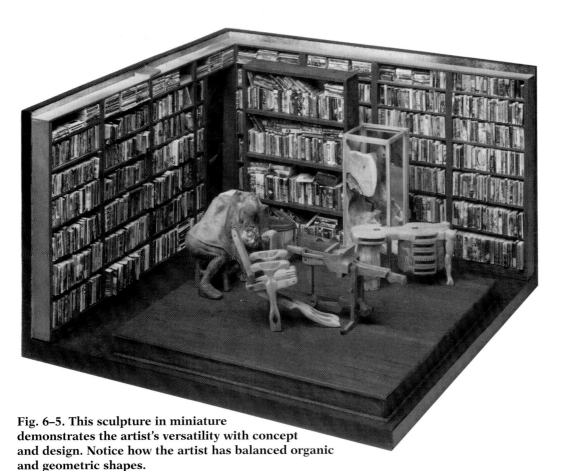

Fig. 6–5. This sculpture in miniature demonstrates the artist's versatility with concept and design. Notice how the artist has balanced organic and geometric shapes.

Michael R. Ransdell, *Figure in a Book Room*, 1998.

Construction, 9¾" x 16¼" x 16¼" (24.7 x 41 x 41 cm).

Color

In sculpture, color—produced when light strikes an object and is reflected back to the eye—is an important consideration. Sculptors must think about the natural color of the substance (wood, stone, and so on), and how it will change over time. A sculpture's aged surface is known as its patina. Patinas may also be created by treating the material's surface with chemicals. Sculptors may also paint the surface, thus changing its color. The use of a single color achieves a sense of unity. The artist of the work shown in **Fig. 6–6** used many different colors to create variety and to make each part of the sculpture stand out.

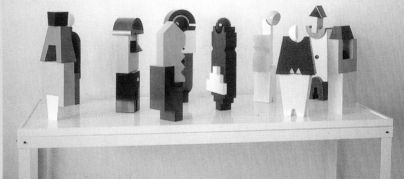

Fig. 6–6. In addition to experimenting with color, the artist here is exploring the use of geometric shapes in space. What might these side-by-side forms symbolize?

Ronald Kostyniuk, *Urban Landscape/All the President's Men Revisited*, 1992.

Aluminum, 24" x 53" x 41" (61 x 134.6 x 104 cm).

Heavy Construction

Heavy construction usually involves using raw materials such as wood or metal. The works tend to be large in scale, exploring volume and open forms and the interplay of positive and negative space.

Sculptors working with this method find their materials at building-supply stores, which stock all types of construction items, from huge sheets of plywood and plastic plumbing tubes to heavy-duty chains and iron rods. Sculptors may also collect manufactured or discarded industrial objects and machinery, such as car parts or wooden railroad ties. Whatever the material, they allow their imagination to roam, leading them to exciting new sculptural forms.

When creating constructed sculptures, sculptors typically work with construction tools used by woodworkers or metalworkers. Because of the complexity and large scale of some works, the sculptor may also choose to work with professional technicians or a machine shop, providing an idea that others then manufacture. Some constructed artworks require the use of many tools; others require minimal tool usage.

Fig. 6–7. The use of diagonal lines adds a dynamic aspect to this design. Can you name the construction skills used to create this sculpture?
Cindy Harper, *Disc*, 2001.
Cedar, aluminum, 3' x 3' x 4' (1 x 1 x 1.2 m).

As you explore this constantly evolving sculptural process, you will learn about some of the tools and materials commonly used by sculptors, past and present. With this knowledge, you will be equipped to realize your own constructed sculptures.

Fig. 6–8. With an arc-welding machine, scrap metals can be used to create large-scale sculpture at low cost.
Deborah Butterfield, *Billings*, 1996.
Found steel, 102" x 87" x 32" (260 x 221 x 81 cm).

Origins of Construction and Assemblage

Sculpture after World War II underwent radical developments, sometimes building on prewar experimentation. The flurry of intense activity in sculpture paralleled that of the abstract expressionists in painting. There was a quest for new forms of pure abstraction.

Most notable was the proliferation of artists who extended the idea of "construction." This new way of working was pioneered by Russian artists after World War I, as well as by Picasso, Calder, and some surrealists. The major innovation that came about in post–World War II construction was the use of colossal scale. In the late 1960s and early 1970s, large-scale, simple works that relied heavily on industrial construction techniques were dubbed *primary structures*.

Exactly when the first assembled work was created is not known. Assemblage was the logical outgrowth of the found-object and readymade sculptures of the surrealists. Although not considered an assemblage artist, Pablo Picasso added objects to his painted canvases in an attempt to remove the illusion of the picture plane. Marcel Duchamp created a work entitled *Bicycle Wheel* in 1913 that combined a household stool with a front bike wheel mounted in the center of it. This is definitely an assemblage, but it was not known by such a term in that period.

In the late 1950s, Louise Nevelson began exhibiting sculptures made with found objects, mostly wood, with a single unifying color coating. Her works are very stylistic, geometric, and quite formal due to the uniform scrap wood pieces, moldings, and banister posts that she used. They were called assemblages.

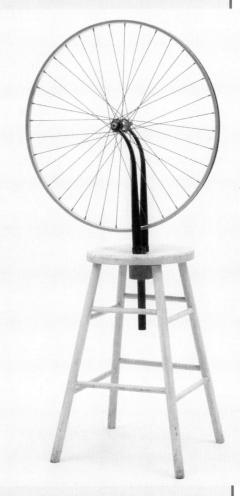

Fig. 6–9. By placing ordinary objects on display as works of art, Marcel Duchamp helped to develop a new approach to construction and subject matter.

Marcel Duchamp, *Bicycle Wheel*, 1951 (third version after lost original of 1913).

Metal wheel mounted on painted wooden stool, 50½" x 25½" x 23¾" (128.3 x 64.8 x 60.3 cm). Gift of Sidney and Harriet Janis. The Museum of Modern Art, New York. Digital Image © The Museum of Modern Art/Licensed by Scala/ARS, New York.

In the 1960s, sculptor John Chamberlain worked with body parts of wrecked cars to create a more spontaneous type of assemblage. He did nothing to change the surface color or finish. As a result of his choice of materials, his works were not only called assemblages but often referred to as "junk art."

Wood

Wood has been appreciated for centuries by sculptors worldwide. You have probably worked with wood at some time in your life, perhaps making stick figures, carving objects, or building with blocks. In its natural and unpainted state, wood projects a warm, vibrant feeling. This warmth, combined with the wonderful tactile qualities of wood, inspires the sculptor to touch, carve, and build.

Wood, in all its shapes and sizes, can be used in both heavy and light construction as well as in assemblage. It is a strong material, but one that will deteriorate over time, especially if exposed to the elements. Its strength comes from the *grain*, or "direction" of fiber, that runs the length of the trunk or tree limb. This grain provides the structure and is a very important consideration for the sculptor. For example, a piece of wood cut against the grain will likely warp or weaken. Wood may be left natural to show its texture or grain, or painted to display a unified mass. It is easy to paint but does need a sealer coat to protect it and to avoid partial absorption of the paint into its surface.

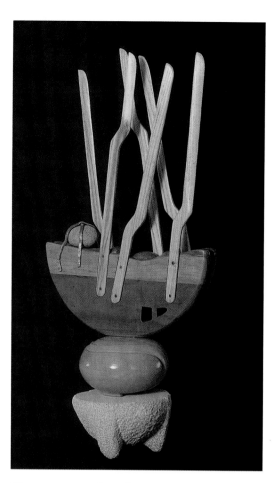

Fig. 6–11. Wood sculptures can be created using different woods as well as other media. How does the artist draw the viewer's attention in this work?
William Kolok, *Stone for Giotto*, 2000.
Wood, limestone, lead, 24" x 14" x 6" (61 x 35.5 x 15.2 cm).

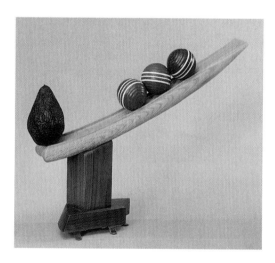

Fig. 6–10. What is most important in this piece, the subject matter or the form's balance? Why do you think so?
William Kolak, *Pear on the Tracks*, 2001.
Composition board, wood, found objects, 23" x 25" x 6" (58.4 x 63.5 x 15 cm).

Sculptors can choose from a wide variety of woods, from scraps to found driftwood to larger pieces purchased at lumberyards. Lumber is wood that is precut for use in the building trade. The most common lumber is pine, a soft wood, available in many sizes. The length is given in feet, whereas the width and thickness are given in inches, with the smallest dimension given first; therefore, a two-by-four piece of lumber is (theoretically) two inches thick by four inches wide. (Commercial lumber is actually supplied in sizes that are smaller than the stated dimensions.) Plywood, another common material found at home-supply stores and in lumberyards, is measured in exact widths and lengths, although its thickness will vary.

Begin collecting your own assortment of wood scraps by visiting local lumberyards or cabinetmaking shops. Be sure not to overlook readily available materials, such as dowels (poles) in many shapes and sizes, drawer knobs, old spools, craft sticks, and wooden slats. Search out unique shapes in natural materials such as tree branches. Select your pieces, closely study and handle them, and try different arrangements.

Techniques

In addition to its many colors, textures, and sizes, there are countless ways to cut, shape, and join wood pieces together. Carving, sawing, and gouging are common techniques to form wood into the desired shape and size. Joining methods include nailing, screwing, bolting, gluing, laminating, and pegging. Each method has its own advantages and disadvantages, depending on whether you wish the wood pieces to be movable or held tightly together.

• Nails can be used in any wood, but predrilled holes, especially in hard woods, are recommended to avoid splitting the wood or bending the nails. Note that nails prevent side motion, but do not keep the wood from coming loose.

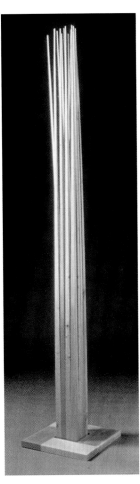

Fig. 6–12. This simple but effective design required skill in precision wood sawing. Why do you think the artist used vertical lines?

Joe Chesla, *Thrust*, 1997.

Wood, 93" x 17" x 17" (236.2 x 43 x 43 cm).

Fig. 6–13. In this fantastical creation, objects are combined in innovative ways and required the use of different kinds of woods, carving, and lamination.

James Mellick, *Ghost Dog*, 1994.

Laminated wood, carved wood, copper, 45" x 15" x 17" (114.3 x 38 x 43 cm) installed.

• Screws hold best but they also need predrilled holes. Screws draw the wood pieces together and hold them securely in both directions.
• Bolts can be used for the heaviest of joints or when the wood is intended to twist or turn.
• Gluing is the most permanent method and does not risk causing the wood to split or deform during the construction process. Carefully cut pieces can interlock like the dovetail joints on the corners of cabinet drawers; used with glue, such

Fig. 6–14. The effectiveness of this piece relies on the contrast between positive and negative shapes. The use of maple provides a warm, natural element to this geometric design.

Philip John Evett, *Maid of Honor*.

Maple, 45½" x 32" x 17" (115.5 x 81 x 43 cm). Photograph: Ansen Seal.

interlocking shapes form the very finest type of joint.

• Laminating one piece to another is another easy technique.

• Wooden pegs can be used to line up and keep the woods in place. Dowels used with glue prevent all movement, whereas unglued dowels will allow the wood pieces to move.

Metal

Metal in all shapes and forms can be arranged and joined to create a construction. The pieces may be in sheets, rods, pipes, rolled wire, or bars. Sculptors can choose from a wide variety of metals, including aluminum, steel, and brass. These three are the most reliable metals for fabrication, particularly for smaller works. All can be brazed, soldered, or welded. While surface finishes vary, all of these metals can be painted and placed outdoors.

Aluminum is a good metal for fabrication because of its light weight and corrosion-resistant surface that does not require additional finishing. It has a silver-white appearance. Steel is the most common metal for fabrication, being the least expensive, strongest, and easiest metal with which to work. In a sanded-surface state, it is gray-silver in color. It is usually finished with a coat of paint or the surface will oxidize into a natural rust color. Brass is the preferred metal to achieve a golden-colored finish. However, it needs a clear protective

Fig. 6–15. Thin sheets of metal were riveted together to create this sculpture. Notice how the sculptor incorporated the rivets as part of his design.

Michael L. Aurbach, *Witness: Conspiracy No. 3*, 1998.

Mixed media, 40" x 36" x 15" (101.6 x 91.4 x 38 cm).

coat of urethane or other finish to retain its bright surface. It is more expensive than most other metals used for fabrication.

Joining pieces of metal clearly presents more challenges than, say, joining wood. Among the many metal-fastening materials and methods are welding, screws, bolts, tap and die, and glue. Two easy-to-learn processes are presented here: riveting and soldering (see pages 133–134). Riveting is a cold method of attaching sheets of metal. Soldering, on the other hand, is a hot method used to join wire, for example. Once you have gained experience with these joining methods, you will be able to successfully work with the strong, durable material of metal.

Riveting is the process of joining materials, usually metal, with a boltlike fastener. A small metal fastener called a rivet is driven through two overlapping sheets. Its exposed ends are flattened to hold the two sheets together. Riveting is an excellent method of joining dissimilar flat materials, whether various metals, cloth, leather, plastics, or another material.

The two basic riveting methods use either a hammer or a rivet gun. Rivets for hammering usually have a flat end that is inserted through a predrilled hole. The hole is slightly larger than the diameter of the rivet. The length of the rivet should extend slightly beyond the combined materials.

Rivet guns come in manual or power versions. They squeeze the rivet (placed into a predrilled hole) so that hitting with a hammer is not required.

Wire

Sculpting with wire is an excellent way to create a three-dimensional work from a two-dimensional drawing. Indeed, a contour line drawing already looks like a wire sculpture and so is easily translated into a three-dimensional form. Wire can be used alone or with other materials to create sculptural constructions or assemblages.

Fig. 6–16. Careful metal cutting was required to compose this design. The dynamic composition keeps the viewer's eye moving from one part of the sculpture to another.
Morgan Watkins, *Continuity of Water,* 2000.
Painted steel, 24" x 42" x 18" (60.9 x 106.6 x 45.7 cm).
Courtesy of the artist.

One of the most interesting aspects of working with wire is the interplay of positive and negative spaces and shapes that result from forming this linear material. Although it can create open, linear shapes, wire can also create volume through wrapping, to form a complex wire mass with little or no transparency.

The most common and economical wires are made of steel, although copper, aluminum, and brass wires are also available at a higher cost. Wires come in varying degrees of hardness, and the soft to medium wires are easiest to manipulate. In addition, wires come in varying thicknesses, designated by gauge size. The heaviest gauge wire has the lowest number, while thin wire has high gauge numbers. Steel wire gauges range from the largest, 7/0, which is nearly .5 inch in diameter, to the smallest, 50 gauge, which is a scant .004 inch in diameter. For your

Rivet Metal

Place the materials together. It is a good idea to use strong clamps to keep them together during the early work. Select a drill that is slightly larger than the rivet body. Drill through both sheets. Check that the hole edges are clean. Place the rivet through the materials. Remember that the flat end, or head, may have a better appearance than the other end once the process is finished. If you are using a hammer, either hold a solid metal block to the flat head, or place the head end on an anvil. This provides a surface to hammer against. When you hammer, the rivet head will flatten against the metal for a tight bond.

1 Insert the rivet into the riveting tool.

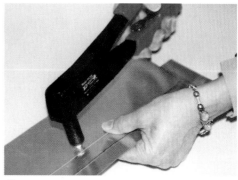

2 Then insert the rivet into the predrilled holes of the two pieces of metal to be joined.

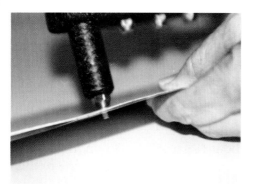

3 Squeeze the handle of the tool to flatten the rivet.

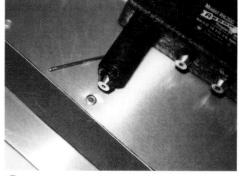

4 The two pieces joined.

purposes, wires that range from 12 to 30 gauge work best. Twelve-gauge wire is about the thickness of a wire coat hanger, whereas 30-gauge wire is as thin as sewing thread.

A trip to your local hardware or home-supply store will introduce you to some of the many types of wire available. Once you have built a small collection, begin experimenting, producing wire "sketches" by quickly manipulating the wire into figural or animal forms or nonobjective designs. Think of the process as building a sculpture with line. Try using wires of varying thicknesses or different colors to further build up your three-dimensional form. As you gain experience with wire, you can move on to the joining method known as soldering (discussed on pages 133–134). Just remember that the impor-

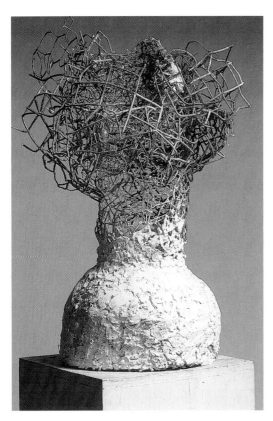

Fig. 6–17. Colorful wires mounted onto a plaster form create a strong sense of energy and movement. What image does this sculpture and its title convey?

Sylvia Wald, *Storm*.

Plaster, wire, 29" x 20" (73.6 x 50.8 cm).

Fig. 6–18. In this sculpture, the artist wove the various wire strands as if she was weaving a basket. Notice how the curving, waving lines create a feeling of motion.

Connie Herring, *Vessels of Life* (detail), 1996.

Copper wire, 58" x 28" x 28" (147.3 x 71 x 71 cm).

tant thing when working with wire is to create a form that occupies space in full three dimension, rather than a flat design.

Types of Wire

Wire can be found in many strengths, sizes, and colors. Stainless steel wire is extremely rigid, stiff, and difficult to bend. It displays a bright silver color that does not rust. Light silver-colored galvanized wire is steel with a thin coating that prevents it from rusting. Brass wire is popular for its golden color. Nonstranded clothesline wire can be used, especially for armatures, as can heavier electrical cable.

The most common and least expensive wire is a steel wire called baling wire. It is about 14 gauge, or .08 inch in thickness. Baling wire is very soft, easily bent and manipulated. However, it easily rusts. Though strong, baling wire does not support length or weight without bending or crimpling due to its extreme plasticity.

Fig. 6–19. Wire can have a quality similar to pencil lines drawn on paper. In these wire pieces, the use of simple shapes allows the sculptor to "draw" in three dimensions.

Eddie Lange, *Insects*.

Wire, 12" x 13" x 4" (30.5 x 33 x 10 cm). Northeast High School, Oakland Park, Florida. Instructor: Marion Packard.

Fig. 6–20. In this composition, can you see how an artist can create volume with wire?
Stacey Ivie, *El Pez*.
Wire, 18" x 12" x 8" (45.7 x 30.5 x 20.3 cm). Canyon View High School, Cedar City, Utah. Instructor: Jared Ward.

Clothesline wire is about 12 gauge, or .1055 inch in thickness. Many brass wires are thin, such as 22 gauge, which is about .0286 inch in thickness. Very thin wires over 30 gauge (.014 inch) are seldom used for wire sculpture.

Wire usually comes in rolls. Baling wire can come in small diameter rolls to large ones weighing 25 pounds or more. Fine wires are wound on small spools. Clothesline wire and stiffer wires are sold in larger diameter coils. Larger diameter coil wire is easier to straighten than wire from smaller diameter coils.

Techniques

Wire is a flexible, versatile art material. It may be manipulated by bending, curving, or twisting, or it may be tied, wound, or wrapped about itself to create more solid volume. The method depends on the wire and the concept or design you envision for your sculpture. Using simple, open shapes can create a feeling of lightness or openness in your sculpture. Tied joints can be focal points of your design,

Fig. 6–21. Notice how the use of color can enhance a simple wire form.
Jennifer Costa, *Brazed Hat*, 2002.
Brazing with steel rods, wire. East Illinois Central College, East Peoria, Illinois. Instructor: Dorothy Plummer.

whereas wound and wrapped wire can add volume.

Other materials may be added to wire for a variety of effects. The size of the work and the type of additive material will dictate the type of wire to be used. Plaster, for example, requires heavier, stronger wire—such as welding rods—for structural strength. The moisture in plaster will cause steel to rust, so it is necessary to choose either a rust-resistant wire or one that can be coated to prevent rust. *Liquid metal* might also be considered as an additive material. It is a metal-filled epoxy putty found at hardware and auto-parts stores that comes in a variety of finishes. For example, liquid aluminum combined with galvanized or aluminum wire forms a sculpture that has an appearance of raw or welded steel.

Safety Note Liquid metal and other epoxies are toxic. Wear gloves and a mask, and work in a well-ventilated area.

Soldering

One of the most useful methods of joining wire is soldering. **Soldering** is the process of joining two metals together with heat by the use of a third metal that has a lower melting point. The two metals that are to be joined must overlap or fit together tightly. The base metals (those to be welded) are heated with the third, faster-melting metal as it is slowly added to the joint. It should melt on contact and be drawn between the base parts by capillary action (the drawing and distributing

Fig. 6–23. This sculpture, made entirely of welded metal rods, creates a strong sense of texture. If you could touch this sculpture, how would it feel?
Norman Holen, *Kiwi*.
Welded steel, 11⅛" x 4¾" x 11¼" (28.3 x 12 x 28.5 cm).

of a substance between two tight surfaces) brought on by heat. The resulting bond from solder is strong, although not as strong as fusion welding.

Solder is classified as hard solder or soft solder. For working with soft solder, which melts at a lower temperature, an electric soldering iron is commonly used. The melting points for soft solders (made from lead and tin) range from 400° F to 600° F. Hard solder (silver solder) is much stronger than soft solder and is melted with a torch; the melting points vary from 1,000° F to 1,700° F.

Note It Soldering aluminum or aluminum alloys is more difficult than soldering other metals. A high-temperature aluminum solder must be used, and surfaces to be joined must be free of oxidation. Attempting to solder aluminum wire is not recommended.

Fig. 6–22. Soldering equipment.

Fig. 6–24. This sculpture was assembled using solder as part of the process. What element plays an important role in the dynamic rhythm of this sculpture?

Earl Krentzin, *Man Feeding Bird*.

Fabricated sterling, semiprecious stones, granite, birch base, 11¾" (29.8 cm) tall.

Soft soldering with an electric soldering tool is a viable method for art studios.

• Select and prepare the metals for the solder. (The metals can be dissimilar, like bronze and steel.) The surfaces need to be cleaned with emery cloth, fine sandpaper, or steel wool.

• Select the solder. The preferred solder roll wire has a rosin core. The most common soft solder is called fifty-fifty (tin-lead) and melts between 360° F and 420° F and is purchased with a separate **flux** called *soldering paste*. Sometimes acid core is used, even though it is corro-sive. Since this already contains the flux, it is simple to use but limited in scope.

• Identify the joints for soldering. These are usually one of three: the lap joint where the two metals overlap; the lock joint where the two metals appear to fold over each other; the butt joint where the two metals simply touch (this is also the weakest joint). The joints must fit well with no gaps.

• Apply the flux to the clean surface prior to heating (if it is not in the solder core).

• Using a soldering iron, heat the surfaces equally to a temperature beyond the solder melting point, which is determined by touching the solder to the surface. If it readily runs, then the heat is correct. If it balls up, it may be too cold to solder or more flux is needed. If it spatters or fumes, the surface may be too hot.

• Apply enough solder to do the job, but do not overdo it. It is more important that the solder penetrate into the joint. Too much solder does not strengthen a joint. Thicker base metals require more heat.

Note It On large or long areas to be joined, it is best to "tack" short distances or corners in order to avoid warping during the heating of large areas. Tacking is placing a small amount of solder in places or points to temporarily hold the metal.

Discuss It Does more technical knowledge make you more creative? How? Is your creativity limited by what you do or do not know? How might the knowledge and use of tools suggest new ideas for work?

Hard Solder

Student Shaviance Mitchell, from the South Carolina School for Arts and Humanities in Greenville, South Carolina, demonstrates hard soldering. The instructor is John B. Gilliam. The photographer was Frank Tribble.

1 A brass rod was selected for this project. A hammer and anvil were chosen to shape it.

2 The newly formed pieces were soldered together with silver solder.

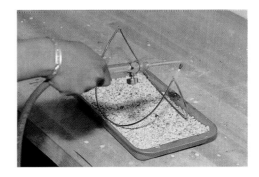

3 Once soldered, the structure was filed and sanded to eliminate sharp points.

4 A dark nylon is stretched over the form to complete it.

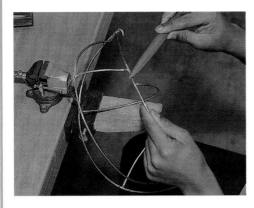

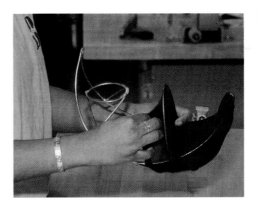

5 The resulting sculpture.

Light Construction

As you have learned, sculptors have found much inspiration in easily available industrial materials. However, creative construction materials need not come from the hardware or home-supply store; lighter-weight common materials are not to be overlooked. Paper, in its varied forms, is an exciting substance with myriad sculptural possibilities.

Unlike such materials as metal and wood, sheet paper is easily formed with minimal tools. Indeed, just crumpling a piece of paper and then carefully smoothing it out will demonstrate how simple it is to transform this two-dimensional substance into a sculptural form. Gather an assortment of different papers, such as poster board, cardboard, and good-quality artist papers (Strathmore, Bristol, Canson, and so on). Study the different qualities of the papers as well as their textures and workability. Are they easy to bend or tear? Notice how light affects the surface and how shadows are created when the materials are bent into different forms. For inspiration, consider the massive sheet-metal sculptures of heavy-construction sculptors, and think of ways to translate such forms into sculptural paper constructions.

From corrugated cardboard to delicate handmade sheets, paper is a viable artistic material. In addition to these sheet-paper forms, liquid forms, such as papier-mâché and paper pulp, can also be used to create exciting three-dimensional constructions. Exploring paper, in all its many sizes, weights, colors, and textures, will open your mind to new ways of seeing and working with a familiar everyday substance.

Fig. 6–25. Another example of student work using the soldering process.

Joe Kay, *Skin and Skeleton*.

Nylon and brass rod, 12" x 12" x 12" (30.5 x 30.5 x 30.5 cm). South Carolina School for the Arts, Greenville, South Carolina. Instructor: John B. Gilliam.

Fig. 6–26. Everyday objects can be recycled to create new forms. This student soldered an old air conditioner's copper tubing together to create a one-of-a-kind sculpture.

Eli Gold. *Brass Instrument*.

Copper, solder, 20" l x 10" h (50.8 x 25.4 cm). Instructor: Arthur Williams.

For Your Sketchbook

Visit a museum, gallery or sculpture park to view sculpture assemblages. Compile a list of the various objects artists used. Sketch pieces that interest you in your sketchbook, drawing them from several viewpoints. Come up with ideas for an assemblage sculpture that you might construct. Describe the objects you would use.

Paper

Five thousand years ago in Egypt, papyrus was used for a writing surface. It was made from the peeled-apart stalks of the papyrus plant, stacked in overlapping layers. Aztecs, Mayas, and Pacific Islanders used tree bark to make forms of paper, and early Europeans used animal skins to make parchment. In 105 AD the Chinese developed the first true paper, similar to what we use today.

Cellulose is the primary ingredient in paper. It is a cell fiber acquired by taking specific plants through a process of beating, soaking, boiling, screening, and pressing. Cotton, wheat, straw, or even sugarcane can be among the plants chosen, but wood from trees is the most commonly used source of cellulose. **Pulp** is a suspension of plant fibers in water—the raw material from which paper is manufactured.

Like wood, manufactured paper has a *grain*—a direction in which the fibers line up in parallel. Ordinarily, this grain is not noticeable, but it does add strength and determines the direction of tearing. Paper tears evenly with the grain, whereas it rips jaggedly across the grain. If paper is layered and glued in opposite directions, it becomes stronger.

Most of the paper commercially used is machined in paper mills throughout the world. High-quality artist papers are also made in this way; these can be found in art-supply stores and catalogs. However, many artists make paper by hand, one sheet at a time. This process involves using a special formula of pulp gathered from plants and fibers, or a commercially packaged dried pulp, known as linter, which is produced just for the paper-maker. Although you can choose from among this wide variety of papers, it is best to choose high-quality, acid-free

Fig. 6–27. A paper and poster board sculpture uses bright colors and interesting shapes.

Michael Checchia, *Flam Berge*.

Poster board and paper, 13" x 22" x 5" (33 x 55.8 x 12.7 cm). Northeast High School, Oakland Park, Florida. Instructor: Marion Packard.

Fig. 6–28. Sculptures made of paper do not necessarily look as if they were made of paper. Look carefully at this work. Can you tell how it was created?

Chyrl Savoy, *Sustenance*, 1992.

Polystyrene and paper, 53" x 34" x 26" (134.6 x 86.4 x 66 cm).

blunt tool such as a letter opener over the paper surface, leaving an indentation in preparation for making a cleanly folded edge. Note that creasing produces a raised line on the other side of the paper. When the paper is folded, the line should be on the inside of the fold. Scoring is similar to creasing, except that instead of a blunt tool, a sharp knife is used to partially cut the paper surface. Thick papers and cardboard are scored rather than creased. The techniques of creasing or scoring in conjunction with folding impart structural strength to paper and allow it to become a self-supporting material.

Try It The way to determine a paper's grain is to moisten a corner of the paper, then rip it in two opposite directions, lengthwise and crosswise. Ripping is more easily done with the grain than against it. You can also hold the paper up to a strong light and observe the alignment, or direction, of the fibers.

Fig. 6–29. Rolling paper into tube shapes of various sizes creates a three-dimensional composition. The use of color adds texture and unity.
Suzanne D. Le, *Tubular*.
Paper, tempera, 16" x 12" (40.6 x 30.5 cm). Eisenhower High School, Houston, Texas. Instructor: Ron Venable.

materials. See the Appendix for descriptions of papers suitable for light sculptural constructions.

Techniques

You can use a variety of techniques to create three-dimensional paper constructions. Paper is a strong yet flexible and resilient material that can be cut or torn into innumerable shapes and sizes. When tearing paper, it is best to work in the direction of the grain.

Paper may also be creased, curled, scored, and folded. All of these techniques require only simple tools, such as scissors or knives, rulers, and pencils or dowels. Creasing is done by drawing a

Fig. 6–30. An unusual type of paper was used for this paper sculpture—one-dollar bills! What message do you think the artist was trying to communicate?
Ken Little, *Buck and Doe*, 1996.
Sewn one-dollar bills, 60" (152.4 cm) tall.

Joining paper is also easy, since pieces may be tucked into folds or slots or attached using glue. Consider painting or applying color before attaching the pieces. Fasteners include tape and a variety of glues (including glue sticks).

By cutting, folding, or rolling paper you can produce sculptures that often resemble large-scale works made from sheet materials. Many large sculptures began as small cardboard models. Similar design issues are shared by small flat sheets of paper and large flat sheets of metal.

Papier-Mâché

Papier-mâché is a material made from strips or shreds of paper soaked in a binder of glue or paste. It is one of the easiest and least expensive materials for creating three-dimensional forms. Papier-mâché is commonly used by artists worldwide to create piñatas, carnival floats, and festive costumes. Historically it has been the material of choice for other purposes as well—in France it was even used for making furniture. Chinese soldiers used it to make armor before the Bronze Age.

The papier-mâché form without an armature is lightweight, quite strong and rigid, but without an armature for support it can collapse if much weight or stress is placed upon it. This is why larger forms have armatures constructed for support. While the wet material is curing (drying), the armature must be able to keep its strength and shape.

Papier-mâché is a logical choice of material for creating large-scale works. It is inexpensive and reasonably quick to assemble, although it does take a while to dry. It is easily painted and results in a lightweight, easily moved and displayed artwork.

When creating a large papier-mâché sculpture, it is always best to begin with three-dimensional models, or at least drawings of various planned views.

Armatures can be made of many materials, depending on the shape, size, or purpose. If the final work is to be a mask

Fig. 6–31. Each year Wilson High School art students produce a Día de los Muertos installation, often incorporating papier-mâché and other forms of paper objects.

Día de los Muertos.

Papier-mâché. Wilson High School, East Los Angeles, California.

Fig. 6–32. A newspaper armature is being readied for finishing in papier-mâché.

Ryan Olivera, *Toilet Man*, 2002.

36" x 29" (91.4 x 73.6 cm). Sequoyah High School, Canton, Georgia. Instructor: Kim Gratton.

or hollow costume, then the armature must be of a removable material. This is called the "indirect" method. Temporary armatures made from clay and Styrofoam are common for this method. If the armature can remain—the "direct" method—it is made of lightweight material, such as chicken wire with wood support, Styrofoam, plastic bottles, cardboard, compressed paper, or paper packed lightly and tied or taped into a shape.

Techniques

Two papier-mâché application methods are the layer and the pulp method. The layer method literally means that the paper is applied in layers. The pulp method involves using pulverized paper pulp to complete the sculpture. You might also combine the two methods.

The Layer Method The materials needed include a binder, such as flour, white glue, liquid starch, or wheat paste, and a paper, such as newspaper, craft paper, or tissue. While flour is the most accessible binder, it tends to lump up and sour if not used promptly. As a food, it is also more prone to attract insects, even after several weeks of curing. White glue mixed with an equal amount of water can be used but is considerably more expensive. Wheat paste is the most commonly used product. It is easily mixed and can be maintained for several days. White glue can be added for strength, especially for the finish coats.

(Wallpaper paste can be used for layering paper.)

Newspaper can easily be torn in strips down the page (the direction of the grain). Tearing is better than cutting, because the frayed edges provide more strength and less pattern to interrupt the design. Applying unprinted paper in alternating layers with printed paper will serve as a guide to consistency and thickness.

The torn strips are dipped into the bowl of paste, removed, and pulled through the fingers—or between the lip of the bowl and the fingers—and added over the armature. Do not oversaturate the strips with paste. Not only will this increase the drying time, but it weakens the structure.

The layers should overlap each other, with succeeding layers at a right angle (crisscross) for more support. The work should progress in thin, complete layers over the entire work. As a layer is finished, another layer can be added. Allow layers to dry before additional layers are added. Thinner layers dry more quickly. The finished work should be allowed to completely dry prior to surface painting.

When applying layers to an armature, add papier-mâché in a maximum of two layers at a time until the entire armature is covered. The exception to this could be that an armature may require lower, partial support prior to finishing. In this case, the lower part would need strong

Fig. 6–33. Students Heather Butler and Bianca Lavios at work soaking newspapers in paste for papier-mâché.
Wakefield High School, Arlington, Virginia. Instructor: Wendy Singer.

mâché added first, and then be completely dried before continuing. After several layers have been added, the work should be allowed to dry throughout. It is then coated or sealed with a layer of white glue and water (fifty-fifty mix), or gesso may be brushed on.

While papier-mâché is not a material ordinarily meant to be displayed in wet weather, it can be displayed outdoors and even take some inclement weather if it is carefully and completely sealed. However, it will not hold up for a very long time in damp weather. To protect both the surface and the design, paint it, then seal it with a layer of clear polymer. This can also add a luster to the final work.

Note It If the armature is to be removed, then a release agent such as petroleum jelly, a layer of plastic wrap, or two layers of wet (but not pasted) newsprint must be placed over the armature construction before adding paper.

The Pulp Method The advantage of the pulp method is that the pulp can be modeled, creating textures and three-dimensional (raised) designs not possible with the layer method.

Tools and materials are simple. A mixer of some sort is helpful in order to blend the pulp (a food blender works well), a pulp container, gloves, if preferred, and a draining screen or sieve. The pulp can be purchased. However, the pulp must still be blended for best results with a binder such as wheat paste and/or white glue.

The least expensive, most commonly used pulp is overnight-soaked newsprint. It is placed into a food blender to create a homogenous mass. Afterward, it is strained to remove excess water and then mixed with a binder. The binder is a solution of wheat paste and water and, preferably,

Fig. 6–34. Paper is lightweight and strong and can be modeled into all kinds of shapes. Paper can even create a sense of volume and weight.
Patricia L. Verani, *Flying Pig.*
Paper, 18' h x 30' w x 8' d (5.5 x 9 x 2.4 m).

Fig. 6–35. Because papier-mâché is easy to paint, it enables artists to add detail and color to their work. Can you see how a papier-mâché sculpture can show personality?
Abigail Olney, *Victory.*
Wire and papier-mâché. Tri-City Prep High School, Prescott, Arizona. Instructor: Susanne Rees.

Pattern

Sculptors use pattern—the repetition of lines, shapes, colors, or other design elements—to give order to a surface. Patterns may be regular and planned or random and inconsistent. They may be restricted to one or a few areas or cover the entire surface, forming an allover pattern. Patterns occur naturally in such materials as wood or marble. Sculptors also apply patterns onto surfaces to unify the various parts of the sculpture or to provide interest.

Fig. 6–36. Notice how the artist has used different shapes and colors to create a pattern in this sculpture. Can you identify the elements of the pattern?

Cherise Vlahouski, *Circulating Wishes*.

Wood, 7½" h x 8½" w (19 x 21.6 cm). Northeast High School, Oakland Park, Florida. Instructor: Marion Packard.

white glue. (The mixture should be thinner than the layer binder mix.) The resulting mix of paper and binder should be uniform, somewhere between milk and cream in body.

Depending on how large the project is, smaller wads of pulp can be mixed with binder as needed. Surplus binder is squeezed out until the pulp forms a more solid mass. It is then applied in limited thickness, being firmly pressed into the surface. Up to 50% sawdust can be added to paper pulp to permit quick buildup to the form, but it also leaves a coarse texture. Because of the nature of application, it is difficult to judge the exact thickness, but if it exceeds ¼ inch, the drying time will be greatly extended. As it is, pulp dries slowly, sometimes over a period of weeks depending on the humidity.

Note It If carefully applied, paper pictures or photocopies can help decorate the last layer, especially if the paper is white. Also, fabric can serve as a final surface decoration.

Assemblage

As you have learned, many exciting sculpture materials are right at your fingertips. The art of assemblage explores the use of still other readily available materials: found and natural objects. An assemblage is a sculpture composed of individual objects. Found objects might include scraps of metal or wood, keys, old kitchen utensils, clock mechanisms, bits of fabric, or toys. Natural objects might include driftwood, stones, vines, or seeds. There are no set rules about what objects are best to use; they may be natural or machine made, broken or discarded "junk," or new items either bought or created by the sculptor. Artists find their materials at flea markets and secondhand shops, or simply in attics or that one drawer that seems to catch all the broken toys or tools. It is not important what is used but rather that the composition achieves the feeling or statement the artist wishes to convey. Assemblages can be small or large. Often, they are referred to as "mixed media" because a variety of

materials are used. Whatever the term, the goal is to create an entirely new sculpture from the individual parts.

Assemblage artists find inspiration in the everyday—items that we use regularly but that are neglected because of their "commonness." They often recycle old objects or transform new items, providing them with a fresh life as part of an artwork. These artists discerningly choose their objects and consider them carefully, studying their shapes and sizes. They usually decide on a theme that they wish to explore and then select objects that will express that idea when they are shown together. Once the theme and the objects have been chosen, the assemblage sculptor will begin practicing with different arrangements before settling on the final composition.

To prepare for creating your own assemblage, begin by closely examining a few small items that you overlook in your daily life. Reflect on a theme that brings these objects together. Consider how certain items can be symbols and how the meanings of certain things are affected when they are placed with other objects. As you explore the art of assemblage, you will begin to appreciate all types of ordinary objects and the complex meanings these items hold.

Fig. 6–38. Artists can be very creative when working with assemblages. They can be made of anything and in any form, such as this colorful half-human, half-horse figure.

Jo Owens Murray, *Fantasy*.

Mixed media, 41" x 9" x 18" (104 x 22.8 x 45.7 cm).

Fig. 6–37. Ordinary objects can be recycled to create new forms. This assemblage is composed entirely of disposable items: paper, cloth, drinking cups, pipe cleaners, bottle caps.

Janice Pearson, *But It Won't Fly!*, 2002.

Mixed media. Instructor: Arthur Williams.

Discuss It How do you begin an assemblage? What makes an assemblage a successful and intriguing art form? Is it the form, the objects selected, the meaning conveyed? One certain answer is that an assemblage—like all art—is personal, made by personal selections by the artist. Why do you prefer some objects over others?

Studio Experience
Create an Assemblage

In this exercise you will create an assemblage. Since assemblages can be created from found objects, you have a tremendous amount of freedom in subject matter. Examine small items that you overlook in your daily life such as castaway toys, tools, or even junk found by the side of the road. Reflect on a theme that brings these objects together. Consider how the meaning of certain items is changed or affected when they are placed with other objects. As you explore the art of assemblage, you will begin to appreciate all types of ordinary objects and the complex meanings these items hold.

Before You Begin

• Search for objects to make a specific statement. Visit your closet, secondhand stores, or garage sales for objects and ideas. Study ordinary objects for their texture and form.

• Remember that all materials do not have to originate from discarded objects. Sometimes raw construction materials, such as lumber, stone, ceramic clay, plaster, and so on, can be an integral part of the assemblage.

• Sketch your ideas. Considering the objects that you have gathered, how large should the assemblage be? Do you have a dominant form or theme in mind?

Fig. 6–39. Students in Ron Koehler's class were given the assignment to create an assemblage sculpture titled *Meal Deal*. Student Andrea Drumond created her piece with polymer clay and paint.

Fig. 6–40. Wood, including plywood, was the medium of choice for student Davis Whitfield.

Fig. 6–41. Can you guess what student Caleb Wells used to assemble his fanciful *Meal Deal*?

Fig. 6–42. Student Hallie Heuser decided to create her sculpture using cardboard. Which of these four assemblages appeals to you the most? Why?

Create It

1 Once you have gathered your materials, place them together in different arrangements. Do all of the items need to be kept intact? Should you use one larger object as the main structure to support smaller items?

2 Put together trial assemblages without joining anything. Look at them from all angles under different lighting. Even though you may desire to present a definite statement, always be aware of the overall form.

3 Assemble your design. Because assemblages are composed of a variety of materials, many of the tools and techniques you have already studied can also be used in this sculptural process. For example, an assemblage composed mostly of metal parts might use soldering or riveting; one made of wooden or plastic objects might use glue or nails. Arranging your assembled structure in an old drawer or placing it on a shelf can add meaning and interest. Or you may choose to attach objects to a base made of wood or of another found material.

4 As a final step, your finished sculpture may be left natural, painted, given a patina, or coated with a preservative material such as polyurethane.

Check It Did you successfully convey your theme or idea? Does the combination of objects establish a new identity in which the whole is greater than the parts? Does the new combination present an aesthetic form?

Sketchbook Connection
Look at the artworks you have created in your portfolio in terms of continuity and change. What subjects or themes do you continue to explore throughout your artworks? Do you use the same forms, shapes, or materials? What has changed the most over time. Use a page in your sketchbook to describe your findings.

Rubric: Studio Assessment

	4	3	2	1
Thematic Statement • Inventive combinations • Variety • New connections • Delivers message	Sculpture combines diverse items in highly unusual or playful ways to promote fresh, unexpected connections between parts; well-established theme. Sophisticated, insightful, inventive	Sculpture combines diverse items in unusual or playful ways to promote some unexpected connections between parts; theme apparent. Satisfying, inventive	Broader diversity of parts needed to create more interest *or* items are used in familiar ways/combinations *or* theme is emerging. Conventional, in progress	Broader diversity of parts needed to create more interest *and* items are used in familiar ways/combinations *or* theme is undetectable. Significant problems
3-D Composition • Color • Pattern • Texture • Unity • Space • Scale	Sculpture interacts in interesting ways with surrounding space and location; selective repetition of particular elements creates strongly unified whole; scale works well with materials to promote theme. Effectively 3-D, unified	Sculpture interacts sufficiently with surrounding space and location; repetition of elements creates unified whole; scale appropriate to materials selected. Effectively 3-D, resolved	Sculpture needs more interaction with surrounding space and location *or* lacks unity; scale may be inappropriate to materials selected *or* may detract from theme. Attention to detail needed	Sculpture needs much more interaction with surrounding space and location *and* lacks unity; scale may be inappropriate to materials selected *or* may detract from theme. Unresolved, incomplete
Craftsmanship • Technical construction • Tool use • Physical balance • Degree of finish	Sculpture sturdy enough for scale; well constructed and balanced; highly effective selection and use of tools/techniques creates desired effect and sense of finish. Highly skilled, controlled, appropriate	Sculpture sturdy enough for scale; adequately balanced; a range of tools/techniques tried and used to create desired effects and sense of finish. Competent, practiced, appropriate	Construction problems lead to lack of balance or cohesiveness; *or* limited choice of tools/techniques detracts somewhat from sense of finish. More practice indicated	Sculpture very unbalanced or poorly constructed; limited or haphazard choice of tools/techniques noticeably detracts from sense of finish. Rudimentary difficulties
Work Process • Observation/Exploration • Sketches • Refinement of idea • Reflection	All products and time on-task exhibit strong personal interest and independent drive. Exceeds expectations, independent	Most products and time on-task meet assignment expectations; some independence exhibited. Meets expectations, satisfactory	Uneven effort in products and/or time on-task—lacks some steps of process. Needs prompting, hit and miss	Products and/or time on-task minimal; lacks many steps of process. Disengaged, inattentive

Career Profile
Blaine Kern

Born in 1927, designer Blaine Kern of Mardi Gras World employs more than 300 full-time people internationally. His largest studio is in New Orleans, Louisiana, where his organization is responsible for more than 80% of the parades, floats, and walking figures featured during the annual Mardi Gras event in New Orleans. Parade floats have a lengthy artistic tradition; even Leonardo daVinci designed parade floats.

You have an unusual background; how did you get started?
Blaine: I was painting signs with my dad at a real early age. I went to World War II just as it ended. Instead of telling the service I was a sign painter, I told them I was an artist. They then had me drawing pictures and doing artwork for different publications. I painted murals in mess halls. When I came home, I painted a mural of the history of medicine on a doctor's wall in a local hospital. This doctor was a captain of one of the carnival krewes [an organization of people who sponsor a Mardi Gras float]. He liked the mural, and he asked me, "Blaine, do you think you could design and paint a parade?" Well, being nineteen, I knew I could do anything. I said, "Sure." Dad and a whole bunch of other people, maybe twenty volunteers, helped me build an eleven-float parade. The first parade was a big success, and another krewe asked me to do their parade. . . .

I know that you still do some of your carnival costumes and sculptures in papier-mâché. Has the process changed much?
Blaine: We are now primarily working a lot with Styrofoam sculpture. Then we papier-mâché over the Styrofoam and spray it with a resin that gets it as hard as a rock and stands up outdoors. These hold up a lot better than older works of papier-mâché.

What advice do you offer a young artist?
Blaine: Whatever your medium is, get more proficient in it. Practice, practice, and practice some more. You learn it working, doing it. Don't become discouraged. Some teachers used to tell me, "You better apply yourself, you're never going to amount to anything." [Blaine Kern now holds two honorary doctoral degrees.]

Fig. 6–43. Kern's colorful, larger-than-life sculptures are a feature of many famous outdoor festivals.

Chapter Review

Recall List three reasons why papier-mâché is considered a good material for creating large-scale works in paper.

Understand Describe the process for layering paper.

Apply Study an ordinary object—something that you see or use every day. Now sketch this object in a new way, stripping it of its practical use and removing it from its usual surroundings. Be creative. What new meaning are you able to see?

Analyze Select a sculpture from this chapter that effectively uses pattern or color. Describe how the artist's use of pattern or color has affected your response to this work.

Synthesize Use two examples from this chapter to tell how new materials and/or processes have influenced sculptors over the last half of the twentieth century.

Evaluate Review the assemblage sculpture you created in the Studio Experience in this chapter. Write a critique of your work. List the strengths and weaknesses of your creation.

For Your Portfolio

Photograph the assemblage sculpture you created in this chapter. Document it with title, date, and size. Write a statement about the construction of your work. Include what inspired you to build this piece and why you decided to use the materials and techniques you used.

Writing about Art
Imagine being an art critic for your local newspaper. Write a review of an exhibit consisting of **Figs. 6–5, 6–16,** and **6–28** from this chapter. Write clear, persuasive statements about what you think about these pieces as works of art. Make sure to address the different media used as well as style and design.

Fig. 6–44. **What features of this composition contribute to an overall sense of strength? Notice the care this student took in design, construction, and craftsmanship.**
Karrianne Ertmer, *Kay Oz*, 2000.

Nu-Gold, copper, Plexiglas, 20" (50.8 cm) tall. Oshkosh North High School, Oshkosh, Wisconsin. Instructor: Jodie Schoonover.

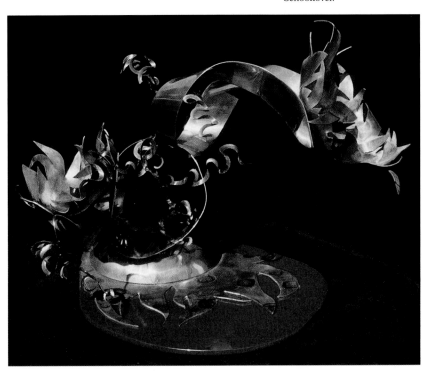

Key Terms

installations
collaborations
site specific
multimedia
earthworks

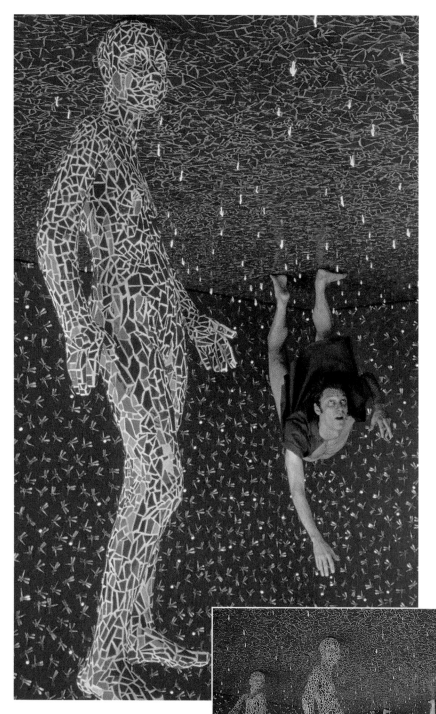

Fig. 7–1 *(detail)*. **In this installation Sandy Skoglund has created a surreal moment frozen in time. This work appears to be complicated, but it possesses few different parts, relying instead on sound engineering and meticulous labor.**

Fig. 7–2 *(full view)*. **The figures are made of glass mosaic, a tradition that the Greeks and Romans perfected thousands of years ago.**

Sandy Skoglund, *Breathing Glass*, 2000.

Installation.

7 Installation and Collaboration

magine a sculpture that you actually become a part of. As you walk through and around a space, you come into contact with objects or images that affect your senses, making you think differently about the area around you. Perhaps your presence triggers a video or a noise, further transforming your perception of the space and your place in it. Sound intriguing?

Beginning in the late 1960s and early 1970s, artists began exploring new ways to transform space and dramatically affect the viewer's experience of it. They started to create environmental **installations,** works created for a particular space, whether indoors or outside. The aim of the installation sculptor is viewer participation—the viewer takes part in the work by walking through the space and interacting with it. Like traditional sculpture, installations may be realistic or nonobjective, that is, without recognizable subject matter. Some of the light installations of James Turrell and Dan Flavin, for example, use colored light projected onto walls to explore the way people perceive space and three-dimensional forms.

Also in recent decades, artists have begun inviting others to work with them as a unique way to expand the art form of sculpture. These **collaborations** provide the opportunity to form relationships with a variety of people,

installations

from artists specializing in other media to working professionals to children, gather diverse ideas, and produce a unique artwork that encompasses a multitude of viewpoints about the same theme.

In this chapter you will learn more about collaborations and the innovative art of installations. You will also have the opportunity to work with your classmates to create your own installation.

collaborations

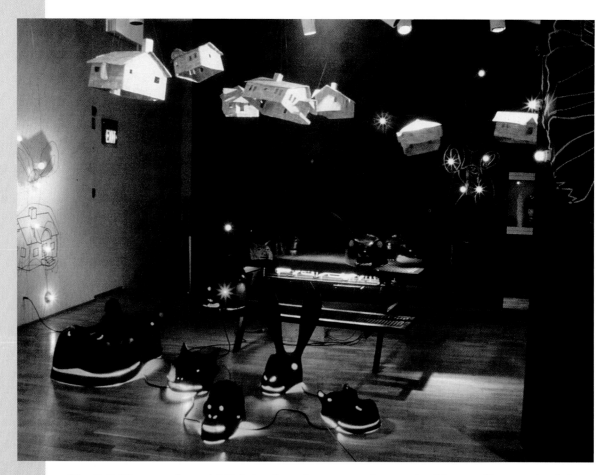

Fig. 7–3. The use of special lighting is an important element in this installation. The full-size picnic table is fabricated from steel mesh, while the floating paper houses are made of text from the King James version of the Bible.
Ken Little, *The Elements of Progress: Dreams Escape*, 1990.
Installation for the Washington Project for the Arts, Washington, DC.

Installation Art

Installations are as diverse as the artists who create them. Because the work is designed for a particular location, it is often called **site specific.** When creating an installation, the artist intends for the viewer to participate in or form a relationship with the work in the space provided. The space may be a room in a gallery or museum, the corner of a store or school, or in a field, or on the beach—almost any space can be transformed by an installation. Whatever the space, the viewer is invited to be an active participant, sometimes through the use of interactive elements, such as sounds or images that are triggered by movement. Other times, the viewer is asked to actually modify the work by touching or moving things—or even removing things—as directed by the artist.

The composition of an installation is also varied. Most installation artists build their works around a theme, drawing the viewer into the space through a series of related objects, images, or experiences connected to the overarching message. The installation may be composed of sculptural forms, paintings or drawings, video or sound, lasers or other technological innovations, everyday objects, or a combination of any of these. The installations that are made of several different art forms are known as **multimedia** works.

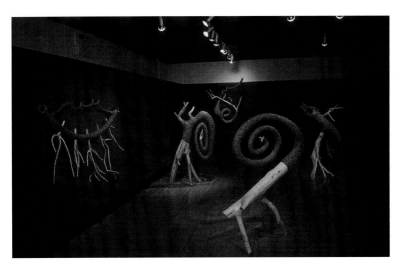

Fig. 7–4. Notice how the whimsical spiral forms in this work create a sense of dynamic energy.

Duane Paxson, *Spiral Dancers Installation*, 2000.

Wood, resin, fiberglass, acrylic, 144" x 360" x 216".

Because installations are total environments in which the entire space is transformed, and often located in unusual places, they are usually temporary. Many are dismantled and sometimes even destroyed. Thus, the only record of the work is in the viewer's mind, a photograph or video, and perhaps the artist's or a critic's description of it.

Discuss It What problems does this kind of artwork pose for museums collecting it? What happens when things start to deteriorate? What about those that use video or other equipment that breaks down or becomes obsolete? Many artists also include diagrams and detailed instructions about how to display the installation. Why would a museum wish to invest in such a problematic art form?

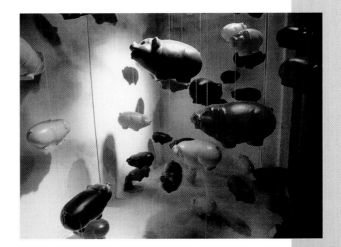

Fig. 7–5 *(detail)*. By placing a recognizable object in an unusual position, an installation artist can challenge the viewer's expectations.

Fig. 7–6 *(full view)*. How are unity and variety combined in this work?

Janice Kluge, *Pigs in Heaven*, 1999.

Photograph: Lee Isaacs.

Installation Examples

Some artists create enclosed, life-size environments in plaster and other materials. George Segal's environments are based on details from everyday life. You can become a part of his environments by moving around them and viewing them from different angles. His sculptures represent everyday people doing everyday things. However, the contrast of real and unreal in his work creates a sense of mystery and isolation.

Some contemporary installation artists create works of art that are not meant to be permanent. Artist Sandy Skoglund creates environments that balance fantasy and reality. Her works challenge viewers with their unconventional, dreamlike images. In works like *Breathing Glass* (**Figs. 7–1 and 7–2,** p. 148), which includes thousands of individual glass dragonflies displayed against a blue background, and *Raining Popcorn* (**Fig. 7–7**),

she encourages viewers to question what we usually take for granted. Because of the intricate nature of her arrangements and the fact that she uses live models, her installations are frequently completed in her studio. She then shares her work with others through the photographic images of her installations that she herself makes.

Another kind of installation art are outdoor projects that involve the real environment of land, sky, and water. These works are called land or **earthworks**—sculptures produced in the outdoors with natural materials. Here artists alter the natural surroundings to heighten the sense of space or form. In many cases, the earth itself is the main material, though it can vary to include concrete, brick, wood, and other building materials. The goal of some artists working in this medium is to make art accessible to more people than would be the case in a gallery or museum. An example is Tanya

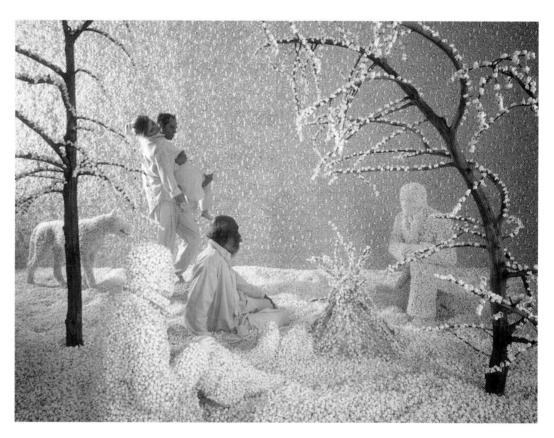

Fig. 7–7. Sandy Skoglund uses dreamlike images to ask questions about modern society. What would it be like to enter the special world of *Raining Popcorn*?
Sandy Skoglund, *Raining Popcorn*, 2001.
Installation.

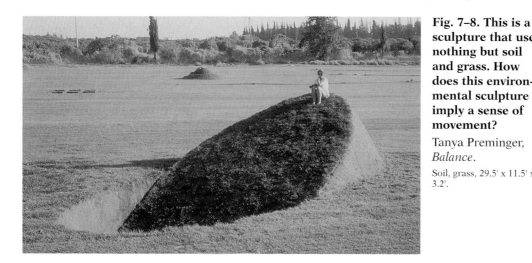

Fig. 7–8. This is a sculpture that uses nothing but soil and grass. How does this environmental sculpture imply a sense of movement?

Tanya Preminger, *Balance*.

Soil, grass, 29.5' x 11.5' x 3.2'.

Preminger's *Balance* (**Fig. 7–8**), where the artist utilized grass and soil to create an unexpected form. Her earthen sculpture urges viewers to consider their relationship with the natural landscape.

Herb Parker's nature-based sculptures are often described as "grass temples." In his *Sella Santuario* (**Figs. 7–9** and **7–10**) he makes a metal skeleton that he then covers with sod, wood, and stone to create a structure with an interior, grottolike environment. His environmental sculpture invites participation and, as the title suggests, creates a contemplative natural sanctuary.

Jesús Moroles's largest single work, *The Houston Police Officers Memorial* (**Fig. 7–11,** p. 154), is made of granite. This formally balanced sculpture consists of an earthen stepped pyramid surrounded by four equal, inverted stepped pyramids excavated from the ground. The installation operates on several levels. While the city landscape where police officers worked is incorporated as part of the sculpture's background, the lower area provides a more meditative space encircled by the sculpture's walls.

Fig. 7–9 *(exterior)*. **In this environmental sculpture something familiar, earth and sod, becomes something mysterious.**

Fig. 7–10 *(interior)*. **The design creates a meditative, natural environment.**

Herb Parker, *Sella Santuario*.

Wood, stone, earth, sod, steel wire, 14' x 18' x 20'.

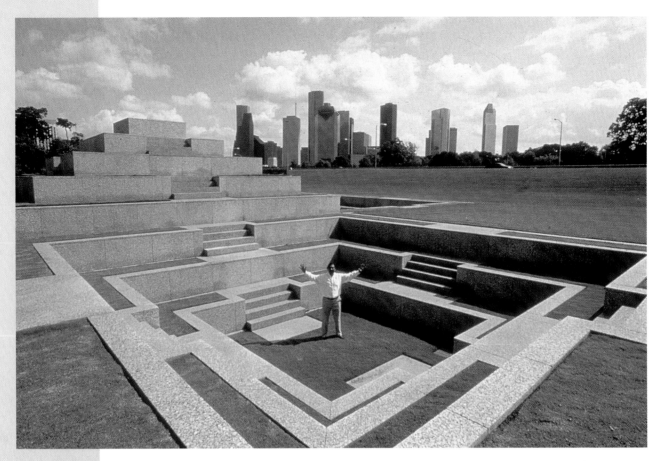

Fig. 7–11. The artist has made this memorial a part of the environment surrounding it. What ancient Mesoamerican culture influenced his design?

Jesús Moroles, *Houston Police Officers Memorial*.

Texas granite, earth, grass, water, 23' x 120' x 120'. Photographer: Evan Agostin.

Movement and Rhythm

Movement in sculpture may be actual, as in the moving parts of a mobile, or implied, as in the work shown in **Fig. 7–4,** on p. 151. Here, the artist used curving and spiraling lines to create a feeling of swaying, dancelike motion.

Rhythm is a closely related design principle: it is a pattern of movement caused by shapes or forms, colors, or lines that occur in organized repetition. Rhythm may be regular or alternating, smooth or jerky, slow or fast, as well as progressive. Movement and rhythm can also influence the viewer's mood and feelings. In this work, the groupings of similar forms create an irregular, jazzy rhythm.

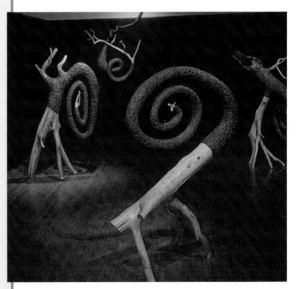

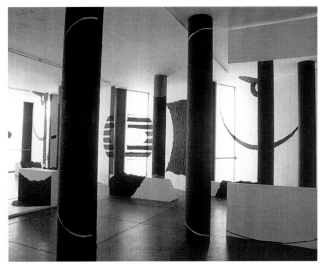

Fig. 7–12. View 1.

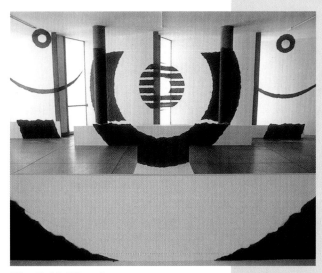

Fig. 7–13. View 2.

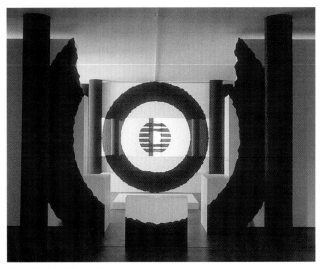

Fig. 7–14. View 3.

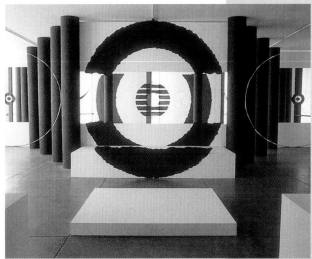

Fig. 7–15. View 4.

As viewers move from one point of view to another in this installation, they become active participants in "arranging" the segments of the work into a final form. Notice how the artist has created an ever-changing pattern by repeating lines and shapes.

Thomas Macaulay, *Installation for Harvard University*, 1988.

Paper, tape, pushpins, solo forms, existing portable walls, platforms, panels, pedestals, chairs, 12' tall x 9' long, Cambridge, Massachusetts.

Thomas Macaulay designs sculptures that he terms "environmental" installations. His focus is on audience interaction, primarily through visual changes in shape in his work. His installations use the existing architecture, but he introduces additional shapes and values to create the overall form. In his *Installation for Harvard University* (**Figs. 7–12** to **7–15**), the architecture visually alters as the viewer moves about the work—shapes appear to change into other three-dimensional forms. From what initially appear as random geometric shapes, a definite focused design emerges.

Discuss It Because of the unlimited possibilities of installations, it is difficult to suggest specific materials or tools to create one. Here are some issues to consider: What is the subject, theme, or idea that the artist wants the viewer to experience? How can this be accomplished? What kind of space will be needed or is available? Will the installation be permanent? If not, how long can it stay in place before it must be taken down or moved?

A Student Installation

On September 11, 2001 (9-11), Kreg Owens and his students at St. Stephen's and St. Agnes School in Alexandria, Virginia, were installing a large fountain on their campus, just five miles from the Pentagon. Suddenly they heard a sound like an explosion and the ground shook. Initially, they did not know what had happened and did not think much about it.

But within minutes they learned that an airplane had crashed into the Pentagon. Kreg's sculpture class decided to create a sculpture in memory of the people who lost their lives that day. It took seven weeks and 6,000 2-by-3-inch terracotta tiles to complete. Their sculpture, called *Tribute*, was designed to possess a large presence, incorporate sound (as the tiles moved), and change over time.

Fig. 7–16. Many students besides those in the sculpture class volunteered to hang tiles. The tiles were designed with an attached wire strap so they could swing in the wind.

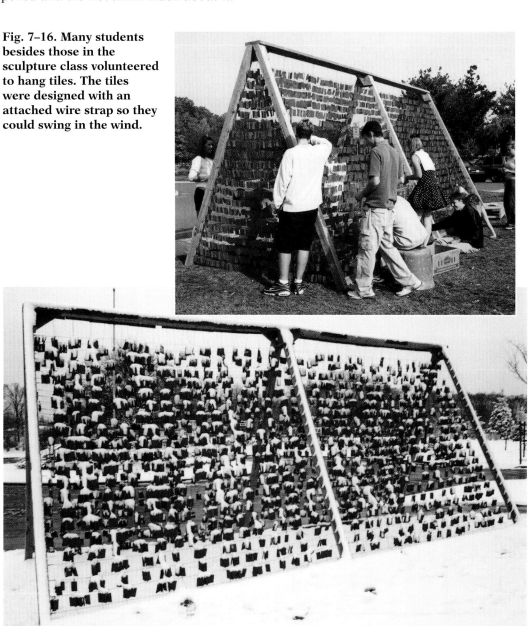

Fig. 7–17. The final work. The students wanted the work to symbolically represent lost lives: the wind blowing through the tiles represents voices, and when it rains or snows, each iron wire leaves a residue creating a unique pattern symbolizing the pattern of a life.

The sculpture students and other student volunteers of St. Stephen's and St. Agnes School, *Tribute: September 11, 2001.*

Alexandria, Virginia. Instructor: Kreg R. Owens.

The Dinner Party: A Collaborative Installation Project

Judy Chicago's *The Dinner Party*, with its new and startling images of female anatomy, created admiration and controversy when it was first exhibited in 1979. Today, this monumental, multimedia installation has been seen by more than one million viewers during its sixteen exhibitions held in six different countries.

The artist was born in 1939 in Chicago, Illinois. In the 1970s she established the Feminist Art Program with artist Miriam Schapiro at the California Institute of Art. The impact of the work produced in this program helped to initiate a worldwide feminist art movement. Chicago continues to collaborate on installation projects today, while also teaching and writing.

The Dinner Party was conceived in the tradition of women's communal sewing bees, with Chicago designing the project herself and then relying on the assistance of a workshop of more than 100 women to complete this work. *The Dinner Party* is a gigantic triangular table arrangement with places for 39 women, including Queen Hatshepsut of Egypt, Georgia O'Keeffe, and Virginia Woolf. The brilliantly colored porcelain plates reflect the specific achievements of the historical figures they represent. The plates sit on handmade place mats created by numerous needleworkers. Inscribed on the hand-cast tile floor are the names of an additional 999 women.

Chicago's incorporation of china painting, ceramics, and needlework—typical of what was considered "crafts" or "women's work," not fine

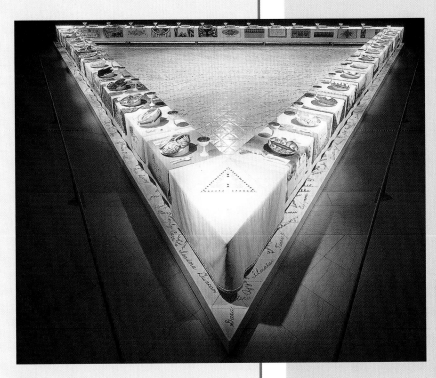

Fig. 7–18. Installation art is often difficult to capture with still photography. How would the experience of viewing this work in person differ from seeing this color image of it?

The Dinner Party, Overall Installation View, © Judy Chicago, 1979.

Mixed media, 48" x 42" x 3'. Collection of The Brooklyn Museum of Art, Gift of The Elizabeth A. Sackler Foundation. Photo: © Donald Woodman.

art—was a way of showing respect for female history and artistic production.

The artist's work is based on her personal philosophy of life, which focuses on educating the viewer about the role of women in history and art. "I try to challenge society's conception of what it is to be a woman," Chicago has said. Beginning in 2004, the work will be on permanent display at the Brooklyn Museum in New York.

Fig. 7–19. Students created this installation in response to September 11. It included a tree with origami birds to represent the people who died and the word *peace* written in the 30 different languages spoken at the school.

Dona Nobis Pacem: Tree of Hope.

Origami birds, colored chalk, 8' x 8' x 16'. North Hollywood High School, Los Angeles, California. Instructor: Cindy Maguire.

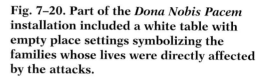

Emphasis

Emphasis is the creation of a center of interest in an artwork. This draws attention and attracts the eye, telling the viewer what the work is about by focusing on what is most important. Size, placement, contrast, and lines of movement are just a few ways to create emphasis in sculpture. What elements did the artist in **Fig. 7–22** use to create emphasis?

Fig. 7–20. Part of the *Dona Nobis Pacem* installation included a white table with empty place settings symbolizing the families whose lives were directly affected by the attacks.

Dona Nobis Pacem: Empty Place Settings.

Mixed media, 12' x 12' x 4'. North Hollywood High School, Los Angeles, California. Instructor: Cindy Maguire.

Fig. 7–21. Public art can help to create a sense of community and identity. This outdoor installation can't help but invite the public to become a part of it.

Barbara Grygutis, *American Dream*, 1994.

5' x 12' x 6'. Socrates Sculpture Park.

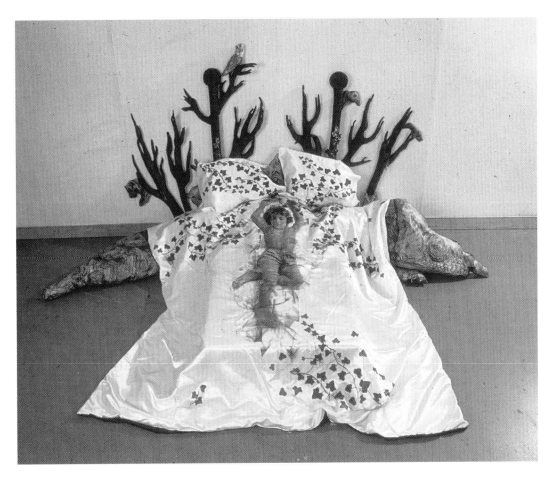

Fig. 7–22. Catherine Jansen utilizes the common material of cloth to create a whimsical installation that incorporates photography.

Catherine Jansen, *Michael's Room.*

Cloth, photography, xerography, embroidery. Scaled to life.

Sculpture Collaboration

There are many ways in which a sculpture can be constructed. Large bronze castings and fabricated steel works are sometimes not even touched by the original artist. Rather, they are designed by the sculptor, acting like an architect, and then built or assembled by specialized workers. Larger or more detailed pieces often require several workers. When the workers are artists and contribute to the actual artwork, it becomes a collaboration of talents, ideas, and techniques.

High school classes are now doing collaborations—some are large, sophisticated, and time-consuming works. This section presents examples of different approaches to collaborations. In most of

them, the teacher takes an active part, not only as an instructor, but also as an artist.

St. Stephen's and St. Agnes School: *Archway*

The sculpture class at St. Stephen's and St. Agnes School in Alexandria, Virginia, wanted to do something special as a permanent legacy for their school. The administration was consulted and gave full support for a student-designed and built archway for a proposed sculpture garden. Since the instructor, Kreg R. Owens, had a background in cast concrete, tile, and freestanding sculpture, the class was able to consider designing a large construction with permanent materials. By using ceramic clay as the major sculpture material, the cost could be kept low and funded entirely from the art stu-

dents' class fees. The only major expense was for concrete and steel.

A design proposal was drawn up and displayed in the work area for study purposes as the work progressed. The class of seven students, grades 10–12, worked together as a group; subgroups were formed for smaller, specific tasks. Heavy-duty, mobile worktables with rollers were built that, when bolted together, could contain the final form. The tables were relocated when sculpture class was not in session to permit other art classes to continue as normal in the same large classroom.

Fifteen hundred pounds of clay was mixed and students began to work with 1-inch-thick slabs of it. The work was time-consuming, as students and teacher reworked seams, smoothed surfaces, and added embellishments.

As the form progressed, structural improvements were made for stability that also required some adjustments in design. Working the clay, the students continued to improvise and enhance the design aesthetics.

Fig. 7–24. The grid is covered with a slab.

The top section alone weighed about 600 pounds with internal gridwork to support it. When the clay sculpture was complete, the initials of the school were inscribed in it. The work was then taken apart for firing in the kiln room prior to glazing. Sections were fired along natural break areas in the design. A combination of terra sigillatas, glazes, and rubbed pigments was used for the finish.

The foundation was measured, dug, reinforced with rebar, and then poured. After it was cured, the heavy work involved installing the clay pieces in place with a flexible mortar that could withstand the weather.

The students were involved in all phases of the undertaking and their problem-solving skills involved engineering, excavation, using construction materials, and scheduling. Math was constantly used to figure the amount of clay shrinkage to ensure that all parts of the final design would fit together.

The project took eleven weeks from inception to completion. Each student took great pleasure in signing his or her name into the durable concrete foundation. Both the students and the administration felt that this was a wonderful legacy for the school and its students for years to come.

Fig. 7–23. A single grid slab was created for the top of the arch. Notice the clay bracing support for each section.
Students and instructor, *Archway*, 2002.

Clay, glazes, stains, grout, mortar, copper tubing, cement. St. Stephen's and St. Agnes School, Alexander, Virginia. Instructor: Kreg R. Owens.

Fig. 7–25. Students work in groups to refine each section.

Fig. 7–26. The massive side support dries.

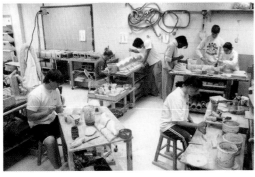

Fig. 7–27. Students glaze the individual parts in preparation for a single firing.

Fig. 7–28. The footing is poured. Notice the support conduit.

Fig. 7–29. The tiles are carefully placed together.

Fig. 7–30. After the side supports are completed, the arch sections are added.

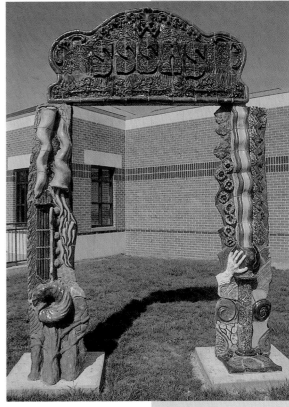

Fig. 7–31. The finished archway ready for placement.

Students and instructor, *Archway*, 2002.

Clay, glazes, stains, grout, mortar, copper tubing, cement. St. Stephen's and St. Agnes School, Alexander, Virginia. Instructor: Kreg R. Owens.

Tuscola High School: Expanding Horizons

An unusual work for high school students to undertake and complete was the design of a four-piece bronze sculpture commissioned by the North Carolina Center for the Advancement of Teaching in Cullowhee, North Carolina. It involved a great amount of time—two years—for just seven students and the instructor. This is the kind of project that takes tremendous dedication to complete. The instructor was Bill Eleazer and the student sculptors were Richie Cunningham, Stacey Hester, Clint Matthews, Eric Pryor, Wesley Hill, Wesley Leonard, and Crystal L. Ward.

The Center had commissioned a work that would include a composition consisting of an adult teacher and two students. As the students discussed ideas, sketches evolved. To better capture authentic movement and mannerisms they went as a group to an elementary school to observe children. One of the art students served as a model for the older figure.

With a sketch in hand, the Center was approached. They were initially doubtful that students could handle a project of this magnitude. In order to prove that the students were capable of doing the level of work needed, the class chose one figure and requested $500 for clay, steel, and the creation of armatures for a single piece. The proposition was simple: If the piece was not good enough, then the Center lost only $500; if it was good and the Center was pleased, the students could complete the project.

When the students finished and presented the single figure, the Center was surprised and quickly approved the project. The Center then raised the rest of the money for the molding, the bronze casting for the entire sculpture, and transportation of the completed work to the Center. The final cost was about $22,000.

From the start the superintendent and principal of the high school were involved and became enthusiastic supporters of the project. The dedicated class of six students worked during the instructor's planning period for the next two years. The students learned how to build armatures, model hands, faces, drapery, and so on. Sometimes a face was redone four and five times. One student specialized in hands.

After the modeling was completed, the artwork was trucked to a professional bronze-casting foundry, where it was professionally molded into wax. The students then checked and corrected the wax model. The sculpture was then cast into bronze as the students looked on. The students had been involved from beginning to end.

After the work was finalized, the North Carolina Center was so pleased that they hosted a special ceremony and reception to unveil the students' work. Many guests were present, including a state senator, but it was the students who were the honored guests. The sculpture has become an important symbol to the teachers at the North Carolina Center.

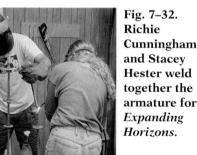

Fig. 7–32. Richie Cunningham and Stacey Hester weld together the armature for *Expanding Horizons.*

Fig. 7–33. Stacey Hester adds Styrofoam to the armature in preparation for the clay.

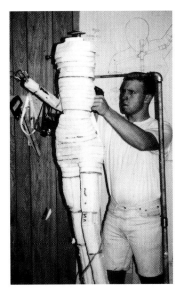

Fig. 7–34. Clint Matthews works on the proportions of the armature. Notice the scale reference drawing on the wall.

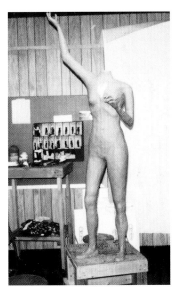

Fig. 7–35. The armature is covered with clay.

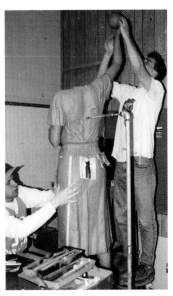

Fig. 7–36. Clint Matthews and Eric Pryor add details to the clay armature.

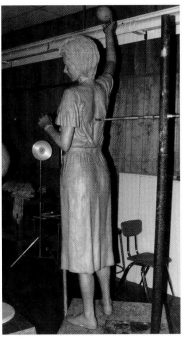
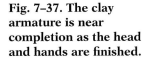

Fig. 7–37. The clay armature is near completion as the head and hands are finished.

Fig. 7–40. The final bronze sculpture on site.

Students and instructor, *Expanding Horizons*, 1996.

Cast bronze, life-size. North Carolina Center for the Advancement of Teaching, Cullowhee, North Carolina. Students: Richie Cunningham, Stacey Hester, Clint Matthews, Eric Pryor, Wesley Hill, Wesley Leonard, Crystal L. Ward. Instructor: Bill Eleazer.

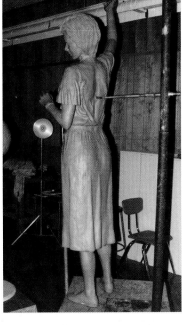

Fig. 7–38. Eric Pryor works on one of the smaller figures.

Fig. 7–39. The completed work is set up to check the final arrangement.

Studio Experience
Speak Out: A Post-it Installation

by Cindy Maguire

Instead of producing your own individual artwork, you will create a collaborative installation using Post-it Notes to record personal observations and opinions regarding a current event. The size of the work will be determined by the exhibition space available, either on or off campus.

Before You Begin

• As a class, scout for an exhibition space on campus. Consider empty rooms, a corner of the classroom, multipurpose rooms, a library, or large storage spaces not in use on campus.
• Do preliminary sketches detailing how the Post-it installation might be installed in the designated space. How many Post-its will be included? Will any other elements be included in the installation, such as sound or video?
• In small groups, present all installation designs. Present each group installation design to the class and choose one final design proposal. Submit your proposal to the school administration for final approval.
• Make a list of materials, including public relations announcements and press releases, invitations, and other materials, needed to install and exhibit the work.

You will need:
• white butcher paper
• glue gun, other glues
• multicolored Post-its
• lighting
• audiovisual equipment

Create It

1 Once the site has been identified and an initial design for the installation has been decided on, it is time to focus on the personal observations and opinions to be recorded on the Post-its. Break up into small groups to brainstorm current events that you are aware of and have a particular interest in. Come back together as a class and share your ideas. Choose one current theme or event. Individually, take 5–10 minutes to write your response to this current event or theme. Do a whip around—each student shares one thought or idea with the class.

Fig. 7–41. Students from Wilson High School in Los Angeles working on a Post-it installation with the theme "What do you want remembered?"
Instructor: Cindy Maguire.

2 Schedule a class visit to the library to research the chosen current event or theme. In class, organize a 20- to 40-minute presentation to share information. Note differences in ideas and opinions.
3 Return to your original written note on this event or theme. Rewrite your opinion on one or more Post-it Notes. Gather class Post-its for the installation procedure.
4 Review the installation site proposed earlier. Do any changes need to be made given current information and ideas generated by brainstorming, library visit, and Post-it production? If so, make changes.
5 Glue individual Post-its on pieces of white butcher paper (size to be determined by installation site). Hang the butcher paper in the installation site. Add any other installation elements such as benches, blank Post-its, video, sound, and sign-in book.
6 Create and distribute public relations materials and announcements to the school and local community. Host the opening exhibit.

Check It Does the installation site function as a unified work of art? Are there any other elements that could be added? What is the response of the viewers?

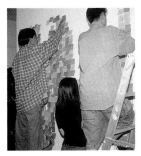

Fig. 7–42. The *Remember This* installation was installed in a gallery in East Los Angeles.
Instructor: Cindy Maguire.

Fig. 7–43. North Hollywood High School students videotape the Post-it installation they created.
Instructor: Cindy Maguire.

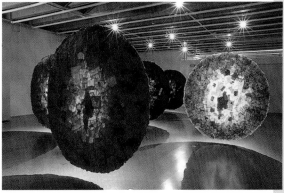

Fig. 7–44. Connie Herring created an installation based on a similar theme consisting of messages of hope incorporated into carefully spaced and suspended circles of colored paper that were then lighted.
Connie Herring, *Circle of Hope*, 2001.

Multimedia installation, seven handmade paper circles, rainbow spectrum colors, messages of hope from all over the world, recorded music composition; circles are 8' tall.
Photographer: Simon Spicer.

Sketchbook Connection

In your sketchbook, do a perspective drawing of the exhibition site, preinstallation. Make visual and numeric notations of the area of the space, and any other elements such as windows and doorways. What is the best way to hang the work? Consider viewer traffic flow and note in your sketchbook. Once the work is hung, do a postinstallation sketch documenting the installation at the site.

Rubric: Studio Assessment

4	3	2	1
Quality of Experience • Theme • Alteration of perception • Site-specific • Viewer participation			
Selection and alteration of site constantly attracts viewer participation; significantly changes expected perception of space; enhances delivery of well-developed message or theme.	Selection and alteration of site regularly attracts viewer participation; changes expected perception of space for most; effectively communicates theme.	Selection and alteration of site attracts viewer participation; changes expected perception of space for some; *or* delivers underdeveloped message or theme.	Selection and alteration of site occasionally attracts viewer participation; changes expected perception of space for some *and* delivers underdeveloped message or theme.
Engaging, surprising, effective	Communicates idea, effective	Somewhat ambiguous	Fragmented or incoherent
3-D Design • Movement • Rhythm • Emphasis • Unity			
Different elements work together smoothly and effectively to unify installation; visual rhythm moves viewer to clearly established point of emphasis.	Different elements work together to unify installation; visual rhythm adds to unity and creates movement; point of emphasis definitely evident.	Different elements work together somewhat to unify installation; visual rhythm and/or movement a little disjointed *or* point of emphasis unclear.	Different elements work together poorly—unity not present; visual rhythm *and/or* movement disjointed; point of emphasis unclear.
Well-designed flow, gets to the point	Good flow, reaches point eventually	Intermittent flow, uneven but rescue-able	Isolated experiences, little connection
Teamwork • Collaboration • Individual responsibility • Group responsibility			
Classmates worked together well throughout all steps of process; most went above and beyond to fulfill responsibilities and help each other out.	Classmates improved collaborative skills as process evolved; most fulfilled responsibilities and helped each other out.	Some classmates worked together well throughout process; some worked hard to get more of the group involved.	Few classmates worked together well throughout process *and/or* few seemed to care about each other's or their own ideas.
Full collaboration	Satisfactory collaboration	Emerging group cohesion	Limited group cohesion

Career Profile
Jesús Moroles

Internationally known and recognized for
his work with granite, Jesús Moroles
employs fifteen assistants at his studio
located in Rockport, Texas. He
has completed works of all sizes,
including a site sculpture in
Texas, the *Houston Police Officers
Memorial* (**Fig. 7–11**), that meas-
ures 120 by 120 feet. He has held
more than 100 one-person exhibi-
tions and appears in numerous
publications, including two books
specifically about his work.

How did you begin as a sculptor?
Jesús: I went into sculpture
because it was the worst grade I
got; the only B that I received in college. I
said, "I have to work at this harder," and
then I realized that the teacher just never
gave an A. I finally got into stone carving.
I thought that was interesting. Got into
different kinds of stone . . . I tried granite
. . . I had to buy tools for it. I totally fell in
love with it because it was pushing me
instead of me pushing it . . . like a total
challenge.

*What is your process for working with a
sculpture space?*
Jesús: I go to the space and explore it,
look at it, try to understand the people,
how people enter the space, what is possi-
ble. . . . By being there and working there,
I get more of an idea of what to do. A lot
of times I am just working with what is
there. I don't know if it is environ-
mental . . . maybe interactive . . . contem-
plative spaces . . . sacred spaces.

I try to bring in the community to work
with me, to help create the space, to feel
like they are part of something. I feel like
we have lost stewardship, so we don't feel
like we are part of anything, so we don't
take care of things, because we don't feel
like they belong to us. I am trying to get
this message out through the work.

I want sculpture to do more than just
be something sitting out there that people
look at. It needs to engage, create some
emotion and be interactive and create
stewardship. Sculpture needs to do more;
it has not done enough. Any place can be
a sacred place. You can change a space.

*What advice do you have for younger
sculptors to get started?*
Jesús: It never gets any better than it is
in college. You have at your disposal a
studio that you will never have again in
your life. Every studio at your finger-
tips—clay, woodworking, modeling,
life drawing—everything will be there.
I would tell them to go apprentice with
somebody after they get out of school . . . to
work with someone that uses a different
material. Everything translates, learning
from the good things and the things that
didn't work.

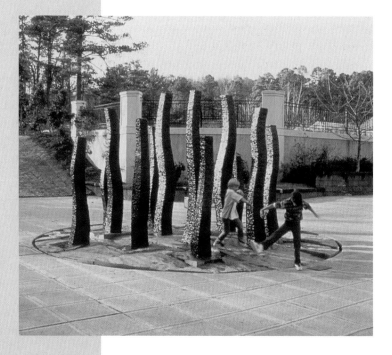

**Fig. 7–45. Moroles's granite forms are
symbolic of natural forms found in the
environment. How does his work help
viewers appreciate their environment in
new ways?**

Jesús Moroles, *Birmingham Botanical
Gardens*, 1987.

Texas premier rose granite, 5' to 11' high, Birmingham,
Alabama.

Chapter Review

Recall What does the term "land" or "earthwork" refer to in sculpture?

Understand Under what circumstances might it be important for the installation artist to know about photography?

Apply Create a maquette, a small-scale model, of a proposed installation sculpture designed for a public, outdoor space. A maquette can be made of any material that suggests how the final sculpture will look. For example, if your sculpture was made of metal sheets, you might use cardboard; various kinds of foam core can be used for curved shapes; moss can be used for environmental design, and so on.

Analyze What is the center of interest in Connie Herring's *Circle of Hope* (**Fig. 7–44**, p. 165). How did she make this part of the sculpture the most important?

Synthesize Review the career profiles that are explored in each chapter of this text. Which career would you be best suited for? Why?

Evaluate How has a student's or artist's installation artwork in this chapter challenged your expectations as a viewer?

Writing about Art
Examine one of your favorite sculptures—your own or one by another artist. Write a song lyric or poem that explains how the artist mastered the elements and principles of design in the piece you selected.

For Your Portfolio

Photograph and document examples of work on which you have collaborated. Include statements of your ideas about working on group projects. Would you rather work alone or in a group? Do you think creativity is helped or hampered in a group?

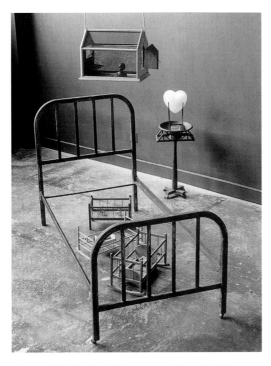

Fig. 7–46. Janice Kluge uses found objects as a basis for her installations. This work includes an ice heart that is melting.
Janice Kluge, *Lamentation*, 1998.
Room installation, objects, and ice.

Key Terms
slide portfolio
museums
galleries
art fairs
artist statement

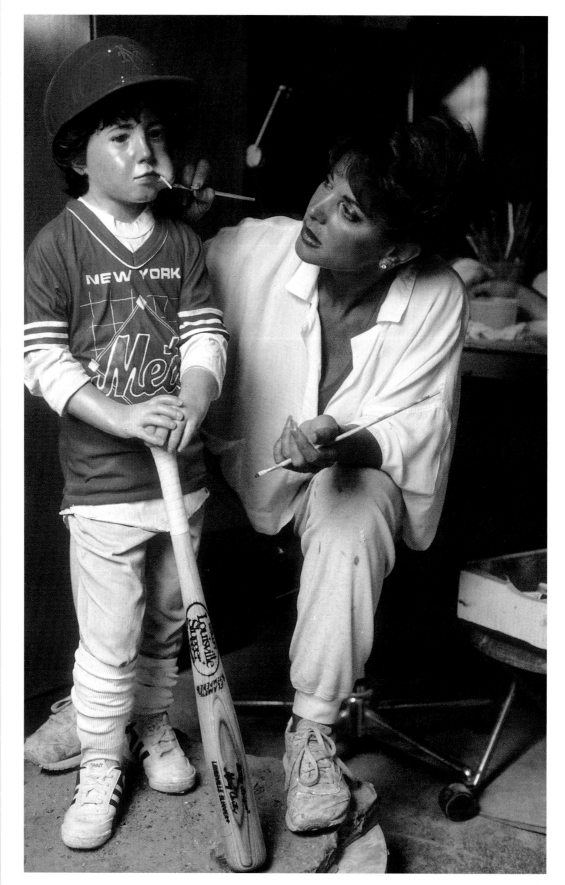

Fig. 8–1. A portfolio is an important tool for an artist. A portfolio photograph of the artist Carole A. Feuerman with a work in progress.

Carole A. Feuerman, *On Deck*.

Mixed media, life-size.

8 Portfolio, Exhibition, Education, Career

An important part of being an artist is showing your artwork to others. The exhibition process is the natural culmination of all your hard work, determination, and vision. It is your opportunity to demonstrate your skill and mastery of a medium.

You probably have many questions about the process of collecting your best work and finding appropriate places to exhibit it. Perhaps you are wondering how to show your sculpture to potential gallery owners or art schools. You may be uncertain about how to present your work in the best possible light so that others may fully appreciate your expertise. As a sculptor, you realize that the viewer's understanding of your sculpture is vital, and you want to ensure that viewers are able to clearly see the manifestation of your concept and ideas. The answers to such concerns are essential to your success as an artist.

exhibiting

In this chapter, you will learn about preparing a portfolio, including the criteria for the works it should contain, tips on how to photograph your work, and what information to include. You will also become familiar with the issues you should consider when choosing an art school. Finally, the challenge of creating a group exhibition will help you gain vital experience in this important last step of the art-making process. Armed with this knowledge, you will have a solid foundation on which to build your sculpture career.

photographing

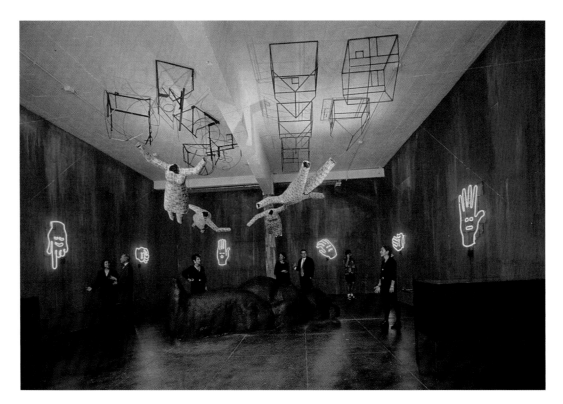

Fig. 8–2. Large installations require planning to locate the best photographic view to properly illustrate the artist's work. In this installation Ken Little also incorporated the space of the gallery into his work.

Ken Little, *Soaring: The Rules of Engagement*, 1995 installation.

ArtPace: A Foundation for Contemporary Art, San Antonio, Texas.

Preparing a Slide Portfolio

A collection of personal artwork slides arranged in an orderly manner for presentation is called a **slide portfolio,** or slide résumé. Few sculptures can be carried to an interview in a portfolio. Slides may be the only way a sculptor's work is visually evaluated. Slides are chosen that best represent the artist's work or for a specific purpose, such as an entrance portfolio for a juried art show or art school, a gallery, or perhaps a potential commission. The art school portfolio would be broad in scope, while the commission portfolio would narrow the focus to best display the sculptor's abilities in a specific type of work, material, or other required area. A general slide portfolio should always be kept ready to demonstrate a complete range of the artist's work. It is especially useful for gallery or museum applications.

Fig. 8–3. A carefully planned photograph of a relief sculpture. Notice how the photographer was able to capture the subtle background shadows that suggest shallow depth.

Ted Ramsay, *Odysseus Escaping*, 2001.

Handmade paper, carved wood, enamel, 43" x 58" x 33.5" (109 x 147.3 x 85 cm).

Taking Photographs and Slides

Slides or photographs are often the only "go-between" from the sculptor to the art buyer, potential school, or exhibit curator. Learn what will help you most with the particular person to whom you are showing your sculpture images. You might wonder if two-dimensional images can fairly represent three-dimensional work. The answer: not completely, but if well photographed they can be interpreted to your advantage.

Cameras

Although there are larger format (film size) cameras, the standard for slides is the 35mm SLR (single lens reflex). It allows the operator to see through the lens and to change the focus while the camera is in use. Almost all are automatic, compact in size, and reasonable in price. Avoid cameras that do not allow manual focus or shutter use. There are times when you will need to make manual adjustments. Film available for this camera comes in a great range of color values, brands, lighting requirements, and action speeds.

Fig. 8–4. Student Ron Ott with a 35mm camera used for taking slides.

Note It At the time of this writing, colleges were not accepting digital images, nor was I for this book. Our technology is moving fast, but at this time the equipment that could equal slide quality is still out of reach for most students. Also, few colleges have yet made adjustments to view digital images. It is possible that in time students will be required to submit a DVD computer disk as part of their entrance requirement. If digital work is requested, this chapter is as valid for digital cameras as for 35mm cameras. It is the quality of the photo that is important, not the camera. Study the

How to...

Prepare a Slide Portfolio for Academic Admission

1 Be selective. Do not show everything. You will be remembered for your weaker as well as your best work.

2 Be accurate in description. Do not try to mask poor work with colored lighting and incomplete views.

3 Label slides and present them as the school requires. If the school requests plastic sheets, use them. If a carousel tray is required, arrange your slides in one.

4 Arrange your slides carefully, especially if presented on a sheet. They can be arranged by media, size, or even color. The grouping should be a logical, single-page presentation that is attractive and focused. Many schools receive so many slides that they are initially judged only by holding up the slide sheet to the light for preliminary viewing.

5 Send only the best views.

Fig. 8–5. Placing the main light behind the sculpture in this photograph emphasizes its shape and form.

Leah Solomon, *Three Wise Men*, 2002.

Nu-Gold, 17" (43 cm) tall. Oshkosh North High School, Oshkosh, Wisconsin. Instructor: Jodie Schoonover.

manufacturer's instructions with diligence. Remember, cameras do not take photos beyond the knowledge and abilities of the operator.

Lenses

The 50mm lens that accompanies most cameras is very similar to how our eyes see the environment. Wide-angle lenses see a larger range, while telephoto lenses bring objects closer but narrow the focus. Multirange lenses such as 35–80mm allow the camera to use wide angles as well as telephoto with only a slight twist of the lens.

Film

Experiment with different brands and film speeds, but ultimately you should choose one specific film and learn how to use it to the best advantage.

The film speed determines the quality. The best ISO (film speed, also called ASA) is the lowest number that can capture the image in the available light. High-speed film can result in film grain or less detail. Thirty-five millimeter film can be obtained almost anywhere, but the specific

Fig. 8–6. The lighting used in this photograph highlights the sculpture's various media in subtle ways. To achieve this effect it is important to choose the right color film and filters.

Steve Linn, *In a Station of the Metro*.

Glass, wood, bronze, 46½" x 82" x 20½" (118 x 209 x 52 cm).

speeds and brands you want will usually come directly from a photography store.

Daylight film is best in the 100–400 ISO range. A true multipurpose film for art does not exist, although 400 speed fulfills many requirements. Films are usually designed for outdoor lighting or for the indoors with a flash. If indoor light, such as fluorescent bulbs, is present and no flash is used, then you will need a higher-speed film and possibly a blue filter to correct the color balance. Flashbulbs and electronic lighting are designed to compensate for indoor light. Film (tungsten) designated for indoor use will appear too blue when used outdoors.

Other Equipment

A dark-colored sculpture stand mounted on a large turntable greatly aids in displaying a sculpture against a backdrop. The sculpture can be rotated to create new views along the way.

A sturdy tripod is helpful when situating a shot, especially if it is to be level. A shutter-release cable attached to the camera trigger mechanism can keep the photographer from vibrating the camera as the pictures are taken.

The backdrop should not distract from the sculpture in texture, color, or shadow.

Fig. 8–7. Careful lighting and a black backdrop help to dramatize this sculpture. How would you describe the use of line in this work?

Lynn Olson, *Seated Lady*.
Cement, 25" x 20" x 15" (63.5 x 50.8 x 38 cm).

Fig. 8–8. Notice how a neutral backdrop and foreground lighting highlight the artist's use of color in this playful piece.

Patz Fowle, *South Bound Gator*, 1997.

Hand-built stoneware and porcelain, 12" x 11" x 8" (30.5 x 28 x 20.3 cm). Photograph: Joseph D. Sullivan. Private collection.

Fig. 8–9. The familiar woven texture of cotton is used here to create a lively, tactile sculpture. How does the choice of the background color in the photograph affect the result?

Marianna M. Troll, *Summer Vortex.*

Knitted cotton thread with beads and wire on a twisted wire base, 15" x 5" x 5" (38.1 x 12.7 x 12.7 cm).

Opposite values and neutral colors are best. The picture composition should not include surrounding objects, clutter, or other distractions. Choose a time of day that will enhance the form. Avoid unintentional backlighting, too bright sunlight, or heavy overcast.

A large amount of equipment is not necessary. Many photographers prefer to hold the camera in their hands as the picture is taken, rather than use a tripod. This allows the photographer to move all around the sculpture and select the best view from the camera's viewpoint.

Lighting

Lighting can make or break a good sculptural form. A camera's light meter can give accurate readings. Floodlighting (tungsten) is a constant, inexpensive light source. Other floodlights vary. Some require a filter to balance the film. Some produce color-corrected lighting. Others can produce a warm (hot) working environment. Search out good advice from a professional before selecting floodlights.

A built-in camera flash produces a good light but will destroy the form by killing the essential shadows. These flashes are too bright and will "wash out" an image. They should be used sparingly or not at all.

Portable electronic flash units produce accurate indoor lighting, allowing for slower film and consistent measurable results without heat. They can be placed about the sculpture for the best use of shadows. The main drawback is the expense.

Discuss It Which is the best lighting for three-dimensional photography: natural lighting or flash? Are there specific situations for both methods?

Enhancing the Form

Shadows enhance a sculpture as long as the form and surface are correctly depicted. Lighting from above will create lower shadows, while lighting from below creates top shadows. Lighting from one side creates shadows on the opposite side. With all of these considerations, the sculptor needs to place lighting close enough to secure detail but not so close as to erase shadows.

Ordinarily, shadows to one side enhance the form as long as the details can still be seen in the shadows. The best way to ensure this is through portrait lighting. This is accomplished by placing one light fairly close and to one side in order to create opposite-side shadows. Another light is placed slightly to the opposite side at a greater distance in order to lightly enhance details in the shadows. Sometimes a third light is

Fig. 8–10. A cluttered background and an out-of-focus, poorly lighted photograph detract from the appreciation of this sculpture.

Fig. 8–11. The same work correctly photographed. Notice how the control of light here was especially important for a successful photograph.
Arthur Williams, *Mother with Infant.*
Carved mesquite, 19" x 9" x 9" (48.3 x 22.8 x 22.8 cm).

placed under or behind the sculpture to create a rim, highlighting, or backlighting effect. Rim lighting helps a dark sculpture show up against a darker background. Special highlighting can enhance a specific area. Backlighting may be needed to show all of the form accurately.

Composition

It is best to shoot the sculpture from the same height as it is to be viewed. This would be at the sculpture's midsection. However, the location of the photographer is essential. For example, if you are photographing an outdoor sculpture, is it possible to move the viewfinder to a location that will crop out unnecessary objects such as telephone wires or vehicles? Within the slide, the sculpture needs to be carefully framed, usually toward the center and not out of the frame. Several views should be tried as well as close-up views for details.

Shooting

While many cameras have automatic focusing, it is not always best. Always check the focus for sharpness. Stay in focus; check after every shot.

The exposure must be correct. Too much or too little light is a common problem. Read the meter. Bracket shooting is good—that is, shoot one or two f-stops below and above the meter reading. This allows you to make some exposure mistakes and yet still come away with a good picture.

Fig. 8–12. Dramatic lighting and a dark background allow the viewer to focus on the sculpture. Adequately capturing the artist's use of color was also an important element in this photograph.
J. Jaia Chen, *Golden Lotus,* 1998.
Chinese bound foot cast in candy, 35" x 18" x 14" (88.9 x 45.7 x 35.5 cm).

Depth of field determines what is in sharpest focus in the frame. A small lens opening is displayed as a high-numbered f-stop. This creates a greater depth of field. A large lens opening, or low-

Fig. 8–13. The next four images show how background, lighting, and season can affect an outdoor sculpture. Here, the sculpture was photographed in the bright light of a fall afternoon.

Michael David Fox, *Darling, Don't You Think You've Over-Hosed the Garden?*

Cinderblock, rock, hose, 5' tall.

Fig. 8–14. The same work in winter, with minimal background distraction.

Fig. 8–15. A heavy snow significantly changes the form's shape.

Fig. 8–16. Lighting, in this case natural light photographed at a particular time of day, can add a dramatic element.

Fig. 8–17. The positioning of the light source can alter the perception of a form's shape and texture. Here the shadows created by the lighting add a sense of volume to this angular composition.

Clifford W. Lamoree, *Umbrella Figure.*

Steel, 80" h x 38" w x 38" d (203.2 x 96.5 x 96.5 cm).

numbered f-stop, creates a shallow depth of field, often resulting in out-of-focus slides of the sculpture.

A good way to select views for photos is to walk around the sculpture or rotate the sculpture on a turntable stand while viewing it through the camera lens. If a good angle is located, utilize it in a photo. Spatial relationships change as your angle, or point of view, changes. You may find views through the camera that you would not otherwise have noticed. Artists and photographers can take advantage of point of view to produce dramatic photographs.

Try It Practice your photo-taking skills while testing films. Use a 35mm camera. Secure two or more rolls of film of different ASA speeds, maybe 200 and 400. Use daylight film for outdoors and indoor film for indoor light. Select a location and light source. Try different ways to feature your works. Try different camera settings. Take notes. Afterward, determine the best speed of film, best shutter speed, and best framing methods.

For Your Sketchbook

Take slides of several of your sculptures using a 35mm camera that allows for manual adjustment of focus and shutter. Experiment with different brands of film and film speeds. In your sketchbook, document the results of each experiment. Choose the film that you think worked best and shoot each of your best sculptures from several different viewpoints.

Fig. 8–18. A photograph of a limestone sculpture taken at sunset. A soft light was focused on the front of the sculpture allowing the sunset to beautifully highlight the back.

Arthur Williams, *Mother with Child.*

Texas limestone, 42" x 24" x 24" (106.7 x 61 x 61 cm).

Note It If outdoor film is used for indoor work, you will need a lens filter to correct the color. The same is true if you use indoor film for outdoor shooting. Check with your film or camera dealer for the correct films and filters.

Documenting and Labeling Slides

Slides should always be labeled on the slide's front. Use an adhesive label that has been computer printed with your information. If the viewer has requested information in a certain way, follow the specified instructions. If there are no instructions, the following is an accepted way of labeling:

* At the top: the title followed by the media.
* At the bottom: the size followed by the artist's name.

All slides should be stored in trays or slide sleeves. Never store them flat. Correct storage should protect the slide from light and dust, and it should provide quick accessibility.

Fig. 8–19. Slides must be labeled and should possess a consistent labeling plan.

Preparing for Exhibition

Display

Sculptures often stand upright without any special preparation. They have a *base* (the bottom of the sculpture) they can rest upon without a problem. However, some sculptures may have a very small base that would fall over without being attached to something, while some just need additional security or a permanent location. Sometimes, a *base block* structure (round or square) is attached in order to stabilize or aesthetically display the piece. A *plinth* is used to set off the sculpture. It resembles a tabletop. Being of little depth and much width, a plinth is a good way to exhibit a sculpture, since it

Fig. 8–20. This sculpture is anchored on its own built-in stand, which becomes a part of the overall composition of this piece.
Wendell Castle, *Morning*, 2001.

Bronze, gilded wood, 50" h x 24" w x 216" d (127 x 61 x 548.5 cm). Photograph: Steve Labuzetta.

demands visual space for the work. It can be placed on a stand or on the floor.

Smaller works usually need a stand to present them at an appropriate viewing height. A stand or pedestal is designed for the display that is freestanding on the floor with enough width and depth to ensure solidity. Also, it must be strong enough to support the work. Stands are easily constructed out of plywood and finished with paint, or they can be made of particleboard that is covered with countertop material. Painted stands are best when covered with flat paint colors; black is common because it provides a neutral background that does not distract from the artwork. Stands may conceal lights or mechanical devices designed for a specific sculpture, but this is not common. The size and type of stand can greatly influence a sculpture's effect on the viewer.

Selecting an Exhibit Location

The obvious places for exhibitions are art galleries, museums, and art fairs, but other locations are also possible. A bank foyer, a library, a personal studio or home, a hotel lobby, a private business foyer, or even a restaurant may welcome sculptures. It all depends upon the energy and preparation of the artist.

Schools seldom have specific gallery space; exhibit space may be a hallway, classroom, the auditorium foyer, cafeteria, library, or even the school yard. Most such areas are unprotected or not set up to safely exhibit three-dimensional work. This is also the case with some commercial locations, so there are many problems to be aware of and solve.

Museums are excellent places for an exhibit. They contribute to the reputation of an artist, though they seldom sell works for the artist. Their purpose is primarily that of educating the public about art and artists. Since museum galleries are nonprofit, many choose not to even list the prices of the works. It is difficult to get a museum showing. The best way to begin is by entering competitions that

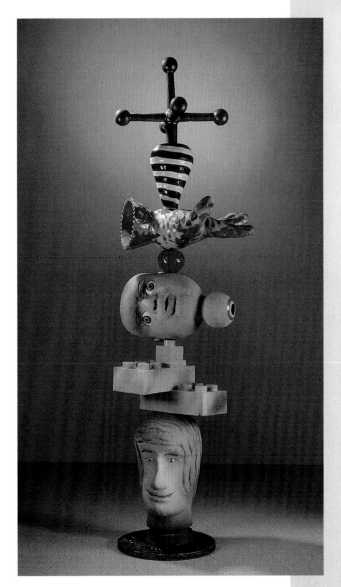

Fig. 8–21. A sculpture that is set on the floor with a small base requires careful display consideration. Why do you think the artist used this type of base to display this sculpture?
Michael Hough, *Midnight Barefoot Finds*, 1998.
Clay, 86" (218.4 cm) tall.

museums sponsor or by joining an art league that regularly holds group exhibits in a museum.

Galleries are of two types, either commercial or noncommercial (university galleries). Commercial galleries exhibit for profit, for both the gallery and the artist, while noncommercial galleries function primarily for education. If commercial galleries do not think they can sell an artist's work, they will not show it. Every gallery exhibits specific kinds of

Fig. 8–22. This exhibit space is an example of how well-placed lighting and well-organized and mounted works create an artistically pleasing environment.

Janice Kluge, *Exhibit*, 1998.

Block Art Gallery, University of Montevallo. Photograph: Lee Isaacs.

works depending upon its clientele or patrons. The young sculptor needs to research different galleries to see if they are interested in the type of sculpture he or she creates. The medium, the size, and the price range required are considerations in deciding to approach a gallery. Perhaps the gallery only exhibits representational work, for example, and the artist's work is highly abstract. Sculptors should also find out what application procedure the gallery uses and comply with it. Common procedures include personal recommendation, submission of a slide portfolio, and completion of an application form. If the gallery director is interested, an interview will be granted.

Good personal and communication skills can be as important as good work. Commercial galleries require commissions, or a fee for their services, usually a percentage ranging from 30% to 50% of the asking price of a sculpture. Most require 50%. University galleries may not require commissions, or require a lower

Fig. 8–23. Top lighting the sculptures in this exhibit produces a light that emphasizes texture and form and creates dramatic light and shadow contrast.

Dahrl Thomson, *Un/Common Ground*, 2001.

Springville Art Museum, Springville, Utah.

Fig. 8–24. Well-designed display cases can be used for smaller sculptures.
A group exhibit by students from Oshkosh North High School.
Oshkosh, Wisconsin. Instructor: Jodie Schoonover.

percentage. At a noncommercial gallery, all works are on consignment—the artist is not paid until the sculpture is sold. The best commercial galleries regularly advertise the artist's work, provide a constant display of the sculptures, and pay promptly.

Art fairs or shows in a public setting are an easy way to exhibit. The artist may be required to be a member of a group or organization. The application process may involve the presentation of a portfolio before the artwork is accepted. Fairs are designed for the artist to meet the potential buyers and to personally market the work. Exhibit space may be in an outdoor tent or an indoor mall setting. The organizers often charge based on the specific amount of exhibit space each artist receives. The artist is responsible for setting up, handling all selling transactions, and taking down the work. Exhibits last from a day to a week. The public not only comes to see the work but expects to buy. This can be an excellent way for beginning artists to sell their work. The less expensive work tends to sell fast.

Nontraditional locations such as business lobbies, libraries, or restaurants present a greater challenge. The artist will usually have to bear sole responsibility for his or her work, furnish all the display stands, and be totally responsible for the exhibit. The environment may not be designed for sculpture. Chances are the artist will need to work hard to display the sculpture in a way that will not interfere with the business. Sales do not always happen, and the business seldom keeps track of prospective customers. At best, the business will refer the potential buyer to the artist. On the positive side, apart from exhibit expenses, the business takes little, if any, sales commissions and the exposure can be quite good.

The Actual Display

Always listen to the people in charge of the space. If they are in charge of a professional art space, then they should know what they are doing. Ask questions. Be prepared to assist or do what they request, yet keep in mind that you can also inform them of your wishes. They are in charge of their space, but not of your work.

Use these basic guidelines when arranging an exhibit space:
- Check the lighting. What is available? If the exhibit is to be shown at night, is the lighting adequate? Can the sculpture be placed where lighting is best? Do not blind viewers with a light aimed directly into the path of their eyes.
- If the exhibit is shared, have you and the other artists planned it together? All artists participating deserve adequate space and lighting, but there is not always

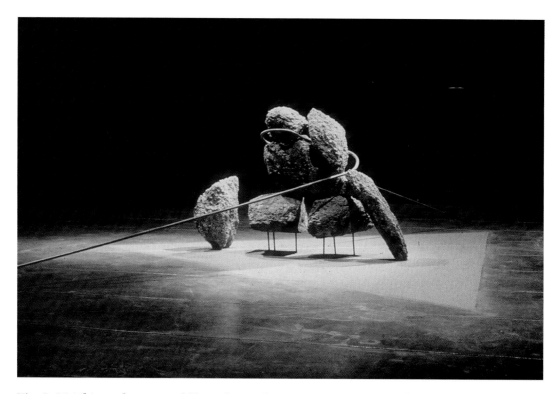

Fig. 8–25. This sculpture could have been photographed from several angles. Why do you think the artist chose this particular angle?

Milt Friedly, *Passing Through*.

Granite, steel, sand, 16' span x 3' height (4.8 x 1 m).

enough available. Be ready to share or downsize.

• Think about providing visual interest and variety. Do you want to display sculptures at various heights? Do you have adequate stands?

• When you need to show several pieces in a small space, group the work in a complementary fashion. Use stands of various heights and sizes to retain individual characteristics.

• Do not line the walls with sculpture, unless it is an absolute necessity. Three-dimensional work needs space all around it to be truly appreciated.

• Small or frail works are best put in a display case or attached to a stand in a way that ensures they cannot break or disappear.

• Do not display sculpture directly in front of a painting. Both will be compromised. Select placement for contrast and make a point of complementing the two-dimensional work with the three-dimensional sculpture.

• Provide concise and interesting gallery labels to accompany each piece. Gallery labels should include the artist's name, medium used, dimensions, information about the form and theme selected, and a sentence about what the artist is attempting to communicate to the viewer.

Safety Note Do not place sculpture in expected walking paths. Pay close attention to the safety of the display. See that the work is childproof if small children are visiting the exhibit.

Educational Preparation

While there is no substitute for the personal experience that comes from creating and completing artworks and maintaining a production schedule, an art education affords a fast way to learn how to work with various materials and techniques that might not otherwise be discovered.

After high school, colleges and art schools offer a continuation of sculpture

The Armory Show

Revolutionary—Radical—Controversial. Such terms are often used to describe art. Artworks have the power to effect change, defy the norm, and break new ground. A case in point is the group of artworks exhibited at the International Exhibition of Modern Art in New York City in 1913. Held in an armory, the exhibition became known as the Armory Show. It featured the work of many artists who are today considered masters of painting and sculpture: Constantin Brancusi, Pablo Picasso, Marcel Duchamp, Henri Matisse, and Americans William Glackens, Robert Henri, and George Bellows. But for Americans at the time, these unfamiliar artworks were shocking and even offensive. Fortunately, this response is exactly what the show's organizers were trying to achieve.

The Armory Show was a year in the making, carefully planned by a small group of artists, the Association of American Painters and Sculptors. They hoped to shock Americans out of their old notions about art and force them to accept a new aesthetic. Up to that time, artistic standards in America were set by the National Academy of Design, a museum and school established in 1825. The Academy dictated that artists work in a realistic, traditional style. As a result, most Americans were unaware of modern art movements—such as Post-Impressionism, Expressionism, Cubism—sweeping through Europe during the late nineteenth and early twentieth centuries.

Visitors to the Armory Show wandered through eighteen makeshift galleries to see, for the first time, modernist paintings, sculptures, and decorative art by about three hundred European and American artists. The show succeeded in introducing Americans to the "new art" being produced in Europe, as well as to American artists whose works did not conform to the Academy standards. What the organizers did not count on, however, was how American art would appear lacking when compared to the innovative European styles. Indeed, the majority of works bought by major American museums and collectors were by European artists. The show did more than simply shake Americans' aesthetic values and judgments about art. It compelled American artists to radically change their style and manner of working. The Armory Show changed the American art world forever.

Fig. 8–26. The Armory Show presented works that many people rejected because they didn't understand them. One critic described this sculpture as "a hardboiled egg . . . on a cube of sugar." What is your assessment?

Constantin Brancusi, *Mlle Pogany* (version I, 1913, after a marble of 1912).

Bronze, 17¼" x 8½" x 12½" (43.8 x 21.6 x 31.7 cm), on limestone base, 5¾" x 6⅛" x 7⅜" (14.6 x 15.5 x 18.7 cm). The Museum of Modern Art, New York. Acquired through the Lillie P. Bliss Bequest. Photo © The Museum of Modern Art/Licensed by Scala. © Artists Rights Society, New York.

ter of fine arts) degree. The MFA could take an additional two to three years to complete.

Check the colleges carefully. What are the different instructors' attitudes? Are any of them capable of earning a living as a professional sculptor? Have they ever? "Theory" is fine; "concepts" are good, but just what can the instructor teach? It is possible to earn a living as a sculptor, but it takes time. A good formal education can speed up the process.

education. Art programs introduce the student to all aspects of art and art history as well as sculpture. One thing is of the utmost importance: If an artist wants to learn about sculpture, there should be a full-time sculpture instructor in the art department of the school. If not, go elsewhere. The promising sculptor needs a teacher who knows the field of sculpture and who wants the student to succeed in the field. Most programs last four or five years, and the degree is the BFA (bachelor of fine arts). The student has several choices after that. One is to serve as an apprentice under a professional sculptor, another is to begin on one's own work, and another possibility is to continue with higher education by going on to graduate school to acquire an MFA (mas-

Fig. 8–28. How the individual objects in this sculpture are displayed becomes an important element in this work.

Patz Fowle, *Friends of the Library*, 2001.

Slab-built stoneware and porcelain, 23" x 12" x 11" (58.4 x 30.5 x 28 cm). Public Art, Hartsville Public Library, Hartsville, South Carolina.

Fig. 8–29. Carole Feuerman's studio has plenty of space and excellent natural lighting.
Carole A. Feuerman, *Private Studio*, Jersey City, New Jersey.
Photograph: David Finn.

Written Résumé

The artist's written résumé is a summation or brief account of his or her education, experiences, and qualifications. It is needed so that the college, client, or potential employer will have a better understanding of the artist's skills and abilities. It should include the artist's education; a list of art workshops attended with instructors' names; and a list of all exhibitions, collaborations, and prizes. It should accompany the slide portfolio, but it can also stand as its own document.

The artist's résumé is similar to other résumés except that it often includes an **artist statement.** Though colleges usually furnish an application form to submit in lieu of a written résumé, many college art departments require an artist statement to accompany the application. The artist statement is personal and individual; it has no set formula. It is important for the artist to explain what he or she is trying to accomplish as an artist in the work that has been created so far. The statement should include the technical as well as cognitive process that makes the

work unique and important to the artist. A supporting quote or statement from another artist or supporter is helpful. However, numerous rambling words or long quotes are not as effective as a concise, succinct presentation.

Using the Internet

The World Wide Web is an excellent location to check out colleges and art schools. You should look for an art department that features graphics of the work of faculty, current students, and alumni on its Web site. Other specific information to look for is: Does the college offer the program that you want? Is there a qualified instructor in your studio area? (One with an MFA degree is best.) Are the facilities and tools available capable of fulfilling the program of studies? Is there a gallery to exhibit your work with a definite calendar showing a variety of professional artists? E-mail the department for more information and contact the specific instructor in your area. A Web site for locating all colleges' Web sites is www.usnews.com.

Career
Sculpture Studio

Every sculptor has a different dream of what the perfect studio should be. However, few can afford the ideal. Instead, they adapt to what is available at the time. This is a challenge to a beginner but not an insurmountable task. Great sculptors can have humble beginnings, whether it be in a spare bedroom or a garage.

All sculpture studios have several requirements in common, depending on the work the sculptor does. The concerns include ventilation, safety, storage space, utilities and temperature control, physical comfort, and tools. All must be considered.

• Sculptors who work with large compositions need larger space, maybe an empty warehouse, while sculptors who prefer smaller works need less space.
• Ventilation that allows adequate dust and fume removal is a necessity, even in a garage.
• Safety is a key concern for those working with flammable materials as well as for those using toxic substances.
• Storage space is required for raw materials, while space for a display room is desirable.

Fig. 8–31. Spotlighting against a dark background is a good way to display sculpture that includes painted surface designs.

Nancy Cerna, *Ode to Magritte*, 2002.

Clay, acrylic, 80" x 38" x 38". Fairfield High School, Fairfield, California. Instructor: Michelle Daugherty.

• Water, gas, and proper electrical wiring are all important. Some materials require temperature control.
• Physical comfort and ergonomics, the efficient design of the workplace, are also important.
• The outdoors, if practical, is a great place to work, but the storage of tools and the finishing of work usually needs to be performed indoors.
• Tools are a necessity. The selection depends on what is needed and what is affordable. If necessary, buy used tools, one tool at a time. The author once adapted mechanics' chisels and hardware hammers for stone carving. With hard work you will, in time, acquire what you need.

Fig. 8–30. A high school art studio and classroom with student work on display.

South Mountain High School, Phoenix, Arizona. Instructor: George Reiley.

When choosing a studio location, safety must override all other concerns. Whether the issue is fumes, fire, dust, or noise, no location is valid unless the sculptor, and those in contact with him or her, will be in safe working conditions.

Sculpture as a Business

Assuming the sculptor has talent and enough space, tools, and materials to begin, business judgment will make or break the artist. Personal sales often begin with the artist creating the opportunity. Work must be made ready and shown, newspapers notified, and galleries contacted. Some artists thrive working directly with people. If an artist is to be successful, personal contact with the customer can be influential. Otherwise, a gallery or art representative is a necessity. But getting there takes effort.

Pricing work is difficult. The beginning artist initially receives what price he or she can get rather than what the work may actually be worth. The beginning artist has no reputation, maybe no representation, and the labor is long and the materials expensive.

Three concepts need to be remembered in pricing: the labor involved, the cost of the materials, and the size of the piece. Early in the artist's career, he or she may never have a good return on his or her labor, but should recover at least the material costs and enough to keep on going. Creating large pieces sometimes helps because people expect to pay more for larger works, but at the same time, larger works are usually more expensive to make. Pricing cannot be based on someone else's work. It has to be based on where the individual artist is now in his or her career cycle. Questions include: Are you a student as compared to being a longtime artist? Do you have buyers lined up, or are you lucky to have one in front of you?

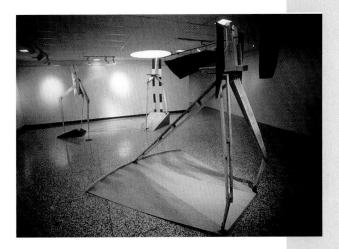

Fig. 8–32. Spotlights aimed at the wall enhance the display of objects in this exhibit.
Cynthia Harper, *Tripods #2, #3, and #4,* 1996. Wood, cloth, metal.

Contrast
Contrast is a great difference between things. In art, it is used to add interest or visual excitement. Sculptors can create contrast through the use of differing forms, textures, colors, or sizes. Dramatic contrast can be achieved when surprising or unusual materials are juxtaposed, or placed together, as in the combination of human and organic forms in the work shown in **Fig. 8–33**. Contrast is also created through the use of different textures.

Fig. 8–33. Contrast can add interest to a work of art.
Amanda R. Tuttle, *Flora.*
Clay, 8" x 9" x 10". Washington Township High School, Sewell, New Jersey. Instructor: Bob Duca.

Studio Experience
Preparing a Group Exhibition

Exhibiting your work, in either a solo exhibition or a group exhibition, is of great importance to you as an artist. If you do not show what you have done, you will neither earn a livelihood from your work nor receive recognition for your efforts. Exhibiting your work with others is a wonderful experience, but it must be planned with care in order to accurately represent you. This studio experience will lead you through the steps in working on a group exhibit.

Before You Begin

• The exhibiting student artists need to discuss what artwork will be exhibited. Will every student in the class participate? How much work will each student be showing? Will the exhibit have a particular theme? The perimeters of the exhibit will determine the amount of space needed, or perhaps the available space will determine the size of the exhibit.

• The lighting, pedestrian traffic, sculpture stands, and exhibit security all need to be addressed. If the exhibit is to be held in the school building, how much will the school staff be involved? What are the responsibilities of the student exhibitors with regard to the facility?

• Check the school calendar carefully. Perhaps the exhibit can correlate with another school event such as a school play, an open house, or a music concert. Solicit the administration's help. Select the exhibit title and opening date.

Create It

Make a checklist of all the tasks that need to be done.

Pre-exhibit:

1 Take an accurate inventory of the work to be displayed and begin to prepare the space. Select or design stands for the sculptures.

2 Plan the invitation for the exhibit opening. Design an artistic invitation that reflects the theme of the exhibit. Make sure the administration approves it.

3 Make up the mailing list. Include family, friends, faculty, staff, fellow students, and potential buyers. Print up the invitations. When possible, follow up with a personal invitation.

4 Plan press releases to local newspapers. Submit photographs, if possible. Invite the press to visit students at work preparing the exhibit. Send special press invitations for the exhibit opening.

5 Plan exhibit handout sheets with price list included.

Exhibit:

1 Display the sculptures and adjust the lighting. Make sure the viewers can examine each sculpture from several angles.

2 Write and mount gallery labels for each piece that can be easily read by viewers.

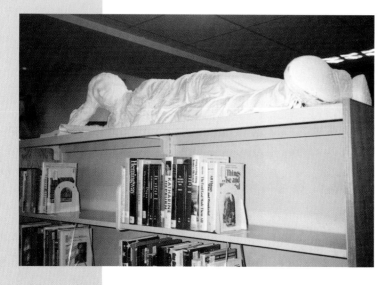

Fig. 8–34. Students' plaster sculpture displayed in a library. The title of the work is very appropriate for its location.

Brittany Falk, Leslie Carlton, *Relaxing with a Good Book.*

Plaster wrap, white latex paint, life-size. Manchester High School, North Manchester, Indiana. Instructor: Debra Schuh.

3 Take photos prior to the opening and during the exhibit to document it.

Check It Did you go over your checklist prior to the opening? What about sales? Will you have some way of receiving checks or making change on opening night? Have duties been assigned for each task, including food preparation, reception servers, janitorial tasks? How formal is the reception; what is the appropriate dress?

Sketchbook Connection

In your sketchbook, do a perspective scale drawing of the selected exhibition site, preinstallation. Make visual and numeric notations of the area's space, and any other elements such as windows and doorways. What is the best way to display the work? Consider viewer traffic flow and note it in your sketchbook. Once the work has been placed, do a postinstallation sketch to document the installation at the site.

Fig. 8–35. Sometimes a hallway must be used for exhibit space. This one is chained off to protect the sculptures.

(left to right) Shawn Steele, Duane Strasser, *Chillin*; Lucas Zapt, *Joey*; Matt Straka, *Piper at the Fountain*; Scott Zubowski, *Sitting by Myself*; Andrea Shoemaker, Laura Sisson, *Bicycle Wreck*.

Plaster wrap, white latex paint, life-size. Manchester High School, North Manchester, Indiana. Instructor: Debra Schuh.

Rubric: Studio Assessment

4	3	2	1
Exhibition Coherence • Unity • Individual focus • Movement			
All sculptures and exhibition details work together with prepared space to unify exhibit; individual sculptures displayed for best effect; planned movement through exhibit space supports good traffic flow to develop theme of show. Achieved "Work of Art" status	Most sculptures and exhibition details work together with prepared space to unify exhibit; most individual sculptures displayed for best effect; planned movement of viewers through exhibit space supports good traffic flow. Achieved comfortable success	Some sculptures work together with selected space to unify exhibit *or* some individual sculptures poorly displayed; movement through exhibit may be difficult. Needs editorial assistance, attention to detail	Exhibit appears to be just a collection of works with no apparent connection, *or* many works "fight" with exhibition space (or vice versa); movement through exhibit difficult. Fragmented effect
Teamwork • Collaboration • Individual responsibility • Group responsibility			
Classmates worked together well throughout all steps of process; most went above and beyond to fulfill responsibilities and help each other out. Full collaboration	Classmates improved collaborative skills as process evolved; most fulfilled responsibilities and helped each other out. Satisfactory collaboration	Some classmates worked together well throughout process; some worked hard to get more of the group involved. Emerging group cohesion	Few classmates worked together well throughout process *and/or* few people seemed to care about each other's or their own ideas. Limited group cohesion

Career Profile
David Finn

David Finn is the photographer of 84 books, which include works by sculptors like Carole Feuerman, Henry Moore, Chillida, and Michelangelo, and photographic essays such as "How to Look at Sculpture."

Photograph: J. Herbert Silverman.

He is known throughout the world for his public relations firm, Ruder-Finn, which employs more than 500 people completing public relations for such clients as the Guggenheim, Getty, and Tate galleries. Although he graduated with an English literature degree from City College in New York (bachelor of social science), it was several years later while in his late thirties that he began to publish books.

How did he begin taking and publishing photographs of sculpture? On a trip to Oslo, Norway, he visited a sculpture garden. He saw the work of sculptor Gustav Vigeland and was so taken that he purchased a camera and began photographing the artist's work. He showed his photographs to a friend, who happened to be Harry Abrams, a publisher. Abrams thought the pictures were wonderful and offered to publish a book based on them.

An excellent method to study photography is to learn from a master photographer. David Finn's books of sculpture photographs can be found in almost any library or bookstore, and on bookstore Web sites.

From your vast experience as a photographer of sculpture, what is most essential for a good photograph?
David: The background is terribly important, even if it is a flat background, or if it is a ceiling background. . . . Compose a photograph the way a sculpture is composed. . . . Arrange the lighting so that it brings out the quality of the form. That's very important.

What should a student know about film?
David: I usually use 400 ASA speed both color and black-and-white for interior and exterior. . . . Some of my photographs have been five feet high.

What advice do you have for younger sculpture photographers?
David: It doesn't really matter what camera you get . . . there are a lot of good cameras. You can take great photographs with a very modest camera. Look into the camera viewfinder, be careful about everything that appears in that square or rectangle . . . not only the subject that you are looking at but all the other subjects as well . . . they can be in the background. Compose them so that you are planning the composition of the entire area. . . . Details are almost always more interesting than overall shots. . . . When I photograph sculpture, it is always the details that are most interesting. . . .

Fig. 8–36. This photograph of Henry Moore's magnificent bronze sculpture *King and Queen* is one of David Finn's favorites.
Henry Moore, *King and Queen*, 1952–53.
Bronze, larger than life-size. Located in Scotland. Photograph: David Finn.

Chapter Review

Recall What is the accepted way of labeling art slides?

Understand In photographing sculpture, what are the drawbacks of using a built-in camera flash?

Apply Select a sculpture you completed recently and prepare a gallery label for this piece.

Analyze Select a sculpture in this chapter that makes effective use of contrast. How did the artist create this contrast?

Synthesize There are many places to exhibit art. Select two mentioned in this chapter and list their advantages and disadvantages.

Evaluate Study Brancusi's *Mlle Pogany* on page 183. Brancusi made sculpture out of marble and bronze, a tradition that dates to ancient times, but his sculpture broke with tradition. How did he do this?

For Your Portfolio

Review the sculptures you have created so far. For your portfolio, write a critique of your work. List the strengths and weaknesses of your creations. Follow up by writing a plan of action for improving your skills and furthering your artistic development.

Writing about Art
How would you define art? In your opinion, what makes a good work of art? Write an artist statement explaining your thoughts and beliefs about art. When you are finished, add your artist statement to your portfolio.

Fig. 8–37. A well designed and displayed student exhibit.
"Visions," an exhibit by students at the Scottsdale Center for the Arts, 2002.
South Mountain High School, Scottsdale, Arizona. Instructor: George Reiley.

Sculpture Timeline

Near East

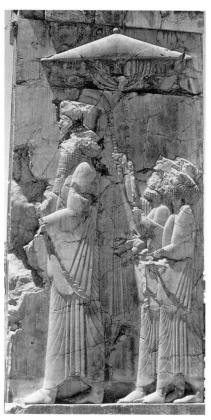

Fig. 1. Humans have been creating sculptural forms since before the Paleolithic era. The cultures of the Near East, a region between the Tigris and Euphrates rivers near present-day Iran and Iraq, created elaborate reliefs to decorate their palaces. One of the most awe-inspiring was Persepolis, the ceremonial capital of the Persian empire built during the reign of Darius I (522–485 BC) and his son, Xerxes. The relief here depicts Xerxes and his attendants from the Tripylon Palace. Although damaged, the fine detail work of the sculpture is evident in the folds of the drapery, the detail of the hair features, and the sense of volume. As is common in ceremonial art, the king is the dominant figure.

Peresepolis, Persia (Iran), *Xerxes I with Attendants,* c. 480 BC, relief from the Palace of Xerxes I.
Courtesy Davis Art Images.

Egypt

Fig. 2. The Egyptians evolved a unique way of life and a style of art that remained almost unchanged for several thousand years. All artistic activities were inspired by the gods. Many sculptors were also priests and followed strict artistic formulas inherited from previous generations. While most Egyptian relief sculpture is formal and static in design, the relief shown here portrays the pharaoh Rameses II in a dynamic and powerful stance subduing his foes. The figure's legs, arms, and face are in profile, with the upper body turned toward the viewer, a typical Egyptian relief technique.

Karnak, Egypt, *Rameses II Slaying Foes,* c. 1290 BC, hypostyle hall relief from the Temple of Amen Re.
Courtesy Davis Art Images.

China

Fig. 3. Buddhism reached China from India sometime before 100 AD. Cave temples and monasteries were hollowed out of rock and embellished with huge carved images of Buddha. The largest and most extensive groups survive today in northern China. The seated Buddha figure from the Yun Kang cave in Shanxi is carved out of the rock of the hillside. Flanked by two large standing figures and a multitude of smaller images, it is a living testimony to the power of the Buddhist religion during this period in China.

Shanxi Province, China, *Colossal Seated Buddha Vairocana,* c. 460 AD, Yung Kang Caves, Datong.
Courtesy Davis Art Images.

3000 BC – 1857 AD

India

Fig. 4. Hinduism and Buddhism have dominated the art of India for more than 2,500 years. At times, one religion was stronger than the other, resulting in distinctly different sculptures. At other times, the two religions coexisted and their sculpture shared similar styles. In southeastern India, a Hindu culture known as the Pallava produced freestanding temples and bas-reliefs cut from live rock, such as the relief here from Mahamallapuram, called *The Descent of the River Ganges from Heaven*. During the rainy season water from the Ganges River flows from a cleft in this massive rock carving. The carving tells about the rewards given to a sage, or honored wise person, for living a simple, austere life.

Mahamallapuram, India, *Descent of the River Ganges* (close-up), c. 625–674 AD.

Rock-cut, life size. Courtesy Davis Art Images.

600 – 150 BC

Ancient Greece

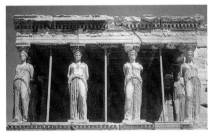

Fig. 5. The Classical Period of Greek art, which lasted from about 480 to 323 BC, produced some of the greatest sculpture in Western art. This was the time of the philosophers Protagoras and Socrates, and of the sculptors Myron and Phidias. The entire ancient world was in awe of Greek achievement, which influenced Roman and later European art. Greek sculpture expressed ideas of humanism and idealism. The temple called the Erechtheum on the Acropolis used six female figures (called caryatids) as columns to support the architrave. The art of the sculptor is evident in that while the figures have a feeling of rigidity appropriate to their function, they also have a sense of life and graceful bearing.

Athens, Greece, *Porch of the Maidens*, Erechtheum, Acropolis, 421–405 BC, designed by Mnesikles.

Courtesy Davis Art Images.

753 BC – 476 AD

Ancient Rome

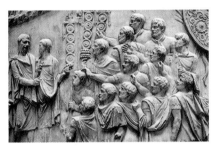

Fig. 6. The Romans, who conquered the Greeks and other nations, admired Greece's sculpture. They even copied Greek works of art. In their own art, the Romans emphasized practical and realistic elements and excelled in architecture and city planning. They developed concrete as early as the second century BC. As conquerors, they carved large monuments to celebrate their triumphs. *The Column of Trajan* is a splendid marble cylinder that rises to a height of more than 130 feet. In a spiral relief some 700 feet long, the exploits of Trajan's campaigns are carved as a narrative history in stone. This relief shows Trajan addressing his troops.

Forum of Trajan, Rome, *Column of Trajan* (detail), Trajan Addressing His Troops, 113 AD, design by Apollodorus of Damascus.

Marble. Courtesy Davis Art Images.

1000 BC – 1500 AD

500 BC – 1900 AD

500 BC – 1500 AD

Mesoamerica

Africa

Native North America

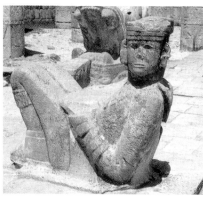

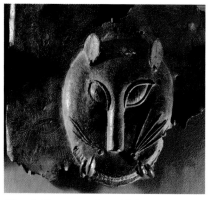

Fig. 7. Mesoamerica includes civilizations that flourished in Mexico, Central America, and South America before the Spanish invasion. Sculpture throughout the Americas was often ceremonial, with heads and figures of gods and kings carved in low or high relief. The Maya and other groups built large cities with plazas and pyramids for use in religious rites. On the Yucatán Peninsula of Mexico, the Maya built a major temple complex at Chichén Itzá. A carved figure of Chac Mool, a messenger of the gods, sits atop the Temple of the Warriors, surrounded by impressive columns carved to look like enormous feathered serpents.

Mexico (Maya-Tolec), *Chac Mool (Messenger of the Gods)*, from the Temple of the Warriors, Chichén Itzá, c. 900–1200 AD.

Courtesy Davis Art Images.

Fig. 8. To appreciate African art it is necessary to know where it originated and the beliefs that surrounded it. Most sculpture was produced for use in rituals and ancestor worship. African artists created cult figures, ritual masks, reliefs, headdresses, and objects connected to kingship sculpted in wood, ivory, and bronze. One of the earliest African cultures is the Nok culture (500 BC), which created large terracotta figures. Later centers of artistic production included the Yoruba of Nigeria, the Ashanti of Ghana, the Dogon of Mali, and the Ife and Benin kingdoms of western and central Africa.

Benin, Nigeria, *Head of a Snarling Leopard*, a plaque that decorated the palace of the Kings of Benin, anonymous.

Bronze. Museum fuer Voelkerkunde, Staatliche Museen, © Werner Forman/Art Resource, New York.

Fig. 9. The way of life of Native North Americans has always been closely tied to a deep respect for nature. Most Native American art has been inspired by the plants, animals, and landscapes they found around them. Their art reflects an appreciation for the materials of nature, a close relationship with the spirit world, pictographic symbolism, and an advanced level of craftsmanship. Today, some Native North American artists use modern methods and materials to express important heritage themes—respect for nature, survival of their traditions, and the meaning of their heritage in the world now. Inuit sculptor Lawrence Beck (1938–1994) combines traditional mask-making with contemporary materials, including dental tools, oil filters, kitchen spatulas, and safety pins, to create a spirit mask for a new generation.

Lawrence Beck, *Punk Nanuk Inua Mask* (Polar Bear Spirit), 1986.

Mixed media. From "A People in Peril" exhibition at the Visual Arts Center of Alaska, Anchorage. Anchorage Museum of History and Art.

Romanesque

Gothic

Early Renaissance

Fig. 10. Romanesque art is characterized by its expressive nature and religious intensity—it was intended to evoke an emotional response from the viewer. During the Middle Ages, constructing churches and carving sculptures to decorate them infused Western Europe. Sculpture during this period was primarily large in scale and attached to architecture. As Christianity rejected the physical world, realism in sculpture declined and symbolism became important. The monastery of Santo Domingo de Silos includes various sculptures depicting themes from the life of Christ. The figures of the apostles in this sculpture are wedged together in tiers and enclosed in a rounded arch that creates a sense of tension and introspection.

Burgos, Spain, *Doubting Thomas*, unknown artist, cloister pier relief from the monastery of Santo domingo de Silos, 1091–1109 AD.
Courtesy Davis Art Images.

Fig. 11. Gothic sculpture is characterized by expressive force and increased realism. The symbolism of Romanesque sculpture gives way to a new awareness of the natural world. There is an increased interest in surface detail, such as the elaborate folds of drapery, but as yet no interest in the anatomical accuracy of the body. Unlike Romanesque art, the full-figured statues from the *Annunciation* are almost free of their architectural columns and are sculpted in the round. The figures' features have expressions and gestures that are free and graceful.

Reims, France, *The Annunciation*, unknown artist, c. 1230 AD, south jamb of the central portal on the west façade of Reims Cathedral.
Courtesy Davis Art Images.

Fig. 12. The Renaissance began in Florence in the early fifteenth century and soon spread to the rest of Europe. The period was fueled by a renewed interest in the ancient Greeks and Romans as well as an interest in science and math. Major sculptors of the period included Donatello and Lorenzo Ghiberti. The work of Claus Sluter (active 1380–1406) falls between the end of the late Gothic era and the beginning of the Renaissance, but his work is so strong and his style so individualistic that it can be placed in the Renaissance period. In *Moses with Two Prophets*, the facial expression is intense and powerful; the full, parted beard and the lush, flowing robes create a dynamic rhythm and visual movement.

Dijon, France, *Well of Moses*, 1395–1406 AD, by Claus Sluter, Charreuse de Champmol.
Stone, 6' (183 cm). Courtesy Davis Art Images.

1500–1525

High Renaissance

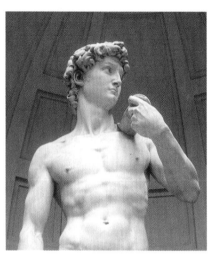

Fig. 13. The High Renaissance lasted a very short time—a mere twenty years or so. But during that time artists in Rome and Venice produced works that are probably some of the most well known in the world. Their work was more expressive than that of the earlier Renaissance artists. Its major trend was a shift from art based almost exclusively on religious concepts to the introduction of more realistic, scientific, and human concepts. This phase brought to perfection the experiments and discoveries of artists like Raphael, Leonardo da Vinci, and Michelangelo.

Michelangelo Buonarroti, *David* (detail), 1501–1504.

Marble, 171⅛" h (435 cm). Galleria dell'Accademia, Florence, Italy. Courtesy Davis Art Images.

1600–1700

Baroque

Fig. 14. The Baroque style emphasized complexity, drama, and grandeur, and it was very ornate. Lively motion, dramatic contrasts, and asymmetrical design are typical of the style. The Italian sculptor Gianlorenzo Bernini (1598–1680) became the most dominant sculptor of the era. His free-flowing forms also influenced architecture. Movement is one of the most important principles in most of Bernini's sculptures and fountains. To produce constant change and motion, Bernini and other Baroque sculptors often designed enormous, elaborate fountains, combining carved marble with flowing and spraying water. His writhing figures in *Fountain of the Four Rivers* are caught in a transient moment from a single viewpoint, bursting into the viewer's space.

Piazza Navona, Rome, *Fountain of the Four Rivers* (close-up of a water god), 1674–1675 by Gianlorenzo Bernini.

Courtesy Davis Art Images.

1750–1875

Neoclassicism

Fig. 15. The discovery and excavation of the ancient Roman city of Pompeii in the 1760s helped to create a revival of Classicism in art in the late eighteenth century. Neoclassicism had its base in France under Napoleon Bonaparte, who favored the style. It was inspired by the themes and principles of classical art. Antonio Canova (1757–1822) is considered one of the great Italian sculptors of the period. His tomb of Princess Maria Christina is dignified and imposing and embodies the beauty, power, and grace for which Canova is known. Another major sculptor of the period was Jean-Antoine Houdon (1741–1828). He revived the ancient Roman interest in portrait busts, sculpting well-known heads of Thomas Jefferson and Benjamin Franklin in classical poses.

Vienna, Austria, *Tomb of Princess Maria Christina*, c. 1798–1805 by Antonio Canova, nave of the Church of the Augustinians.

Marble, life-size. Courtesy Davis Art Images.

Romanticism

Impressionism

Early Abstract Art

Fig. 16. Romantic artists rebelled against the dictates and conventions of Neoclassicism and instead created a style that relied heavily on intense emotion and individuality. These artists set the stage for present-day ideas about the importance of original, individual artwork. Major painters influenced by romantic themes included Goya, Géricault, Delacroix, and Turner. François Rude (1784–1855) and Antoine Louis Barye (1796–1875) were French sculptors who created works in the Romantic style. Rude, an admirer of Napoleon, was commissioned to complete a group sculpture for the Arc de Triomphe in Paris. His composition symbolically shows the French people defending the Republic. The highly charged piece reflects the romantic ideals of energy, symbolism, and passion.

Arc de Triomphe, Paris, *Departure of the Volunteers of 1792 (La Marseillaise)*, façade of the Arc de Triomphe, 1833–1836 by François Rude.

Marble, 42' x 26' (13 x 8 m). Courtesy Davis Art Images.

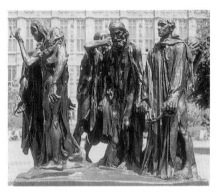

Fig. 17. Impressionism is a style associated with painting, but three-dimensional art of this time was also influenced by its themes. Impressionist artists were interested in capturing outdoor light and color at a particular moment in time. The sculptor Auguste Rodin (1840–1917) infused his work with elements of Romanticism and Impressionism. The rough-textured surfaces over which light dances in his *Burghers of Calais* is an influence from Impressionism, while the introspective, compacted pose of his figures reflects Romanticism's emphasis on drama. The combination of both elements points the way toward the later movement in painting and sculpture called Expressionism.

London, England, *Burghers of Calais*, Victoria Embankment, 1884–1886 by Auguste Rodin.

Bronze, 81⅞" x 55¼" x 74⅞" (208 x 140 x 190 cm). Courtesy Davis Art Images.

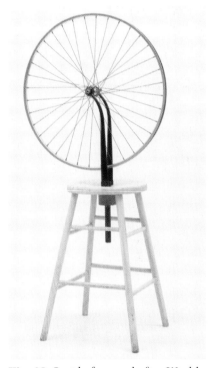

Fig. 18. Just before and after World War I, several groups of artists explored themes of future, fantasy, and change as subjects for art. Some also explored new methods of creating art. Cubism (1907–1914) is a style first developed by Pablo Picasso (1881–1973) and Georges Braque (1882–1963). Shapes are often fractured, then locked together and rearranged so that one picture seems to include many points of view. The Dadaist artist Marcel Duchamp (1887–1968) created an assemblage and used ready-made objects for a kinetic sculpture. The experimental attitude of these artists set the stage for later artists to question whether art must always be made in traditional ways.

Marcel Duchamp, *Bicycle Wheel*, 1951 (third version after lost original of 1913).

Metal wheel mounted on painted wooden stool, 50½" x 25½" x 23¾" (128.3 x 64.8 x 60.3 cm). Gift of Sidney and Harriet Janis. The Museum of Modern Art, New York. Digital Image © The Museum of Modern Art/Licensed by Scala/ARS, New York.

1940 – 1960

Abstract Expressionism

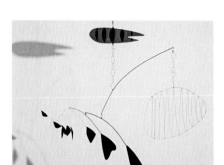

Fig. 19. The first modernist style that originated in the United States was Abstract Expressionism, which began during World War II. Alexander Calder (1898–1976) was one of the first American artists to begin to work with abstract sculptural forms. The sculpture here is typical of many of Calder's works: simple, organic shapes meant to interact with their environment. Sculptor Henry Moore (1898–1986) experimented with abstract forms that incorporate positive and negative space to lead the viewer through and around the whole work.

Alexander Calder, *Lobster Trap and Fish Tail*, 1939.

Hanging mobile, painted steel wire and sheet aluminum, 8' 6" x 9' 6" (260 x 290 cm). The Museum of Modern Art, New York; commissioned by the Advisory Committee for the stairwell of the Museum. Digital Image © The Museum of Modern Art/Licensed by Scala/ARS, New York.

1950 – 2000

New Concepts and Ideas

Fig. 20. After the 1950s sculptors began to expand the ideas traditionally associated with their art form. They assembled together found objects such as televisions, umbrellas, and furniture. Installation and video artist Pepón Osorio (b. 1955) was influenced by his work as a social worker in the Bronx. His work reflects specific experiences in his life or in the life of the community. In *Tina's House*, he worked with a family recovering from a devastating house fire to create what he calls a "memory house." Osorio was featured in the PBS series *Art:21—Art in the Twenty-First Century.**

Pepón Osorio, *Tina's House* (detail), 1999.

Mixed media, 20" x 28" x 17". Courtesy Bernice Steinbaum Gallery, Miami, FL.

*art:21 is a nonprofit organization that produced the Emmy-nominated series *Art:21— Art in the Twenty-First Century.* In addition to the series, Art:21 oversees national education programs and creates Educators' Guides, Companion Books, and a comprehensive accompanying Web site—www.pbs.org/art21

2000 – Present

The Future

Fig. 21. Today, artists want people to help them answer the question "What is art?" and they continue to explore the possibilities of answering that question. Performance and conceptual artists expand on the Dadist idea that art can be an event in time, not just an object. Sculptors constructed artworks out of new and unusual materials such as industrial steel, plastic, and neon lights. They interacted with their environment to create innovative outdoor environmental sculptures. The figures in this installation are made of glass mosaic, a tradition that is thousands of years old, but used in an innovative way.

Sandy Skoglund, *Breathing Glass*, 2000.

Installation.

Appendix

Construction Tools

The best way to begin a study of construction is to study individual tools and materials and how to use them. Once the tools are understood, many artworks can be completed consisting of one, two, or a multitude of materials and techniques. Different tools are available for different projects. This section demonstrates three tool groupings: hand tools, power tools, and stationary power tools.

Simple constructions, depending on the materials, can be completed with only a few tools. A carpenter's hammer, saw, and square are needed for woodworking projects, for example. Metal projects require a fine-toothed saw, pliers, and ball-peen hammer. Common power tools used for both metal and wood are drills, saber saws, and sanders.

Hand Tools for Woodworking

Carpentry hammers come in various sizes. The most useful size is a 16 ounce for common building construction. A smaller hammer, 12 ounces, is referred to as a finishing hammer since the blow is lighter and more controllable due to the hammer's size. It is used with finishing nails. A long-handled 20-ounce hammer is referred to as a framing hammer, since it is used to drive heavy long nails in basic construction. The rear of the hammerhead has a "claw" shape primarily for pulling (removing) old or bent nails.

Safety Note While hammers can be used as pry bars for construction, hammer handles, especially those made of wood, can be broken. Care should be taken to avoid tool damage or injury caused by misusing the tool.

Handsaws for woodworking come in different sizes and shapes for various purposes. The sizes are reflected in the teeth size of the blades. The fewer teeth, the faster the cut, but also the rougher the cut. Teeth are measured by points, meaning teeth per inch. The three most useful large saws are a

Fig. A–1. Hammers often used in construction *(from the top)* are: 10-pound sledgehammer, 4-pound striking hammer, carpenter clay hammer, ball-peen hammer.

crosscut (large tooth, 8 points), designed to cut across the grain (usually the board width); a ripsaw (very large tooth, 4 points), designed for fast cuts with the grain (usually the length of the board); and a panel, or finish, saw (more teeth, 12 points) used for the finer cutting of thin woods or plywood. The "set," or angle, of the teeth from side to side determines the blade's kerf (width of cut) and the ease of moving the saw through the wood. Without set, the blade will bind (stick) in the wood, because there will not be a wide enough path for the blade to move freely.

Keyhole saws, although rather coarse toothed (9 points) for a small saw, help in tight places, especially when working with Styrofoam.

The most useful small saw is the coping saw with a thin blade of about 17 points. The narrow blade is placed within a wide steel arm. It allows sharp turns in the cutting process, but it is limited to thin and smaller boards.

Fig. A–2. Saw tooth sizes *(from the top)*: **8 point, 12 point, 17 point.**

Note It For inner cuts or tight turns, coping-saw blades can be removed and placed through drilled holes in the wood. Then the saw frame is placed around the wood as the blade is reseated into the saw.

Safety Note Blades must be kept sharp. Dull saws can cause accidents due to the exertion required to operate them, resulting in a loss of control.

Try It Rub paraffin on both sides of the hand-saw blade to aid in the smoothness of the cutting.

Carpenter's squares (made of metal) offer an easy way to square large, flat sheets of wood, Styrofoam, even cardboard and paper. They are also convenient to use as a straightedge with which to draw lines.

Hand Tools for Metalworking

Ball-peen hammers not only have a flat striking surface but also have a ball-shaped rounded end for shaping metal without leaving the sharp impression of the edge of the flattened head. Sizes vary by weight depending on specific purposes.

Hacksaws are similar to coping saws, but longer and stronger, holding a slightly wider blade with a hard-tempered tooth designed for hard metals. The teeth are fine for better cutting.

Pliers are designed to grip, cut, and hold objects. The jaws have a flat-end surface with small, serrated teeth designed to clasp objects, while the inner, rounded surface has larger teeth designed to hold pipe or objects that are not flat. The very inner grip is actually a blade designed for light wire cutting. Pliers have a "slip lock," activated by opening the pliers and moving the handles out about the center support or rivet. This enables a larger, wider

Fig. A–3. Gripping tools *(from the top)*: **needle-nose, vise grips, closed pliers, pliers open to show larger jar in open-slip position.**

grip to hold bigger objects. Needle-nose pliers are a version of pliers with a long tapered jaw ending in a narrow point.

Other Hand Tools

Screwdrivers are of several types and sizes, but the two most useful ends are the flat end and the Phillips head. The flat end is common among wood screws, while the Phillips head is more common for metalwork. Tip sizes exist to fit all screw heads.

Clamps are used to temporarily hold sculptures in place while working, especially to keep wood pieces together after gluing. There are many varieties but the C-clamp (sometimes called the G-clamp) and bar-clamp (often called the F-clamp) are the most common. The C-clamp is shaped like a large letter **C** with a swivel handle on one end to tighten for pressure. It is used for smaller works. The bar-clamp, shaped like an **F**, has more length and is used for longer, flat surfaces.

Measuring tapes are essential for longer or larger works. They are quite handy, being retractable into a small case. While a yardstick can be used for shorter measurements, accuracy is affected if it has to be moved to measure several lengths.

A file is a hardened steel tool with fine teeth in ridges designed to cut into hard surfaces. It is usually long and narrow with teeth on both sides. The favorite file of sculptors has a flat side with the opposite side having a rounded body or half-round shape.

Fig. A–4. Clamps *(from the top)*: **wood clamp, pipe clamp, bar clamp, C-clamp.**

A rasp has the same shape and configuration as a file. However, the teeth are larger and much more blunt. A Surform rasp is a thin-bladed rasp with open teeth that allow the cut particles of softer materials (soft wood, Styrofoam, or plaster) to pass through the rasp blade. This enables the rasp to continue cutting without clogging.

Fig. A–5. Files and rasps *(from the top)*: **chipped carbide file/rasp, half-round two-grit rasp, half-round file, riffler rasp.**

Fig. A–6. Surform rasps in various configurations.

Power Tools

Power tools can greatly increase the speed and efficiency of your sculpting work. What was once completed by rapid movement of a sharp-pointed bit, hand-held saw, and sheets of sandpape, can now be finished with power drills, power saws, and power sanders. This enables the sculptor to complete larger and more intricate works with much less effort.

Power drills are available in corded or portable battery models. Drilling holes is what they were originally designed to do. They can also tighten or loosen fasteners, sand works with disk pads and flap wheels, roughen and shape surfaces with rotary files and rasps, and create (drill) holes. Power drills are listed by the largest-size bit shank that they can use. Popular drill sizes range from 1/16 inch to 1/2 inch, with 3/8 inch being the most useful.

Bits for the drills can be of several types, kinds, and steels. The most common construction bits are the hardened steel, the carbide tip, the concrete bit with a carbide tip, forstner wood bits, and flat wood paddle bits.

Circular saws are most often used to cut boards straight across. Saber saws, sometimes called handheld jigsaws, are designed to cut various shapes, especially rounded and square cuts that are self-contained (that is, have no entrance cuts). They are available in different sizes and shapes. These saws can cut various board thicknesses, though thinner boards are easier to cut and result in more controlled cuts. Specific blades are designed for starter holes, long depths, wood, metal, plastics, and so on. They should never be forced, since they will break. Always have at least one backup blade.

The three most useful sanders are the standard disk sander, the random-orbit sander, and the orbital sander. The popular sandpaper grits for these tools range from 16 to 320. A 24 grit is used for shaping, while a 120 grit is used for near finishing work. The standard disk sander with a 5- or 6-inch disk leaves deep, rounded tool marks and even gouges if it is not constantly moved about over the surface. However, with a coarse 16- or 24-grit disk, it can be used for major shaping of a surface. The random-orbit sander with a coarser grit sandpaper can also be used for roughing or with finer papers it can be used for finishing. The round disks, usually 6 inches across, are attached by the pressure-sensitive backing on the disk to the smooth sander

pad. The orbital sander is used for fine finishing with higher grit papers. The most common grits are 120 and 220. Though these sanders come in various shapes, the square sanding pad is the most common one.

Stationary Power Tools

Larger stationary power tools, when available, are very useful for large projects that require greater precision. The most common ones are the table saw, drill press, band saw, grinder, and disk sander.

The table saw is used to cut large, flat boards and plywood sheets with measured straight cuts. The drill press allows pressure to be applied to the drill bit as it is in motion, which makes a hole quicker with greater accuracy. The band saw is

Fig. A–7. A table saw with the appropriate safety guards attached.

Fig. A–8. A saber saw can be used for curved as well as straight cuts.

designed to cut through boards using narrow blades to complete rounded edges. The grinder is primarily used to grind down metal or to sharpen tools. The disk sander is designed for fast sanding of flat surfaces as well as for flattening the foot or base of sculptures.

Adhesives

Carpenter's glue and white glue are used for interior woodworking. Properly applied, this type of glue creates a stronger hold than the wood fiber around it. It comes in containers of various sizes. The smaller containers have an application shape, or device, on the end that helps spread the glue. This adhesive needs to soak into the surface in order to bond effectively.

Epoxy is a very hard glue that comes in two parts ready to mix. Epoxies are weather resistant and come in various strengths and thicknesses. Setting times vary from less than 5 minutes up to 24 hours. This adhesive is used for metals, stones, woods, and so on. It joins hard materials but still needs some "tooth"—roughened surface—to bond.

Contact cement is a glue that is spread on both of the surfaces to be joined and left to dry slightly; then the surfaces are pressed together for adhesion. Upon contact, the glue adheres to most surfaces but needs time to set before it gains strength. Extreme heat can cause this adhesive to loosen.

Glue sticks that are dispensed in an electrically heated glue gun can be used on many substances. The glue sticks are available in various sizes and for different purposes. Adhesion is good for most materials, but the heat of the glue gun may adversely affect some materials.

Safety Note Keep adhesives off tabletops and out of clothing. If spilled, clean up immediately. Do not place glue on your skin, and above all, keep it out of your eyes. Read all labels and know what to do if the glue does get into or on the wrong places.

Cutting and Folding Paper

The weight of commercial printing (office paper) is measured by the ream (500 sheets) in a predetermined size of 17 by 22 inches. Common computer or printing paper weighs 20 pounds. Light printing paper weighs 16 pounds, while heavier paper is 24 pounds per ream. The brightness, or whiteness, of

a paper is stated by a number, usually in the 80s or 90s. A very bright (white) paper would be 98, while a less white paper would be in the very low 90s. Although many papers are available for use, the paper needs to be strong enough to remain reasonably flat when held in the center yet flexible enough to accept a bend or fold. A package of index paper will contain 250 sheets of very good card stock (even in colors) at a very low price for lightweight designs.

You might also want to investigate using rice paper, foil papers, waxed paper, cellophane, tissue paper, and crepe paper.

Note It Construction paper is brittle and cracks easily. Its color fades quickly when exposed to sunlight.

Types of Papers

Papers	Weight	Characteristics
Light-weight paper		
• Strathmore drawing paper	60 pound	good drawing surface
• construction paper	medium weight	weak, brittle, fades
• card stock (index paper)	60-plus pound	smooth surface
Medium-weight paper		
• Strathmore drawing paper	80 pound	good drawing surface
• bristol board drawing paper	100 pound, 2 ply	strong/good drawing surface
• card stock (index paper)	80-plus pound	smooth, bendable
Heavy-weight paper		
• corrugated cardboard	varies	very weak, brown color
• bristol board	5 ply	strong
• poster board	varies	not very strong, easily saturated

Bibliography

Andrews, Oliver. *Living Materials: A Sculptor's Handbook*. Berkeley: University of California Press, 1988.

Barrie, Bruner Felton. *Model Making, Casting and Patina*. Princeton, NJ: Adams, Barrie, Felton and Scott Publishing, 1993.

Beattie, Donna Kay. *Assessment in Art Education*. Worcester, MA: Davis Publications, Inc., 1997.

———. *A Sculptor's Guide to Tools and Materials*. New York: Adams, Barrie, Felton and Scott Publishing, 1996.

Brommer, Gerald F. *Wire Sculpture and Other Three-Dimensional Construction*. Worcester, MA: Davis Publications, Inc., 1968.

———. *Discovering Art History*. Worcester, MA: Davis Publications, Inc., 1997.

———, and Joseph Gatto. *Careers in Art*. Worcester, MA: Davis Publications, Inc., 1999.

Cami, Josepmaria Teixidó, and Jacinto Chicharro Santamera. *Sculpture in Stone*. Hauppauge, NY: Barron's Educational Series, 2000.

Caplin, Lee. *The Business of Art*, 2nd ed. Englewood Cliffs, NJ: Prentice Hall, 1989.

Chappell, James. *The Potter's Complete Book of Clay and Glazes*, rev. ed. New York: Watson-Guptill Publications, 1991.

Chilvers, Ian. *A Dictionary of Twentieth-Century Art*. Oxford and New York: Oxford University Press, 1998.

Coleman, Ronald. *Sculpture: A Basic Handbook for Students*, 3rd ed. Dubuque, IA: William C. Brown Publishers, 1990.

Exploring Visual Design. Worcester, MA: Davis Publications, Inc., 2000.

Finn, David. *How to Look at Sculpture*. New York: Harry N. Abrams, 1989.

Finn, David, Dena Merriam, and Eleanor Munro. *Carole A. Feuerman Sculpture*. New York: Hudson Hills Press, 1999.

Gault, Rosette. *Paper Clay*. Philadelphia: University of Pennsylvania Press, 1998.

Grant, Daniel. *The Artist's Resource Handbook*, rev. ed. New York: Allworth Press, 1996.

Gregory, Ian. *Sculptural Ceramics*. Woodstock, NY: The Overlook Press, 1999.

Greh, Deborah. *New Technologies in the Artroom*. Worcester, MA: Davis Publications, Inc., 2002.

Hall, Carolyn Vosburg. *Soft Sculpture*. Worcester, MA: Davis Publications, Inc., 1981.

Hamer, Frank, and Janet Hamer. *The Potter's Dictionary of Materials and Techniques*. Philadelphia: University of Pennsylvania Press, 1997.

Hobbs, Jack, Richard Salome, and Ken Veith. *The Visual Experience*, 3rd ed. Worcester, MA: Davis Publications, Inc., 2005.

Kirby, Ian. *Sharpening with Waterstones*. Bethel, CT: Cambium Press, 1998.

Langland, Tuck. *Practical Sculpture*. Englewood Cliffs, NJ: Prentice Hall, 1988.

———. *From Clay to Bronze*. New York: Watson-Guptill Publications, 1999.

Lindquist, Mark. *Sculpting Wood*. Worcester, MA: Davis Publications, Inc., 1986.

Lucchesi, Bruno. *Terracotta*. New York: Watson-Guptill Publications, 1996.

MacCormick, Alex. *Paper Mâché Style*. Iola, WI: Krause Publications, 1994.

Mackey, Maureen. *Experience Clay*. Worcester, MA: Davis Publications, Inc., 2003.

Mayer, Ralph. *The HarperCollins Dictionary of Art Terms and Techniques*, 2nd ed. New York: Harper Perennial, 1991.

McCreight, Tim. *The Complete Metalsmith*. Worcester, MA: Davis Publications, Inc., 1991.

———. *Practical Casting*. Worcester, MA: Davis Publications, Inc., 1995.

Miller, Richard M. *Figure Sculpture in Wax and Plaster*. New York: Dover Publications, 1987.

Mills, John W. *Encyclopedia of Sculpture Techniques*. London: B. T. Batsford, 2001.

NAEA. *The National Visual Arts Standards*. National Art Education Association, 1994.

Nigrosh, Leon, I. *Low Fire: Other Ways to Work in Clay*. Worcester, MA: Davis Publications, Inc., 1980.

———. *Sculpting Clay*. Worcester, MA: Davis Publications, Inc., 1991.

———. *Claywork*, 3rd ed. Worcester, MA: Davis Publications, Inc., 1995.

Peck, Judith. *Sculpture as Experience*. Iola, WI: Krause Publications, 1989.

Plowman, John, *The Encyclopedia of Sculpting Techniques*. Philadelphia: Running Press, 1995.

Reiss, Julie H. *From Margin to Center*. Cambridge: The MIT Press, 2001.

Rossol, Monona. *The Artist's Complete Health and Safety Guide*, 3rd ed. New York: Allworth Press, 2001.

Roukes, Nicholas. *Sculpture in Paper*. Worcester, MA: Davis Publications, Inc., 1993.

Rubino, Peter. *The Portrait in Clay*. New York: Watson Publications, Inc., 1997.

Soft Sculpture and Other Soft Art Forms. New York: Crown Publishers, 1994.

Toale, Bernard. *The Art of Papermaking*. Worcester, MA: Davis Publications, Inc., 1983.

Toplin, Jim. *Working Wood*. Worcester, MA: Davis Publications, Inc., 1993.

Williams, Arthur. *Sculpture: Technique-Form-Content*, rev. ed. Worcester, MA: Davis Publications, Inc., 1995.

———. *The Sculpture Reference*. Unpublished manuscript, in press

Wolf, George. *3-D Wizardry: Design in Papier-Mâché, Plaster and Foams*. Worcester, MA: Davis Publications, Inc., 1995.

Woody, Elsbeth S. *Handbuilding Ceramic Forms*. New York: The Noonday Press, 1998.

Zelanski, Paul, and Mary Pat Fisher. *Shaping Space*, 2nd ed. Fort Worth, TX: Harcourt Brace College Publishers, 1987.

Glossary

A

abstraction A technique that emphasizes a simplified or systematic investigation of forms. The subject may be recognizable or completely transformed into a form or essence of the object.

additive A sculptural process in which material is built up or added to create a form.

aggregate A body of granular material, such as sand or gravel, used for color and/or strength in casting mixes.

alginate A molding material primarily used for dental molding, but also used for human body molds because of its quick-drying capability and flexibility.

armature A framework used to support material being modeled in sculpture.

art fair Art shows or exhibitions in a public setting where purchases can be made.

artist statement A written record of an artist's view of why he or she creates art, his or her philosophy, and the influences that have shaped his or her works of art.

assemblage A sculpture constructed from various materials not originally manufactured for artistic purposes, often including found objects.

asymmetrical balance A kind of balance in which the two sides of a composition are different yet appear balanced.

B

balance A principle of design that describes how parts of an artwork are arranged to create a sense of equal weight or interest.

base block The foundation or support for a sculptural object.

bas-relief *See* low relief.

bisque Ceramic ware that has gone through the first firing (cone 010 to 06) and still maintains its porous state.

C

caliper A hinged tool used for measuring the diameter on the inside or outside of a three-dimensional form.

carving A subtractive method of producing a sculpture in which the material is cut or chipped away.

casting A method of reproducing a three-dimensional object by pouring a hardening liquid into a mold bearing its impression.

cast stone A term for a cement mixture that is specifically designed for sculptural purposes.

cement A building material made from calcium aluminum silicate known for its hardness and durability.

ceramic-shell process A procedure for utilizing the heat-resistant ceramic shell into a mold material for casting.

coil technique A process of attaching rolls of clay together to form pottery.

collaboration The merging of several talents to create one work; also an artwork done by a group of individuals.

color An element of design with three properties: hue, value, and intensity.

construction A sculpture made by combining materials often obtained from building-supply stores that uses common building (construction) methods. The materials are usually "raw" or unused.

content The subject matter of a work of art.

contrast A principle of design that refers to differences in values, colors, textures, and other elements to create emphasis and interest.

D

draft The tapering of a mold that allows the mold to be released from the model or casting.

drape mold *See* hump mold.

E

earthenware Ceramic ware that is made from natural clay and remains porous when fired at low temperatures.

earthworks Sculptures produced in the outdoors with natural materials, often large formations of moved earth.

emphasis A principle of design by which the artist or designer may use opposing sizes, shapes, contrasting colors, or another means to place greater attention on certain areas and objects to create feeling in a work of art.

F

flux Chemicals that prevent oxides from settling on a metal's surface as it is heated.

form An element of design that is three-dimensional and encloses volume. Also a general term that means the structure or design of a work.

freestanding A sculpture that stands by itself, usually made for viewing from all sides.

G

gallery A contemporary commercial enterprise that exhibits works of art for sale.

grain The direction in which the fibers in wood and paper line up in parallel.

grog Crushed fired clay used as an additive to a clay body to reduce shrinkage.

H

hard mold A mold made of any rigid substance that remains rigid when filled with a casting substance.

high relief A relief where one-half the figure's normal thickness projects from the background.

hollowing technique A process of removing the internal mass of clay to ensure uniform thickness.

hump mold A support that holds a clay slab in a certain shape until it stiffens. Also called drape mold.

I

installation A sculpture created for a particular site wherein the viewer is a participant or part of the sculptural statement.

K

keys Matching sets of marks made in a mold seam. The keys line up, readily ensuring that the mold pieces fit together.

kinetic Any three-dimensional art that contains moving parts and can be set in motion either by air currents or some type of motor. Also may refer to a work of art in which changing light patterns are controlled by electronic switches.

kneading The process of mixing plastic clay to distribute minerals, organic materials, and water evenly throughout the clay body and to eliminate air bubbles.

L

laid-up mold casting A hollow cast created by adding casting materials directly by hand or brush to the interior of a mold's surface.

laminating A process of building up a rigid surface over a framework by applying thin layers of material.

latex A rubber substance used as a cold-cure molding compound and also as the basis of certain adhesives.

leather-hard The stage between plastic and bone dry when clay has dried, but may still be carved or joined to other pieces.

line An element of design that is used to define space, contours, and outlines or to suggest mass and volume.

liquid metal A metal-filled epoxy that comes in a variety of finishes.

liquid plaster The stage of plaster when it can be poured, thrown, or brushed.

lost-wax metal casting A method of casting molten metal into a cavity originally filled with wax. The result is an exact replica of the original wax casting.

low relief A form of sculpture in which portions of the design stand out only slightly from a flat background. Also called bas-relief.

M

malleability An object's ease of manipulation.

maquette A small-scale model of a larger sculpture. Also called model.

mobile A sculpture constructed of shapes that are balanced and arranged on wire arms and suspended from above so as to move freely in air currents.

model *See* maquette.

modeling The creating of a three-dimensional object in a soft substance such as clay or wax.

mold A hollow container that produces a cast by giving its form to a substance (molten metal, plastic, or plaster) placed within it and allowed to harden.

mold bindings Objects used to fasten mold pieces together temporarily.

molding The process of making a sculpture by building up a form in a malleable material such as clay, wax, or wet plaster.

movement A principle of design associated with rhythm, referring to a way of combining visual elements to produce a sense of action.

multimedia Installations that incorporate several different art forms.

museum A building or institution devoted to the acquisition, conservation, study, exhibition, and educational interpretation of objects of artistic value.

P

papier-mâché The result of binding, with a liquid binder, torn strips of paper together to form a three-dimensional shape. Also called paper mache.

parting line The line or place where the mold parts to avoid undercuts.

patina The thin surface coloration on an old object or metal sculpture resulting from natural oxidation or from careful treatment with heat, chemicals, or polishing agents.

pattern A principle of design that includes the repetition of elements or the combination of elements in a planned way.

piece mold A mold intended for repetitive use; it is designed for easy assemblage and easy removal of the cast object.

pinch method A hand-building technique that involves squeezing clay, usually between fingers and thumb.

plaster gauze Plaster-impregnated surgical gauze; one of the easiest methods of molding.

plasticity The quality of a material that allows it to be manipulated without tearing or breaking.

plinth A block made of wood or stone that raises a sculpture up off the ground.

polyurethane A resin added in paint coating materials for a chemical-resistant hardness.

porcelain Ceramic ware made from a specially prepared, fine white clay that can be fired at high temperatures. It is hard, translucent, thin-walled, and rings when struck.

portrait bust A sculptured bust that shows the likeness of a real person.

pouring duct A channel or opening in a mold through which a liquid medium can enter.

press mold *See* slump mold.

primary structure Large-scale constructions that rely heavily on industrial construction techniques.

proportion A principle of design that includes the relation of one object to another in size, amount, number, or degree.

proportional calipers Calipers used to make measurements when altering the size of something; that is, all dimensions remain in proportion to each other.

pulp The pulverized remains of material used to form paper. It can be of one or many substances, including cotton and plant fibers.

R

radial balance A kind of balance in which lines or shapes spread out from a center point.

release agent A thin substance, such as petroleum jelly, placed on the surface of a mold or model to prevent adhesion by other materials. Also called a separator.

relief A sculptural surface that is not freestanding, but projects from a background of which it is a part.

rhythm A principle of design that refers to ways of combining elements to produce the appearance of movement in an artwork. It can be achieved through repetition, alteration, or progression of an element.

riveting A method of joining sheets of metal using short bolts with flattened heads.

S

sandpaper A stiff paper covered with an abrasive grit coating. Low grit numbers are for coarse papers while high grit numbers are for finer papers.

scale A principle of design that means the relative size of a figure or object compared to other figures or objects.

sculpture A three-dimensional work of art.

shape An element of design that is an enclosed space, having only two dimensions. Shapes can be geometric (triangular, square, and so on) or organic (free-form with curving and irregular outlines).

shims Dividing walls used to make sure that mold pieces remain separate during the molding.

silicone A flexible mold material known for its lubricity and water-repellent nature.

site specific A sculpture created for one particular location.

slab technique A hand-building process that involves shaping clay into a broad, flat, thick piece.

slide portfolio A portable case containing slides of artwork done by sculptors. Also refers to the selection of works that an artist shows to clients.

slip A fluid suspension of clay in water used in joining clay pieces and for surface decoration.

slump mold Molds made by placing the selected pliable material onto a predesigned or selected shape and pressing it onto the surface. Also called press mold.

slush mold casting A process of creating a casting by pouring a liquid substance into a prepared mold; the purpose is to create a lighter casting.

slushed The result of pouring material into a mold that is then turned or tumbled. Some of the material clings to the wall of the mold; the excess material gets poured out.

soldering A process of joining two metal pieces by the use of heat and capillary action with thin strips of metal known as solder.

space An element of design that defines the open areas between, around, above, below, or within objects. Positive space is filled by a shape or form; negative space surrounds a shape or form.

steatite Also known as soapstone, it is easily carved stone with beautiful coloration.

stoneware Ceramic ware made from clay that is fired at a relatively high temperature (2200° F); it is hard and nonporous.

subtractive Sculpture formed by cutting away excessive material from a block, leaving the finished work.

symmetrical balance The organization of the parts of a composition so that one side duplicates or mirrors the other.

T

technique The combination of materials and tools with the abilities of the sculptor.

terracotta Baked earth-red clay used in ceramics and sculpture. Often glazed, it also is used in both architectural decoration and tableware.

texture The element of design that refers to the quality of a surface, both tactile and visual.

U

undercut A recess or awkward angle in the surface or form of a three-dimensional object that would prevent easy removal of a cast from a mold.

unity A principle of design that relates to the sense of oneness or wholeness in a work of art.

V

value An element of design that relates to the lightness and darkness of a color or tone. It depends on how much light a surface reflects.

variety A principle of design that includes the use of different lines, shapes, textures, colors, and other elements of design to create interest in a work of art.

vermiculite A lightweight mineral, commercially sold in small particles, which is used in different sculpting materials, including plaster.

W

waste mold A mold intended for onetime use because the mold must be broken away to release the cast.

wedging A process of improving the workability of clay by reforming the mixture to make it homogeneous and even in texture.

withdrawal angle The direction in which a mold must be removed from casting to avoid draft or undercuts.

Index

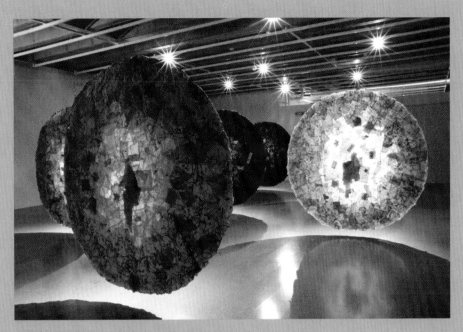

Connie Herring, *Circle of Hope*, 2001.

Multimedia installation, seven handmade paper circles, rainbow spectrum colors, messages of hope from all over the world, recorded music composition; circles are 8' tall. Photographer: Simon Spicer.